dancers
among us

dancers
among us

A Celebration of Joy in the Everyday

jordan matter

Workman Publishing
NEW YORK

NOTE:

No trampolines or wires were used in the taking of the photographs in this book, and the dancers' poses have not been digitally enhanced or altered.

Library of Congress Cataloging-in-Publication Data is available.
ISBN 978-0-7611-7170-6

Cover and interior design by Netta Rabin
All photos by Jordan Matter
Cover photo features Annmaria Mazzini
of the Paul Taylor Dance Company, shot in New York City

I Left My Heart in San Francisco, pages 40–41: *Classic San Francisco*, by Jeremy Sutton, shown with permission of the artist. Jeremysutton.com.
Barefoot and Pregnant, page 146: *American Trailer* wood block print appears courtesy of Hatch Show Print.
Taking Stock 1, page 154: *Charging Bull*, by Arturo Di Modica, shown with permission of the artist.
Sneaking a Peek, page 201: *Forever Marilyn*, by Seward Johnson © 1996, 2011 The Sculpture Foundation, Inc. Based upon the photo by Bernard of Hollywood. sculpturefoundation.org.

Workman books are available at special discounts when purchased in bulk for premiums and sales promotions as well as for fund-raising or educational use. Special editions or book excerpts can also be created to specification. For details, contact the Special Sales Director at the address below, or send an email to specialmarkets@workman.com.

Workman Publishing Company, Inc.
225 Varick Street
New York, NY 10014-4381

workman.com

WORKMAN is a registered trademark of Workman Publishing Co., Inc.

Printed in the United States of America
First printing October 2012

10 9 8 7 6 5 4 3 2

For Lauren, Hudson, and Salish—
you keep me dancing through life.

contents

introduction

THE INSPIRATION FOR THIS BOOK CAME to me one afternoon as I watched my son, Hudson, playing with his toy bus. I was trying to keep pace with his three-year-old mind as he got deeper and deeper into a fantasy involving nothing more than a yellow plastic box and armless figurines. At least that's what I saw. *He* saw frantic commuters rushing to catch the 77 local bus to Australia. He jumped in place, mouth open and slapping his knees, frantically reacting to a world I couldn't see, but one powerfully present for him.

What happens to this enthusiasm, this ability to be wholly in the moment? Why are these pure experiences so often replaced with cynicism, boredom, and indifference? As I played with my son, I thought about creating photographs that would show the world as if through his eyes. The people in the images would be alive in the everyday.

Shortly after playing "bus," I attended an extraordinary dance performance, and I knew I had found my collaborators. Dancers are storytellers. They're trained to capture passion with their bodies. They often create a fantasy world or offer us a deeper look into familiar settings. They bring to life what we feel but what most of us, lacking their artistry and athleticism, are unable to express physically.

I've created these images for Hudson and his little sister, Salish. My children are everything to me; my dreams for them are enormous. I hope they have long and healthy lives, find loving partners and fulfilling careers, and, if it suits them, experience the joys of parenthood. Most important, I want them to be free from self-consciousness, to discover the deep happiness that comes from a life filled with passion, and to find the serenity necessary to be truly present. These photographs communicate my dreams for them more powerfully than words alone: Relish moments large and small, recognize the beauty around you, and be alive!

Jordan Matter
New York, New York

Hudson and Salish, October 2011

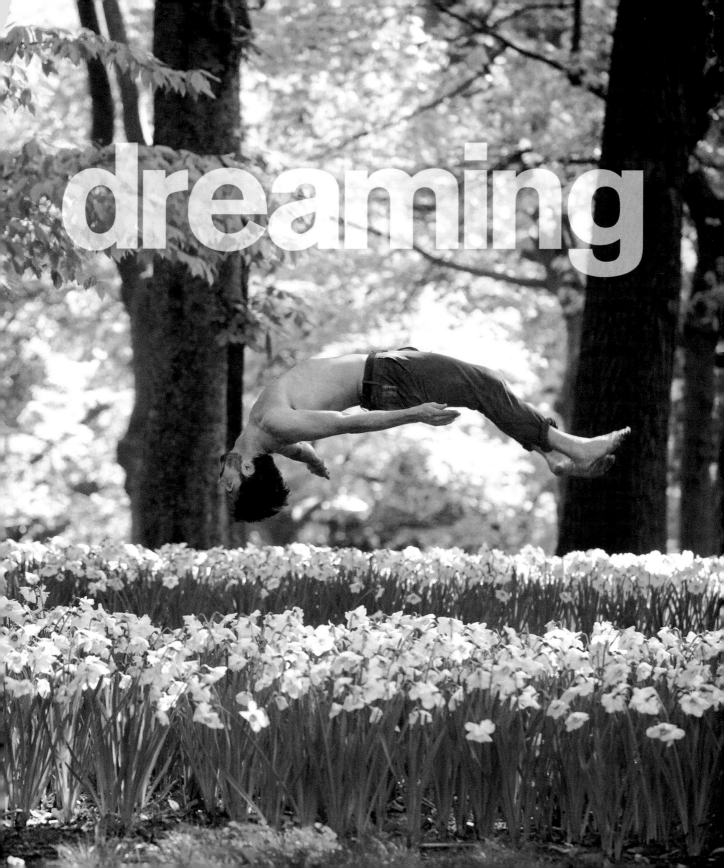

dreaming

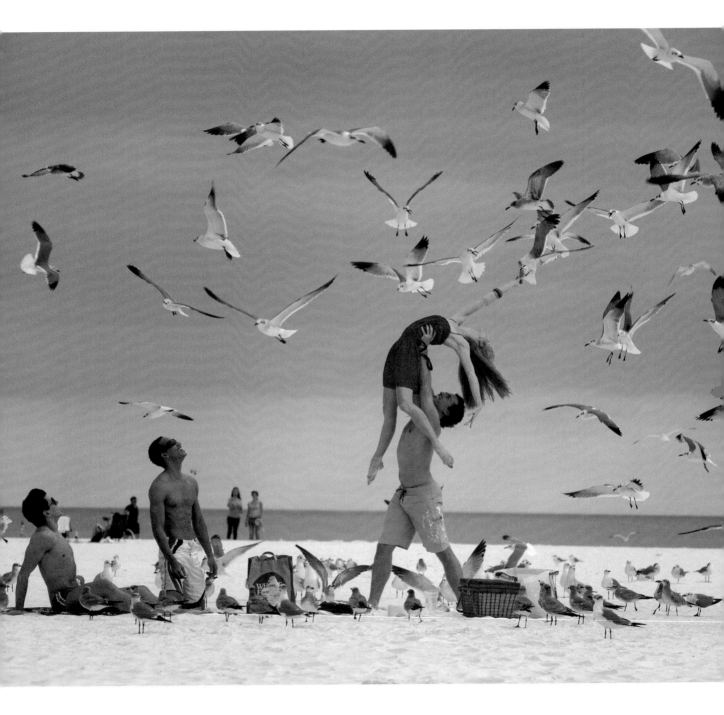

◀Light as a Cloud
Jason Macdonald
New York, New York

Taken
Ricardo Graziano, Ricardo Rhodes,
Danielle Brown, Octavio Martin

Sarasota, Florida

L IKE MILLIONS OF CHILDREN BEFORE ME, I dreamed of playing professional baseball. But I never could have imagined the path I would follow, and where it would lead me.

Some of my earliest memories are of playing baseball with my dad, endlessly hitting, fielding, running. Despite the hours upon hours of practice, I was scrawny and always the last kid chosen. I kept working. By high school I was better but by no means great; my body hadn't filled out. By college, I was good enough to get a partial baseball scholarship but still not good enough to get off the bench. After a year of that, I moved on, this time to Santa Monica College.

When I got there, a late walk-on, the starting lineup

was already established. As the third-string second baseman, I rarely played. I practiced hard, often late into the night. But when I got a chance to be in a game, I froze up. My body was strong, but my mind was weak.

Halfway through the season I didn't have a single hit, and I was universally considered the worst player on the team. My nickname was Blowout, because I played only when the game wasn't close. It was humiliating. I wanted to quit, but I didn't. I put on my uniform each day, and I waited.

If you dream about something long enough, the universe just might conspire to give it to you. Sometimes storybook endings actually happen.

It was the last inning of a tight game. A ball was hit up the middle. Our second baseman dove to catch it and broke his wrist. When our backup second baseman didn't show for practice the next day, the coach was almost as incredulous as I was.

"Well, damn, Jordan, I guess you're starting tomorrow," he said with a laugh.

We were playing the best team in the conference. I was batting last. Our first eight hitters were retired in order. I came up with two outs in the top of the third inning. My teammates tried to muster some enthusiasm.

"Here we go, Blowout. Let's get something started."

"Just take a few pitches. . . . Let him walk you."

I did take a few pitches, and they flew right past me. One ball, two strikes. I stepped out of the batter's box and glanced toward our dugout. Everyone was grabbing his glove, ready to get back on the field. I took a deep breath and stepped up to the plate. The pitcher reared back and delivered a fastball down the middle. I swung hard and watched the ball sail over the left-field fence.

I never sat on the bench again.

If my one teammate hadn't broken his wrist, if my other teammate hadn't missed practice, I would have stayed in the shadows. Serendipity gave me a chance to change my destiny, but it was my underlying devotion to baseball—and all those hours I had spent pursuing my dream—that made it possible for me to take advantage of what luck had tossed my way.

I finished the year leading the team in every offensive category. I was offered a full scholarship to the University of Richmond, where I led the conference in hitting.

I never played professional baseball, but dreaming that I would set me on my life's journey. It was my dream of playing ball that took me to the University of Richmond, where I met my wife, Lauren, and where I majored in theater. It was my dream of becoming an actor that took me to Manhattan, with Lauren, and eventually our children, by my side. And it was my dream of embracing all that life can offer, onstage and off, that made it possible for one Henri Cartier-Bresson exhibit to change my life entirely. Seeing his remarkable photographs sparked an even deeper passion, this time for photography. And so I learned another lesson: It's never too late to dream. ❖

The Thinker
Michael Trusnovec
New York, New York

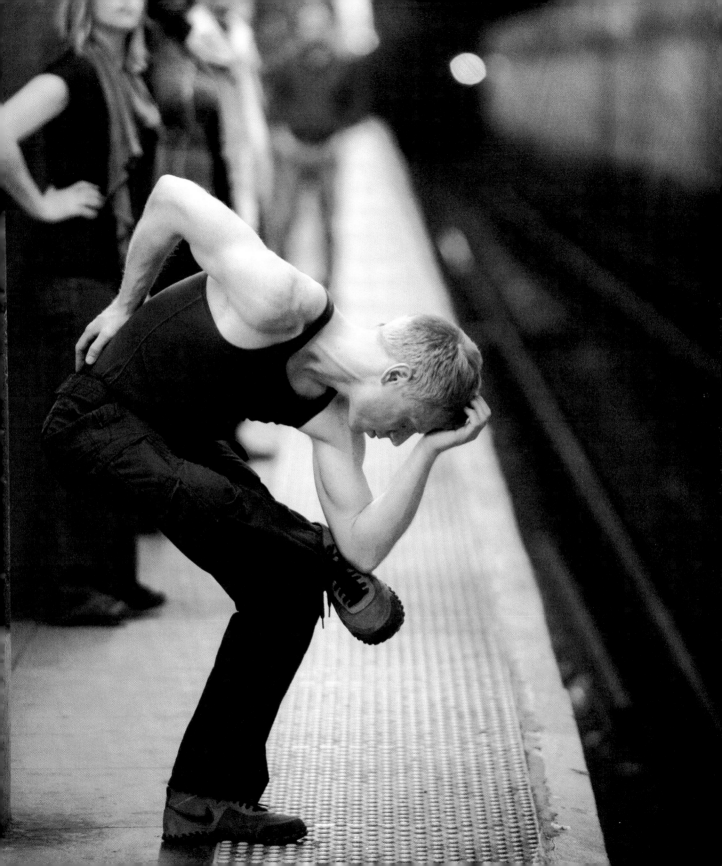

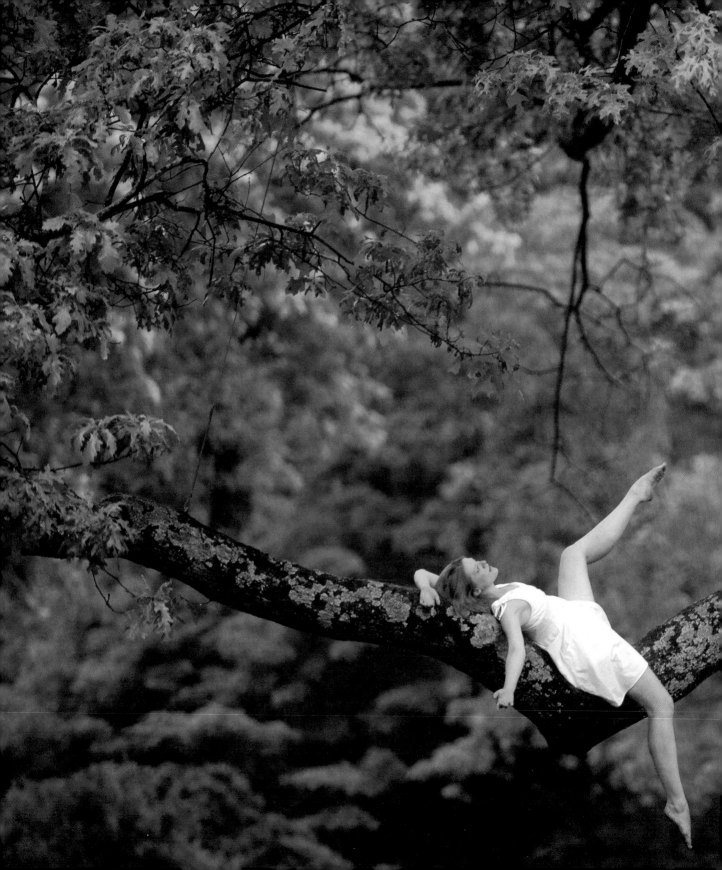

Out on a Limb
K. Louise Layman
Wellesley, Massachusetts

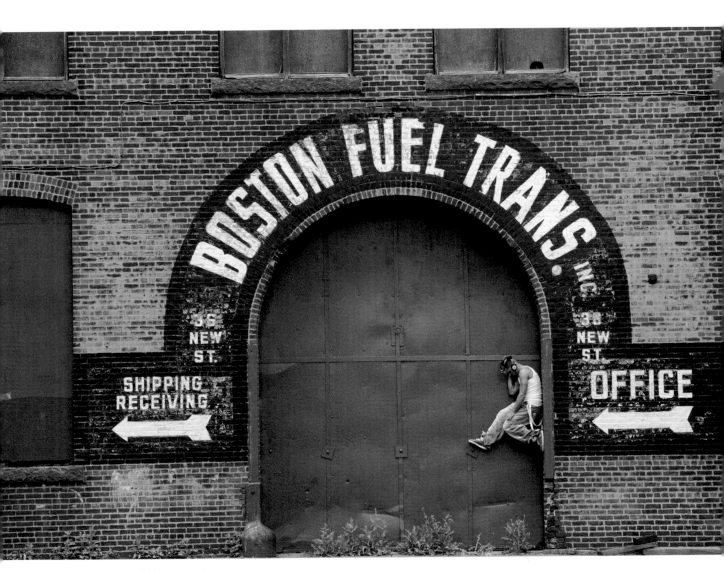

The Beat of a Different Drummer

Shawn Krayenborg

East Boston, Massachusetts

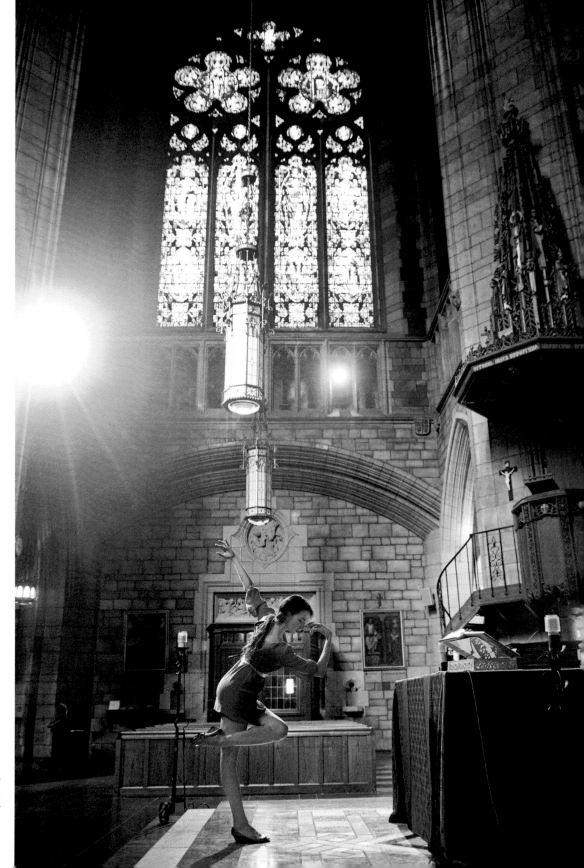

Prayer
Casia Vengoechea
New York, New York

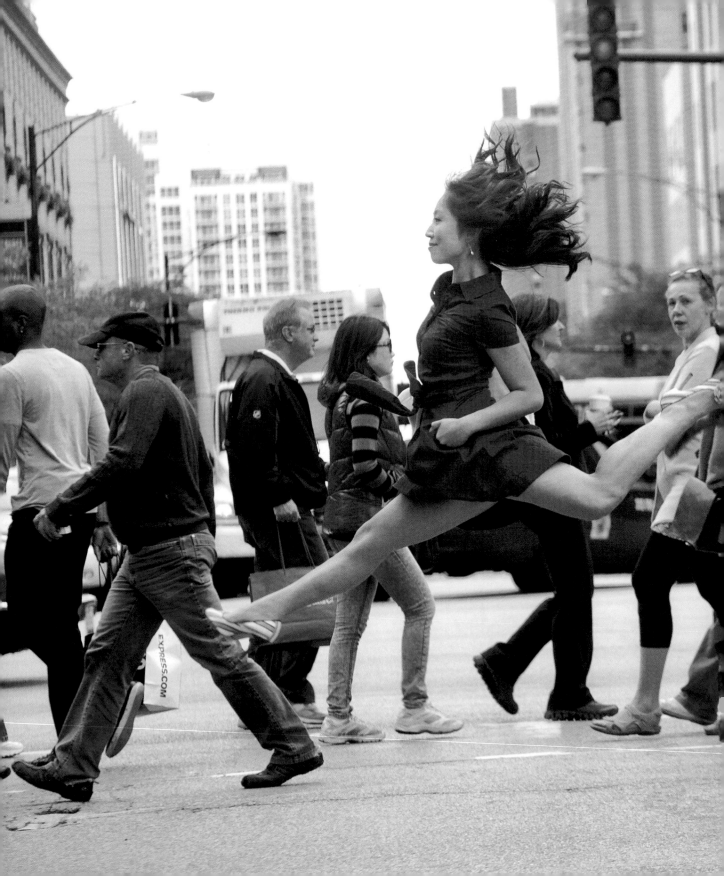

Double Take
Angela Dice, Demetrius McClendon
Chicago, Illinois

"I dwell in possibility."

EMILY DICKINSON

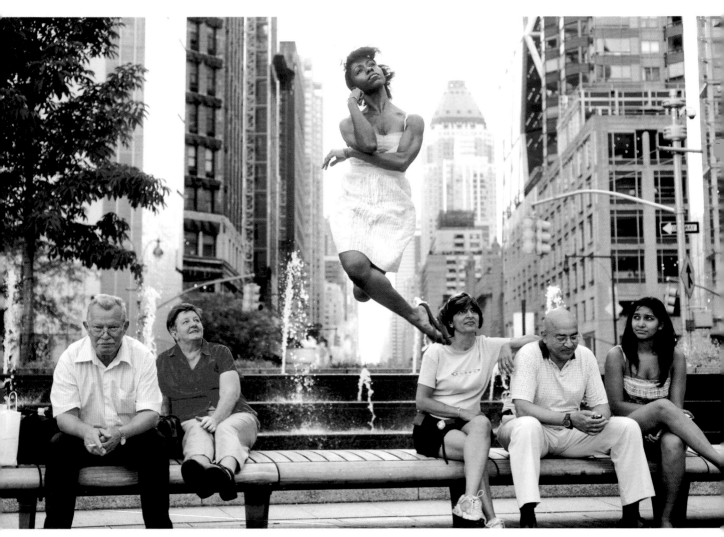

Rise Above It All
Michelle Fleet
New York, New York

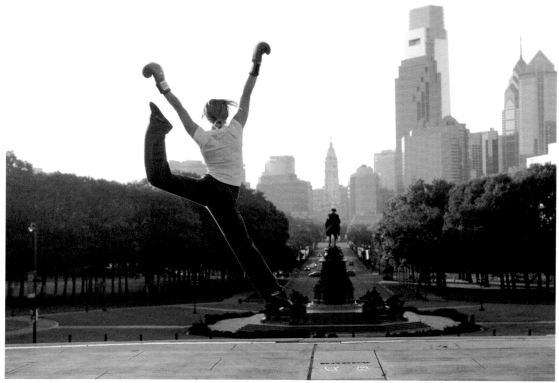

Gonna Fly Now
Evgeniya Chernukhina

Philadelphia, Pennsylvania

Getting Inspired
Kevin Williamson

Hollywood, California

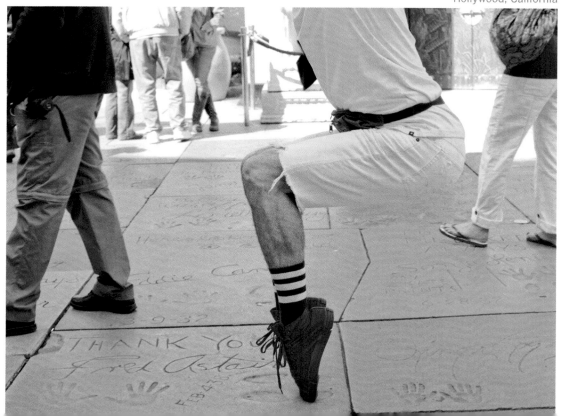

"If thou follow thy star, thou canst not fail of a glorious heaven."

DANTE

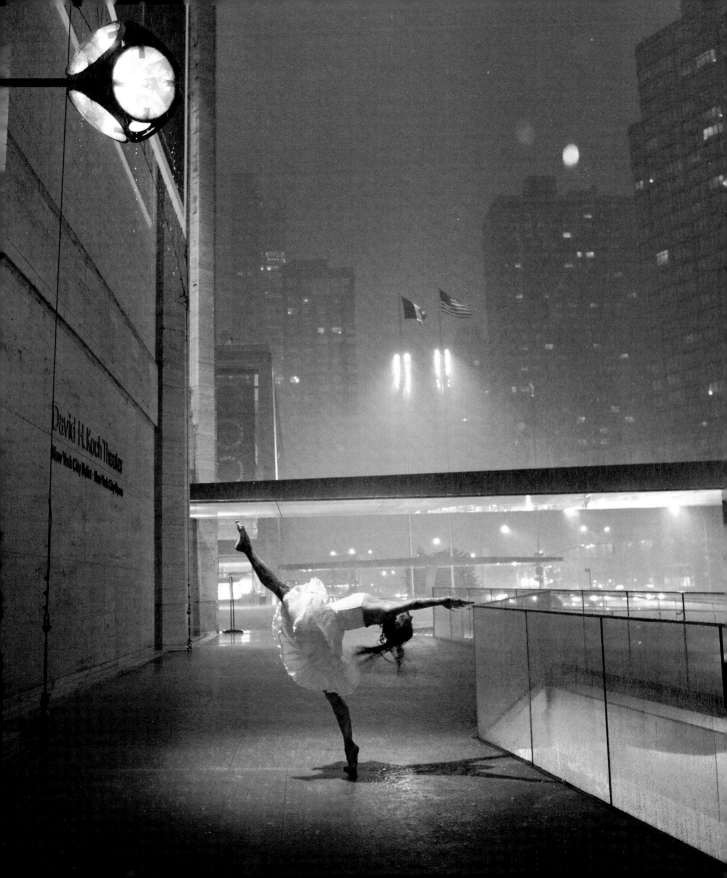

Broadway Bound
Michael Cusumano
New York, New York

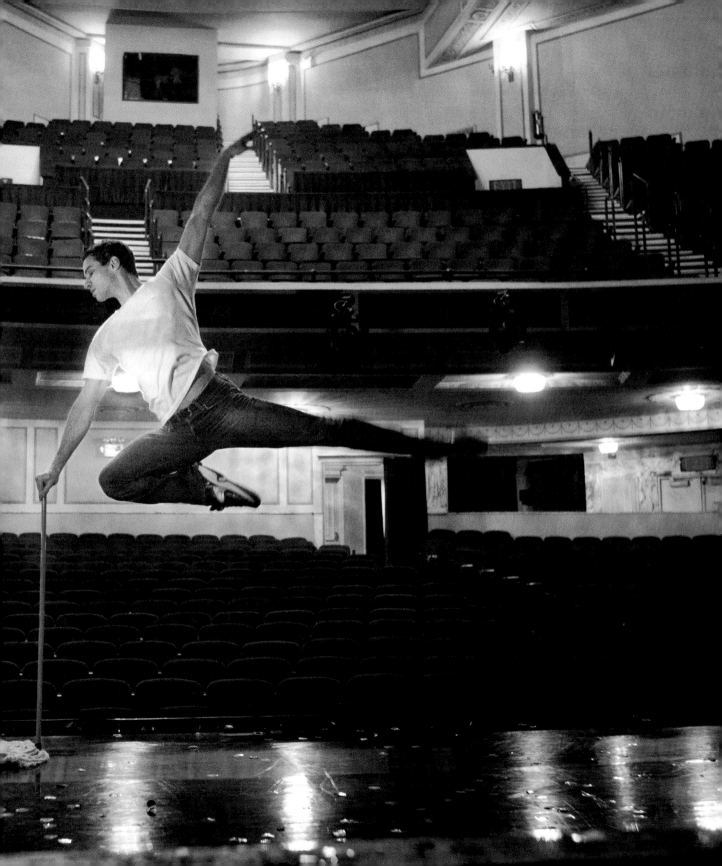

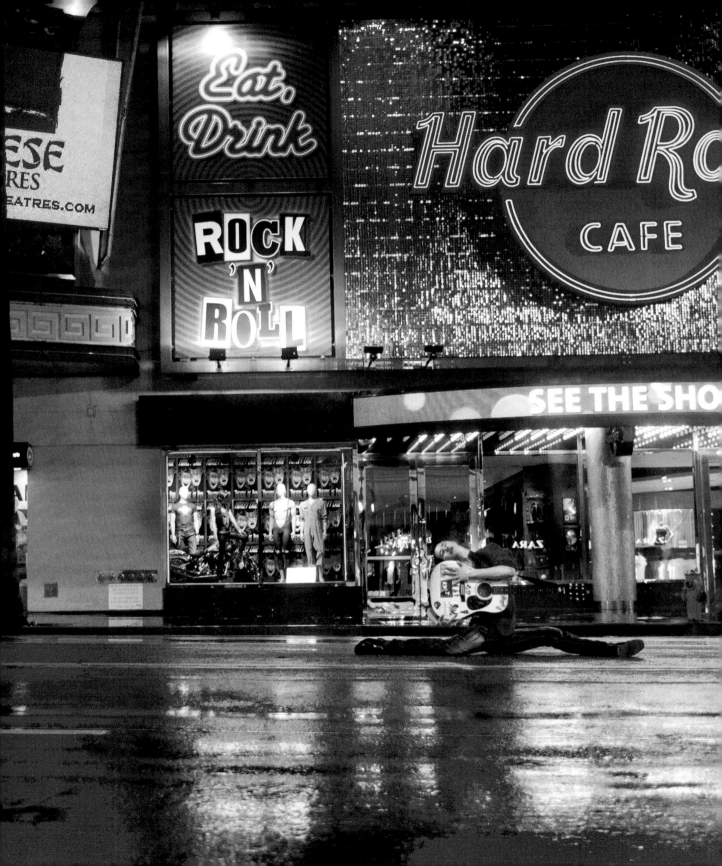

"Who shall command the skylark not to sing?"

KAHLIL GIBRAN

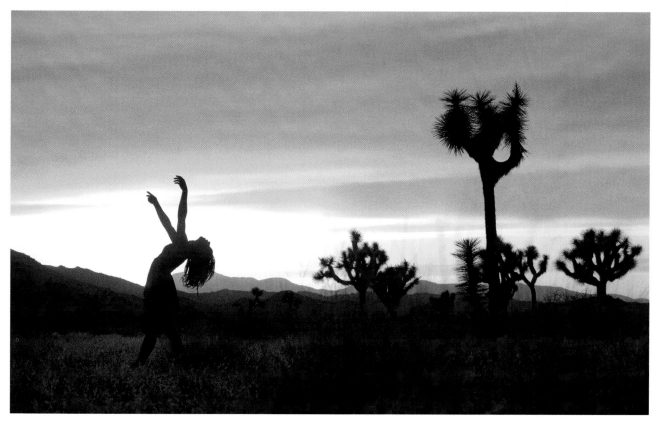

Sunset Salutation
Jamila Glass
Joshua Tree, California

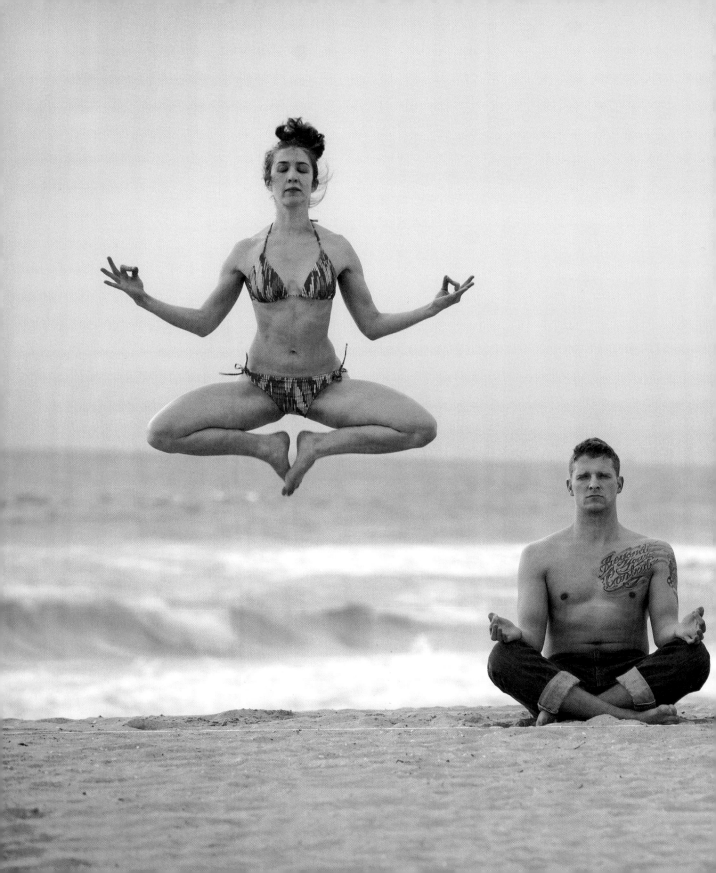

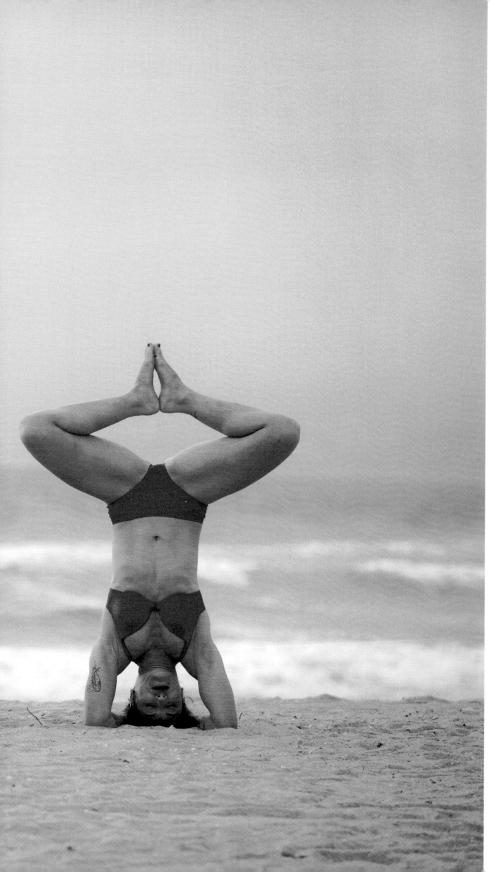

Om

Sofia Klass,
Gilyon Wiley Brace-Wessel,
Amy "Catfox" Campion

Los Angeles, California

Surrender
Rachel Bell
Baltimore, Maryland

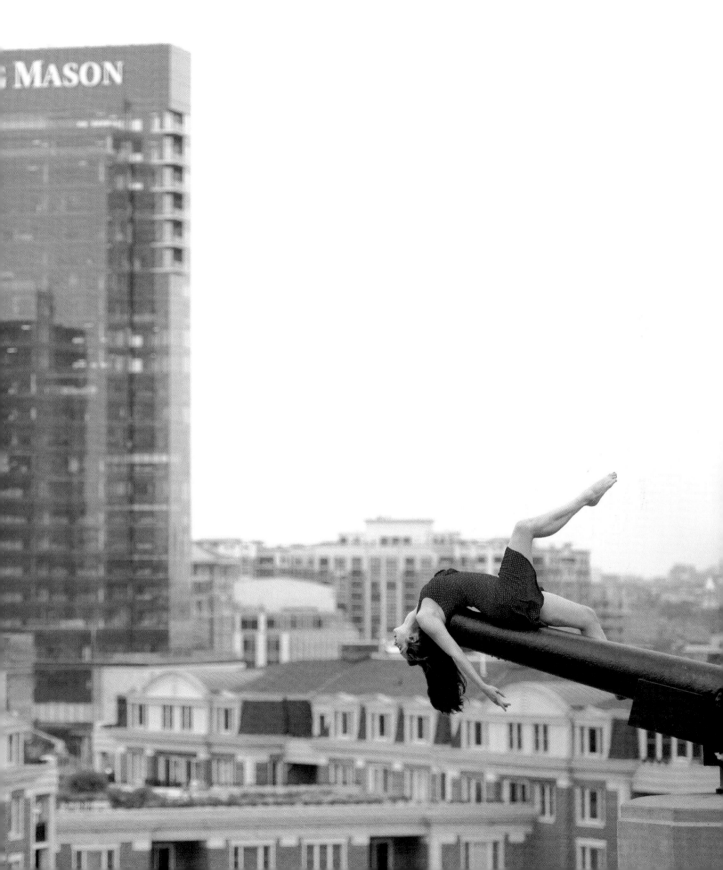

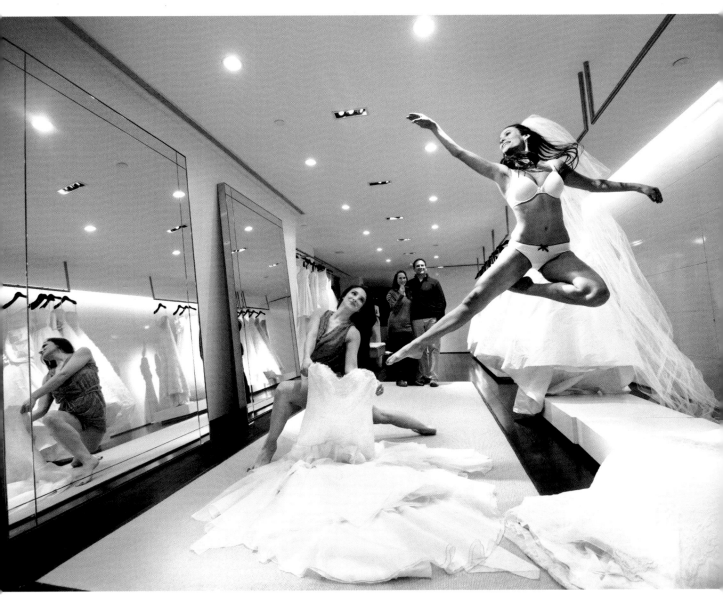

Big Day
Kristin DeCesare, Jessica Press
New York, New York

"Hope sleeps in our bones like a bear . . . "

MARGE PIERCY

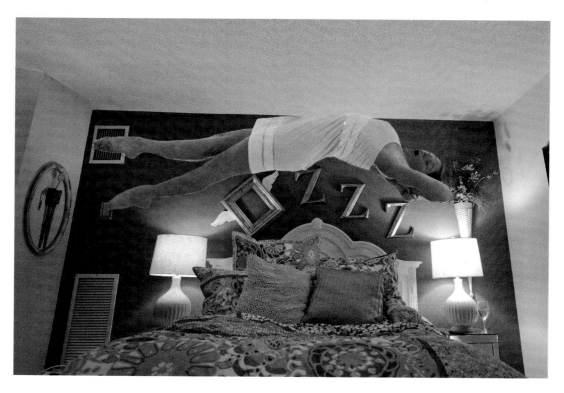

Wildest Dream
Kara Lozanovski
Chicago, Illinois

"Nothing happens unless first a dream."

CARL SANDBURG

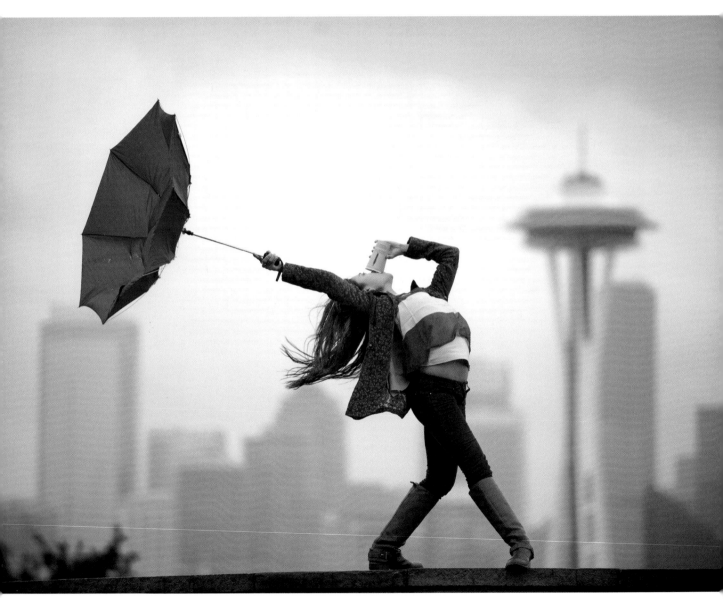

Only in Seattle
Angelica Generosa
Seattle, Washington

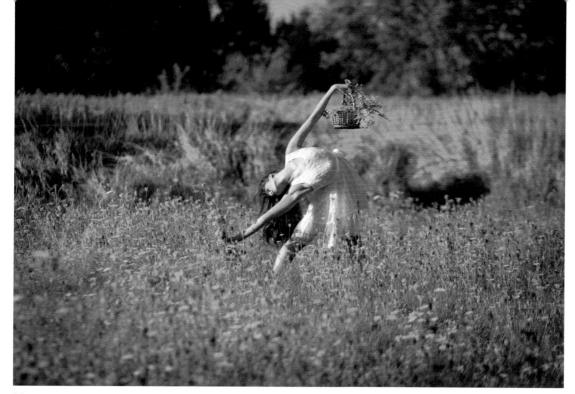

Meadowlark
Katherine Scarnechia
Long Grove, Illinois

My Time of Day
Betsy Ceva
Nyack, New York

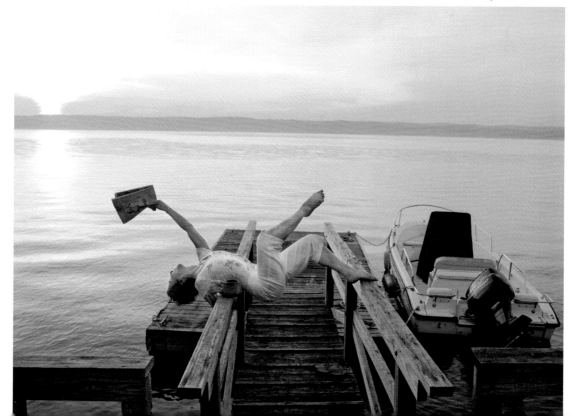

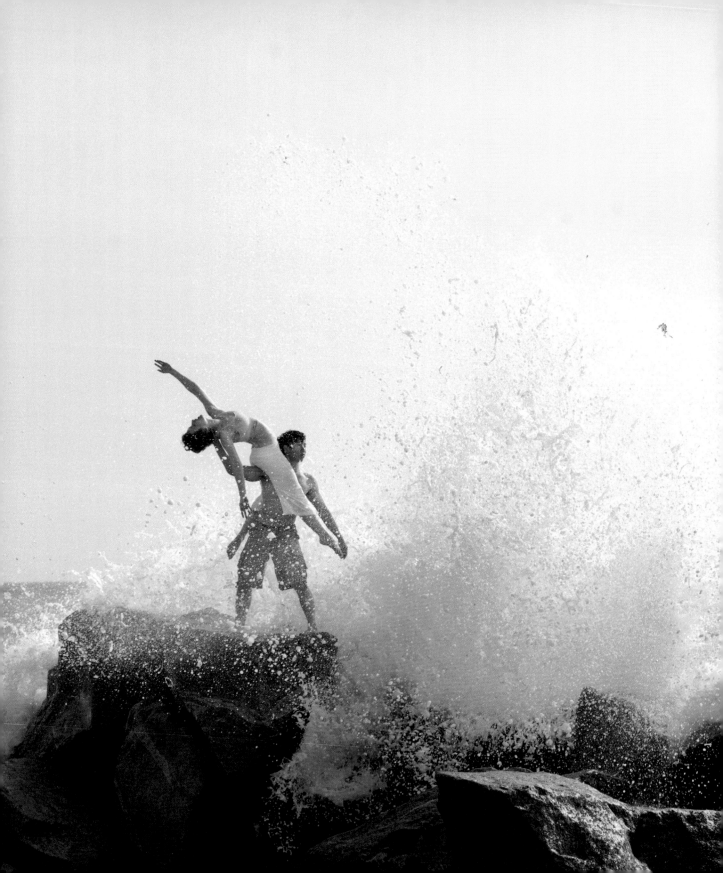

"Too much of a good thing can be wonderful."

MAE WEST

The Break

Mary Tarpley, Thomas Vu
Los Angeles, California

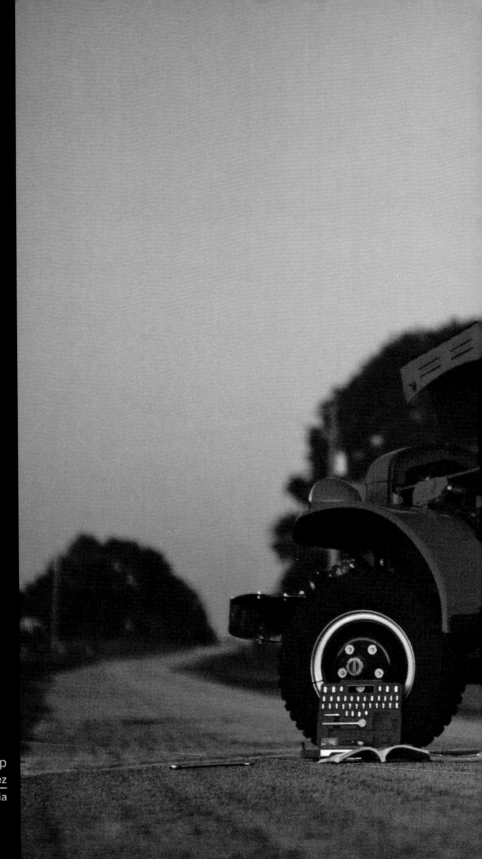

The Pickup
Pablo Sanchez
Madison, Georgia

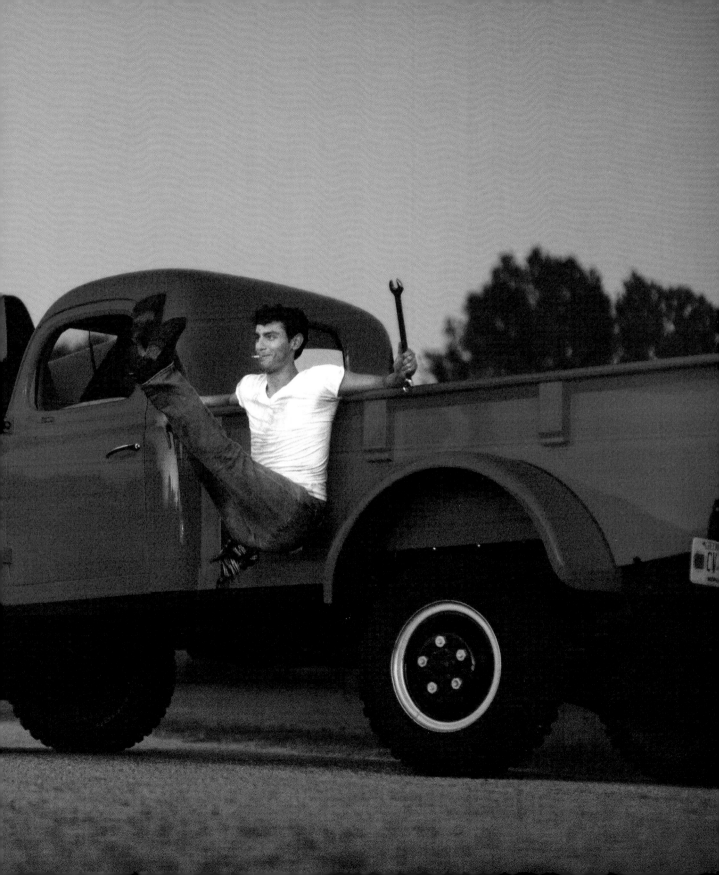

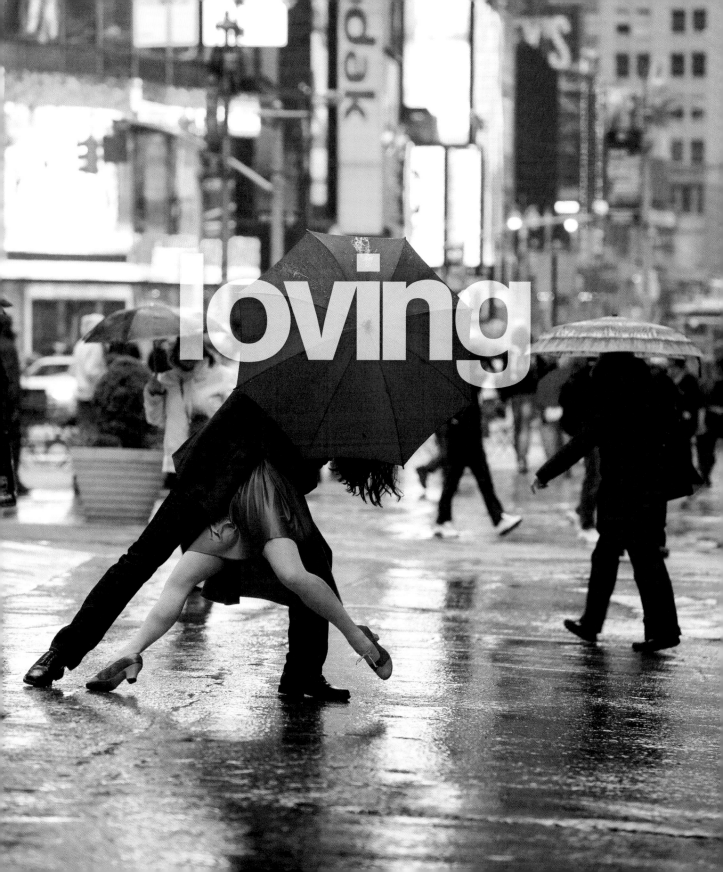

◀Wet Kiss

Michael Jagger, Evita Arce
New York, New York

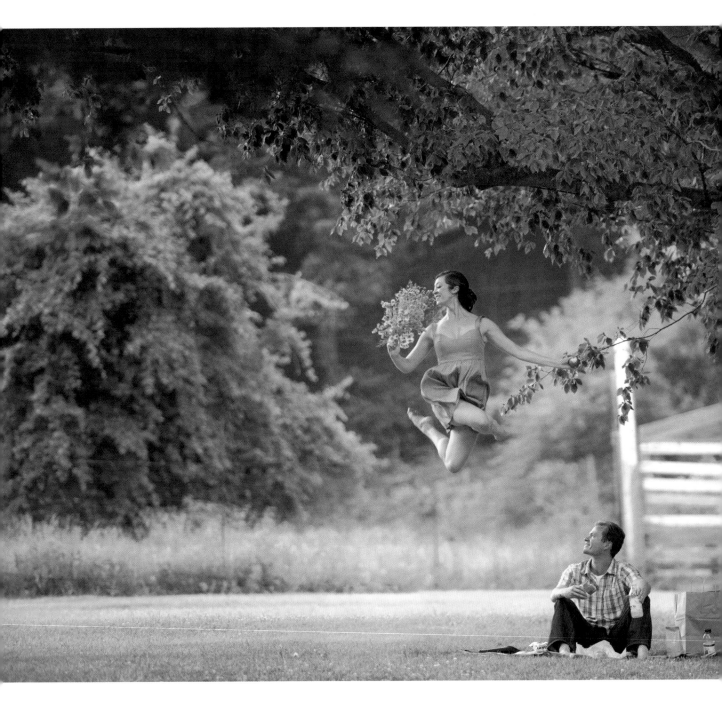

Adam and Eve
Rachel Bell, Mitch Winans
Towson, Maryland

I REMEMBER THE MOMENT I FELL IN LOVE WITH Lauren. We were in college, fresh off our first date. She coaxed me outside for a walk in the snow. The winter storm excited her, and her uninhibited joy amazed me. I watched her skip through the freshly fallen powder, and I fell in love. It just took me a year to realize it.

I remember the moment that I couldn't live without her. We had been together for three years. She was living in Baltimore, and I was in New York. We hadn't seen each other in weeks, so I decided to surprise her. She was sleeping when I arrived, curled up with my T-shirt in her hands, and the phone next to her ear. Her innocence and beauty illuminated the dark room.

My need for her felt desperate, and it scared me.

I remember the moment I wanted to spend my life with her. We had been together for seven years, but I wasn't sure. We had gotten engaged, but I wasn't sure. We had even set a wedding date, but I wasn't sure. Then, when I stood at the altar and saw her—at the end of a long path, my beautiful bride walking toward me, an angel in white surrounded by family and friends, unselfishly sharing her spotlight, with a smile radiating for miles—I was sure.

I remember the moment I discovered new life with her. Hudson had been born the day before. It was late morning and snow was falling; everything had come full circle. Lauren was sitting in bed, propped up by a pillow, nursing our child. She had a look of serenity on her face; she was complete. I had never been happier.

Love is a series of memories. Today's passion is tomorrow's nostalgia. One moment you're kissing under a boardwalk, and the next moment you're playing with your kids in a park. The glue that binds these events together is an amalgam of the memories you've forged along the way. ❖

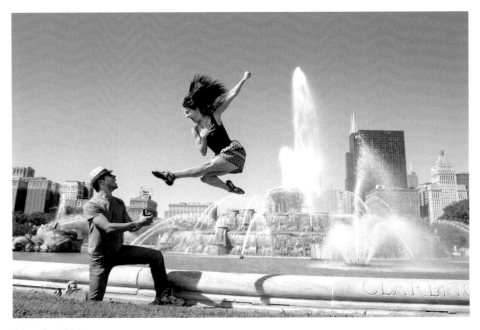

She Said Yes
Ricky Ruiz, Carrie Nicastro
Chicago, Illinois

Quality Time
Jorge Torres, Chino Hara, with their children
New York, New York

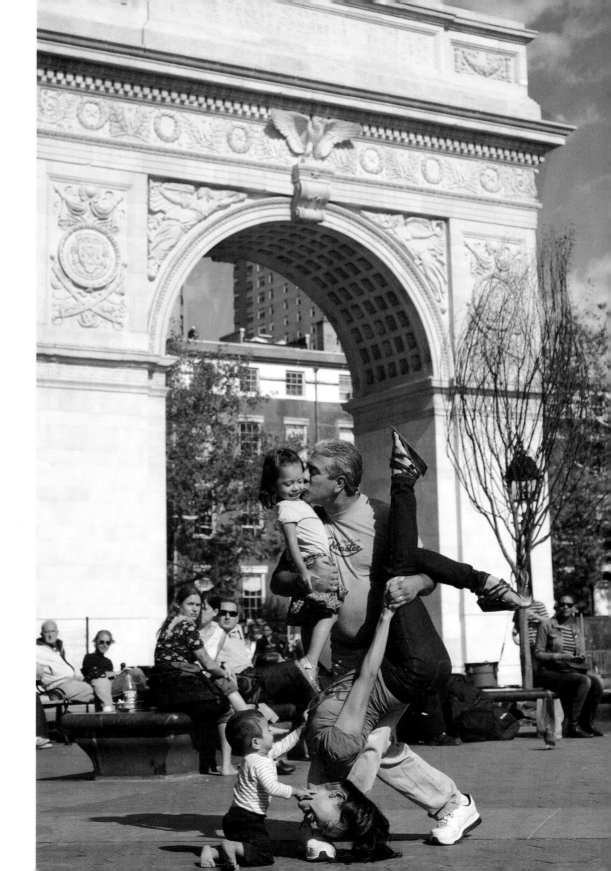

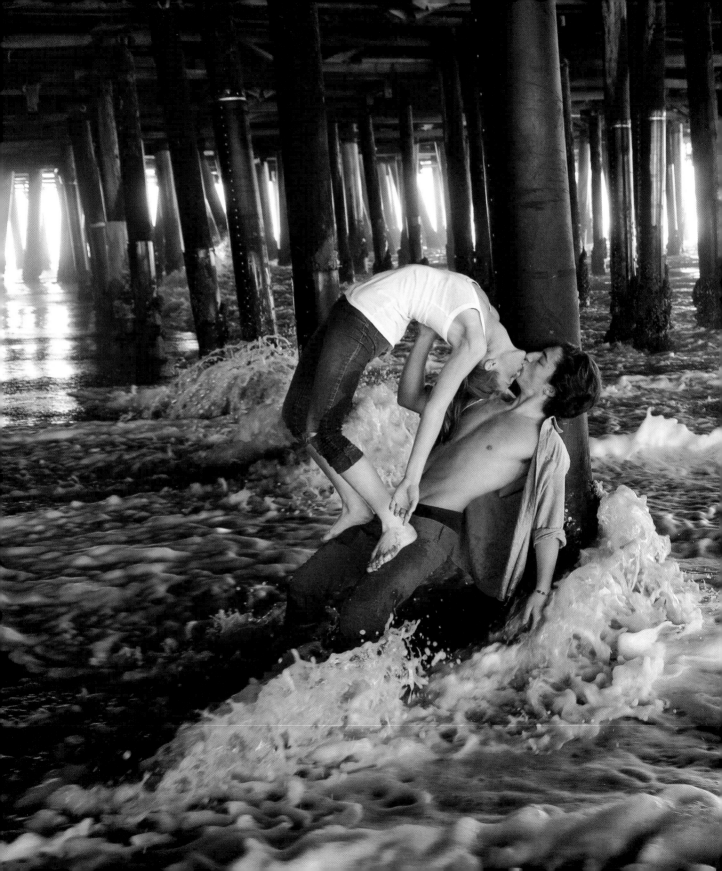

Under the Boardwalk

Jill Wilson, Jacob Jonas

Santa Monica, California

I Left My Heart in San Francisco
Jamielyn Duggan, Oliver Freeston
San Francisco, California

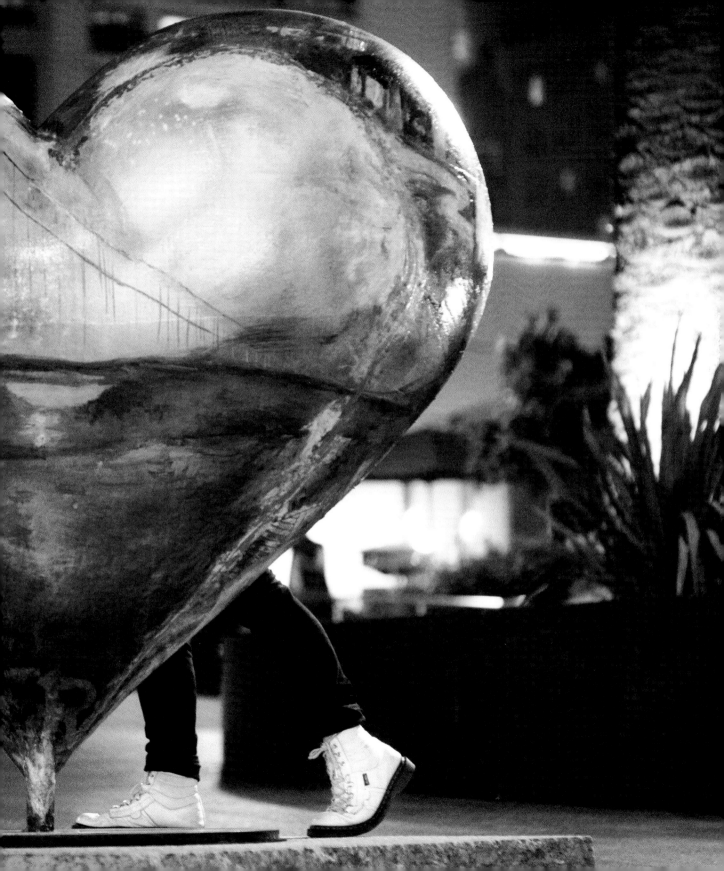

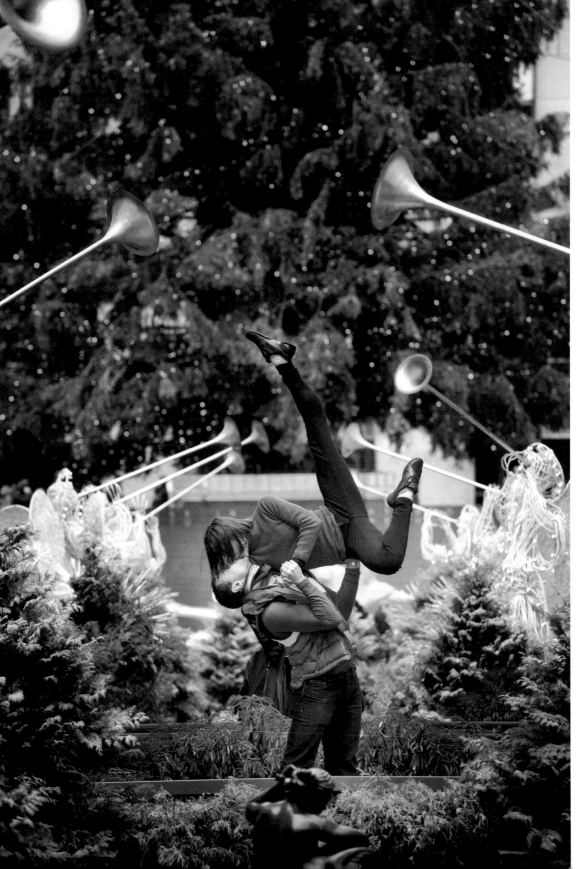

My True Love
Gave to Me

Nicholas Villeneuve,
Vanessa Valecillos

New York, New York

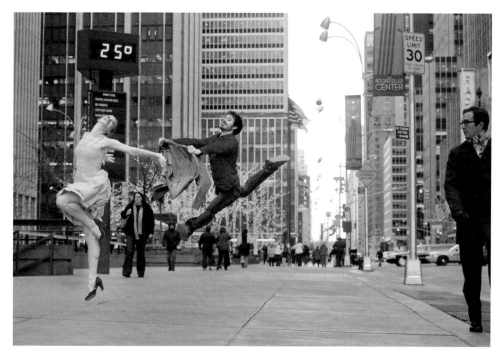

Chivalry Lives
Leah O'Donnell, Dario Vaccaro
New York, New York

Keep Me Warm
Ellenore Scott, Michael McBride
New York, New York

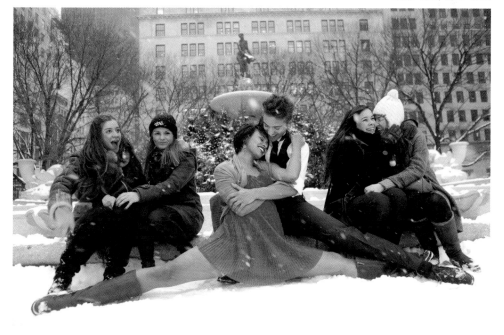

"I am a verb."

ULYSSES S. GRANT

Getaway
Michael McBride, Ellenore Scott
New York, New York

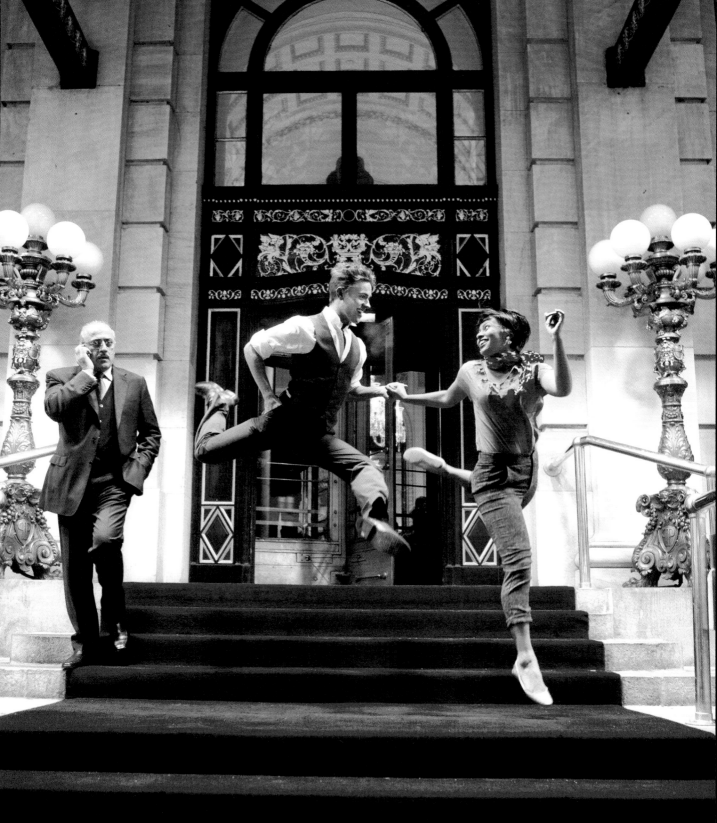

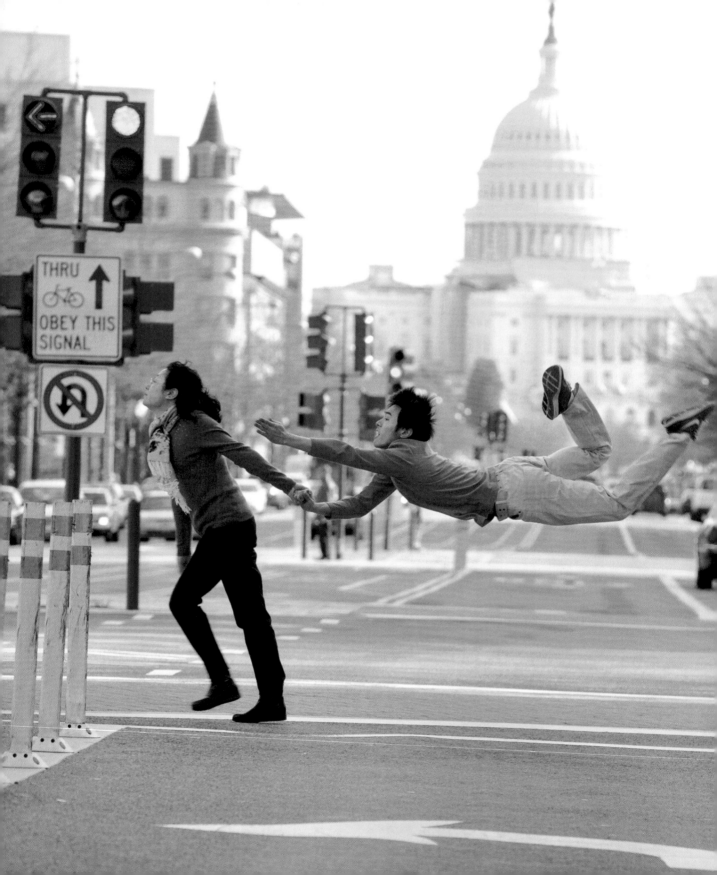

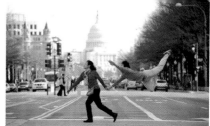

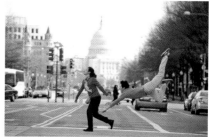

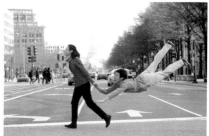

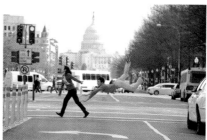

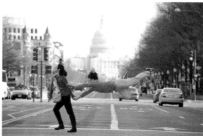

Mama's Boy
Sun Chong, with his mother
Washington, DC

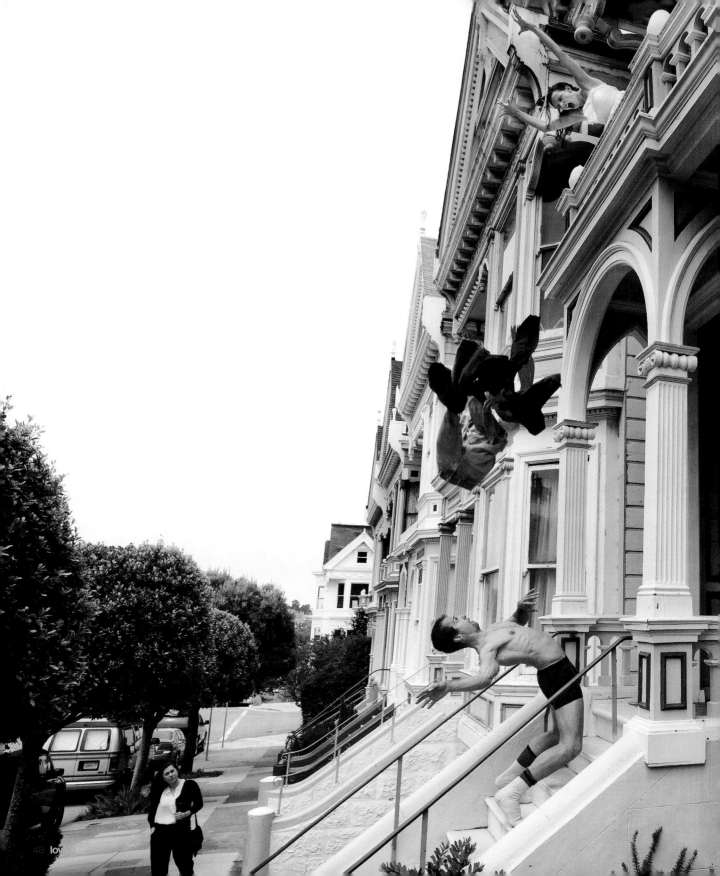

And Don't Come Back!
Brendan Barthel, Kaitlin Ebert
San Francisco, California

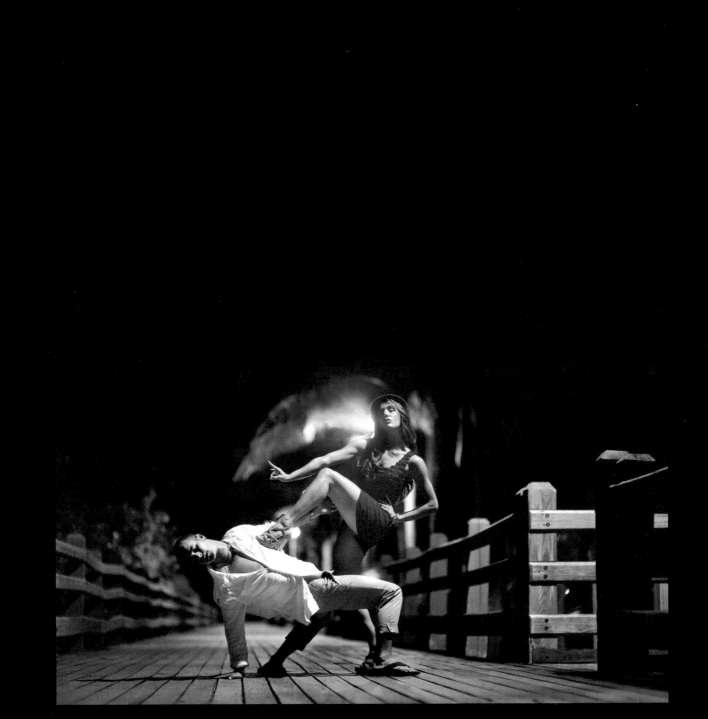

Uh-uh
Steven Vaughn, Maria Elena D'Amario
Miami, Florida

The Last Straw
Annmaria Mazzini, Robert Kleinendorst
New York, New York

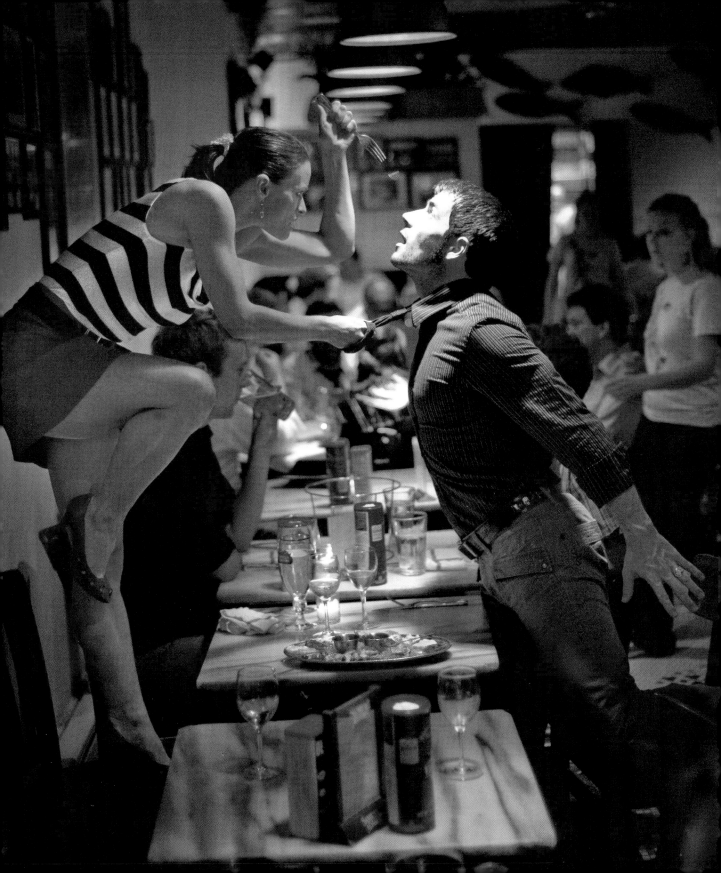

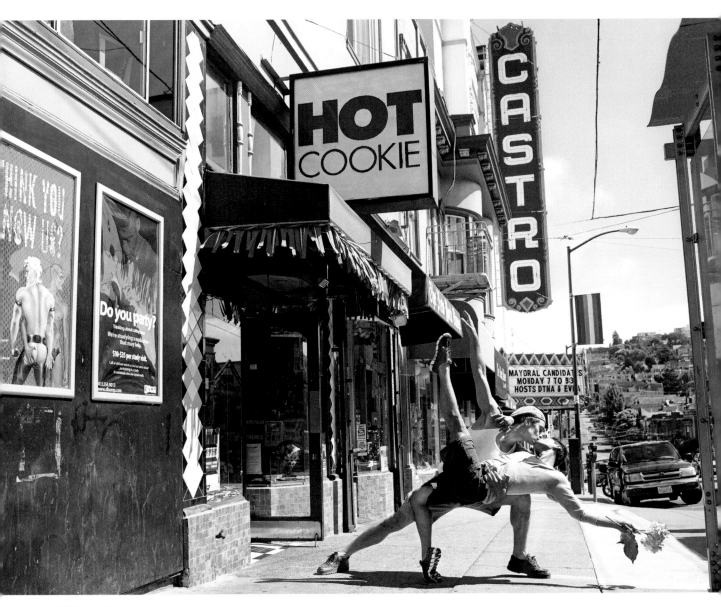

Off Your Feet

Brendan Barthel, Victor Talledos

San Francisco, California

"Dancing is a perpendicular expression of a horizontal desire."

GEORGE BERNARD SHAW

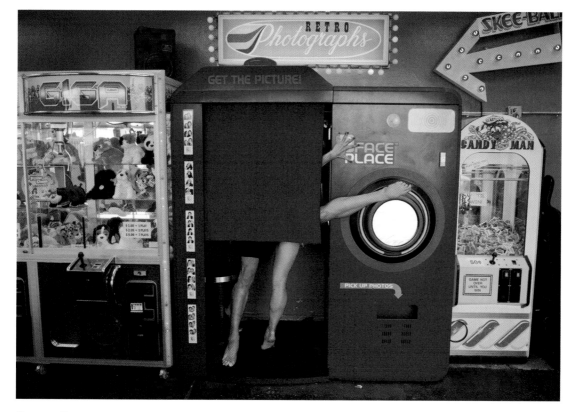

Freeze Frame
Eric Bourne, Dayla Perkins
Rye, New York

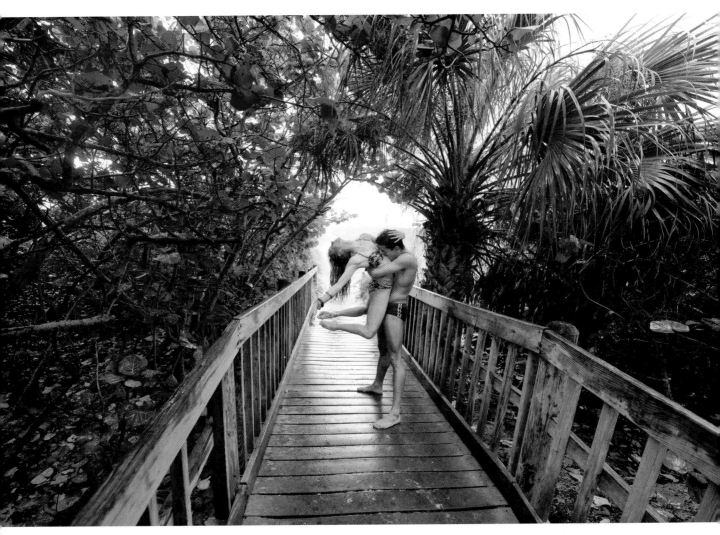

Summer Loving
Danielle Brown, Ricardo Graziano
Sarasota, Florida

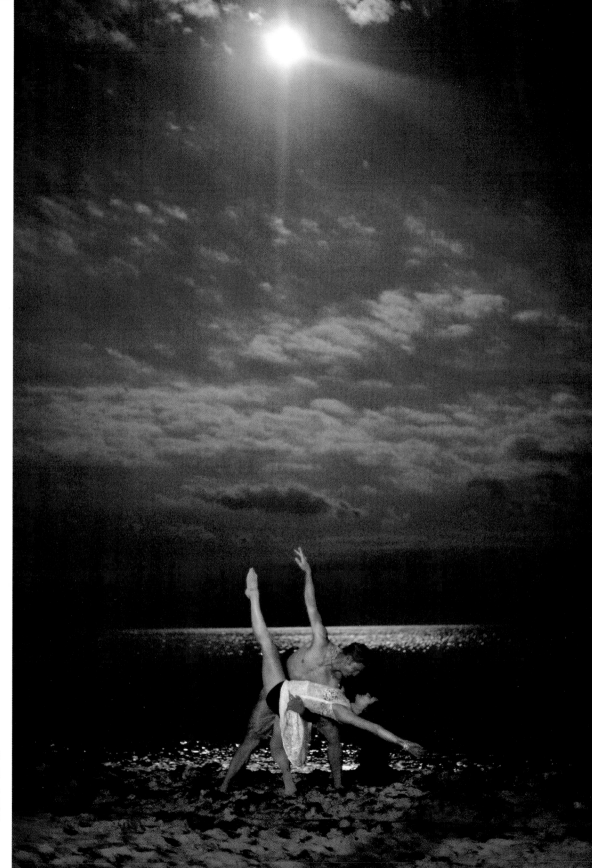

Moonlight
Sonata
Eric Bourne,
Christina Ilisije
Miami, Florida

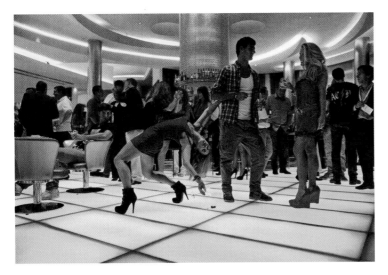

Cutting In
Sarah Braverman
Miami, Florida

3 a.m. in Vegas
Joseph Rivera, Sheila Burford
Las Vegas, Nevada

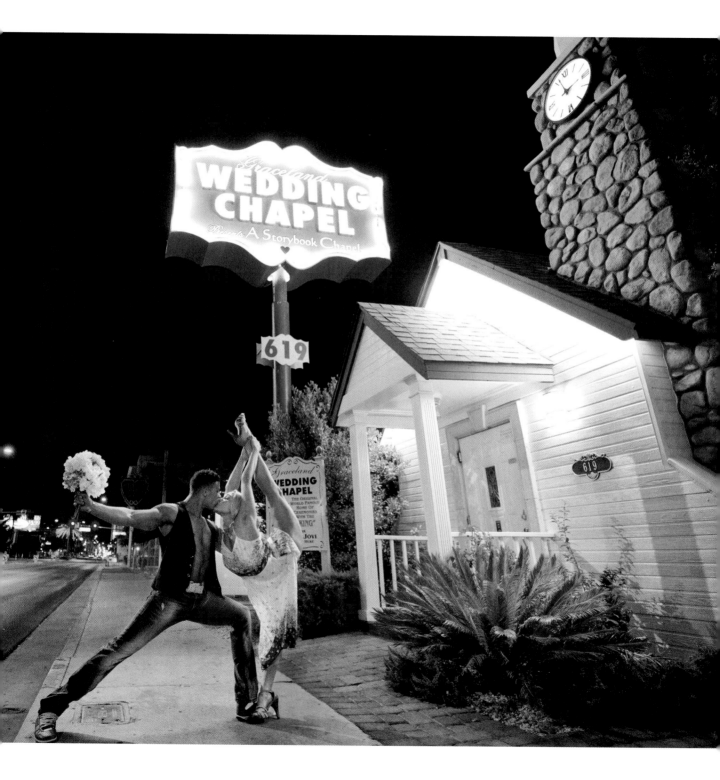

> *"Imagination is more important than knowledge."*
>
> ALBERT EINSTEIN

Sexting
Jesus Hernandez, Carlos Salazar
New York, New York

Hello, Sailor
Eran Bugge
New York, New York

Stepping Out with My Baby
Gus Solomons jr, Carmen de Lavallade
New York, New York

S.W.A.K.
Rhiona O'Loughlin
Steamboat Springs, Colorado

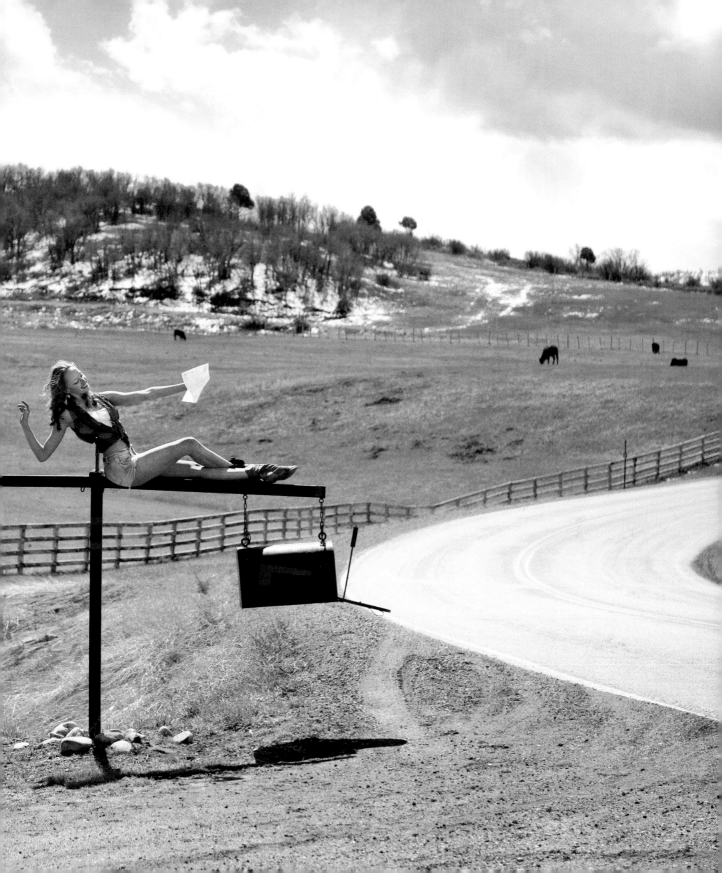

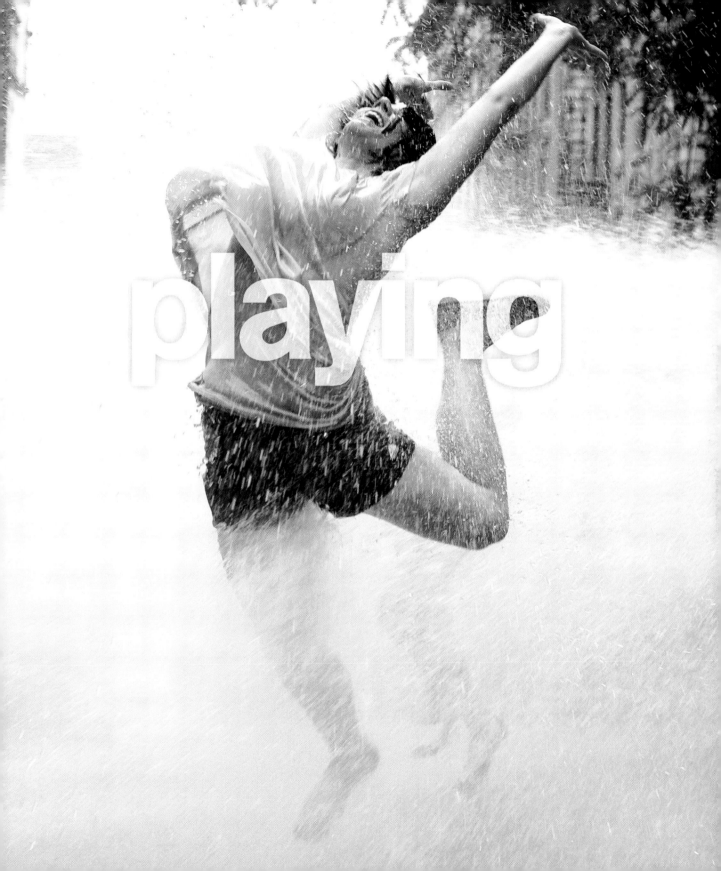

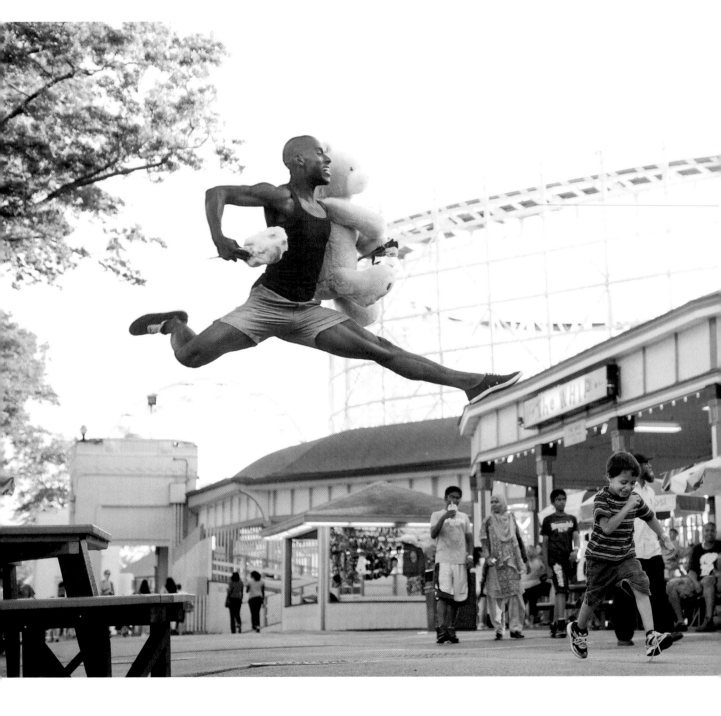

Fair Play
Lloyd Knight
Rye, New York

"WHERE IS HUDSON PERFORMING TONIGHT? I've been telling all my friends that they just have to see him."

We were on an Alaskan cruise, and Hudson was quickly becoming famous among the ship's 1,400 passengers. He was three years old and had been obsessed with playing guitar for more than a year. It came to him naturally. He didn't know chords, but he had an innate and effortless sense of rhythm.

He carried his acoustic guitar with him everywhere. In the rare moments that he didn't have it, he played a stick, a straw, a water bottle, my arm, or anything else remotely straight enough to strum.

On the first night of the cruise, Hudson wanted to

see live music. Naturally, he brought his guitar. He stood as close as possible to the band, clearly intoxicated. I had alerted them to his presence, and after one song he was invited on stage by the singer. She later confessed that she was looking to score some quick cute points and then dispatch him back to Mommy and Daddy after one brief song.

Hudson had never played in front of more than a few people, and the place was packed. His apprehension lasted for about a minute, and then he let loose. He performed three long sets, and the crowd went nuts. Word spread. For the rest of the cruise, he had a gig every night and was treated as a celebrity all day. Lauren and I were thrilled. Hudson was exhausted.

When we returned home, we enrolled him in guitar lessons. It seemed like the obvious next step. He loved playing the guitar as a toy, but he didn't know how to use it as an instrument. It was time for him to discover his full potential.

After the first lesson, Hudson put away his guitar. He has rarely picked it up since. We had imposed adult sensibilities on a child's imagination. The magic was lost. It was no longer innocent play; it was work. What we value as adults—applause, adulation, talent, knowledge—was irrelevant to him. He just wanted to get lost in a fantasy and play. ❖

"Every child is an artist.
The problem is how to remain
an artist once he grows up."

PABLO PICASSO

Slam Dunk
FaTye Francis
New York, New York

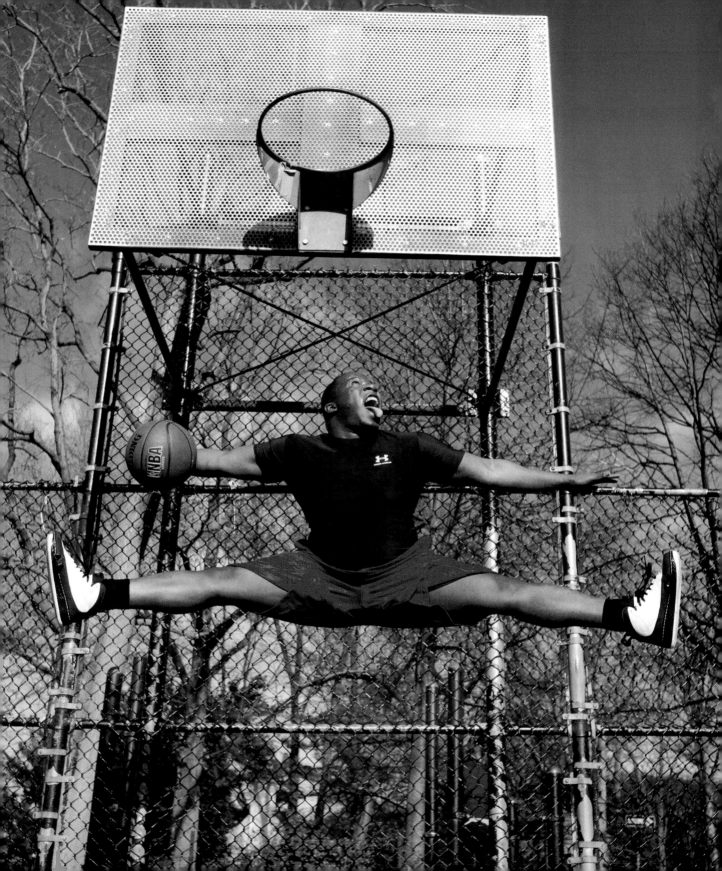

"Time is but the stream I go a-fishing in."

HENRY DAVID
THOREAU

The Big One
Alexei Geronimo
Towson, Maryland

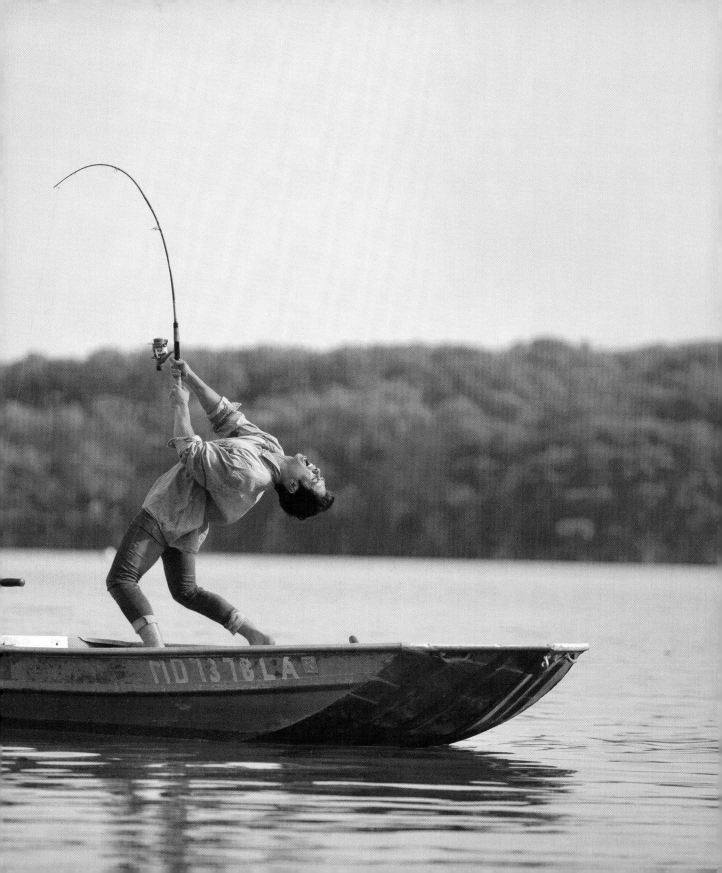

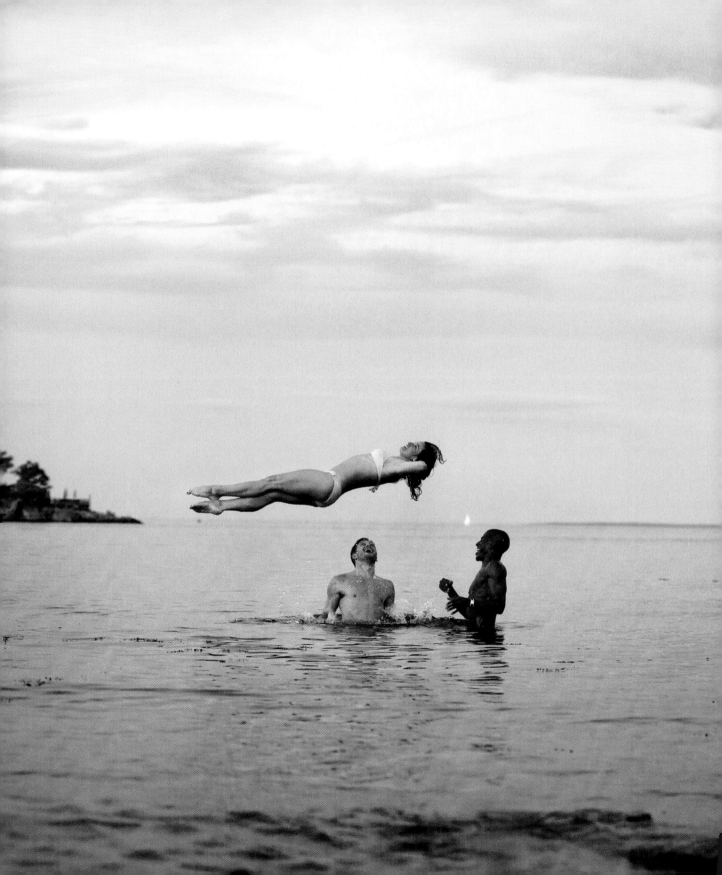

A Good Catch

Dayla Perkins, Eric
Bourne, Lloyd Knight

New Rochelle, New York

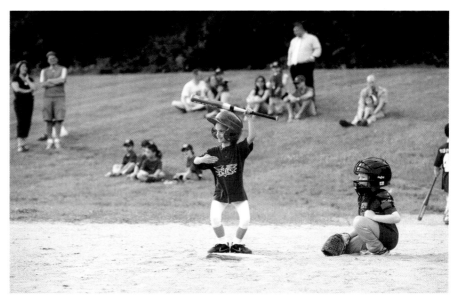

Swing for the Fences

Lucia Maria Golemis

Tappan, New York

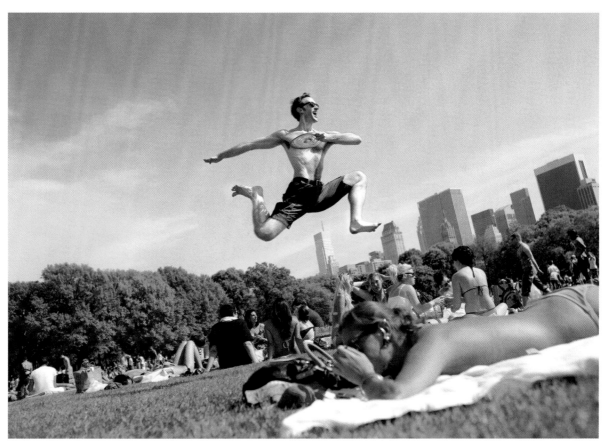

Flying High

John Heginbotham

New York, New York

Fetching
Jessica Deahr
Chicago, Illinois

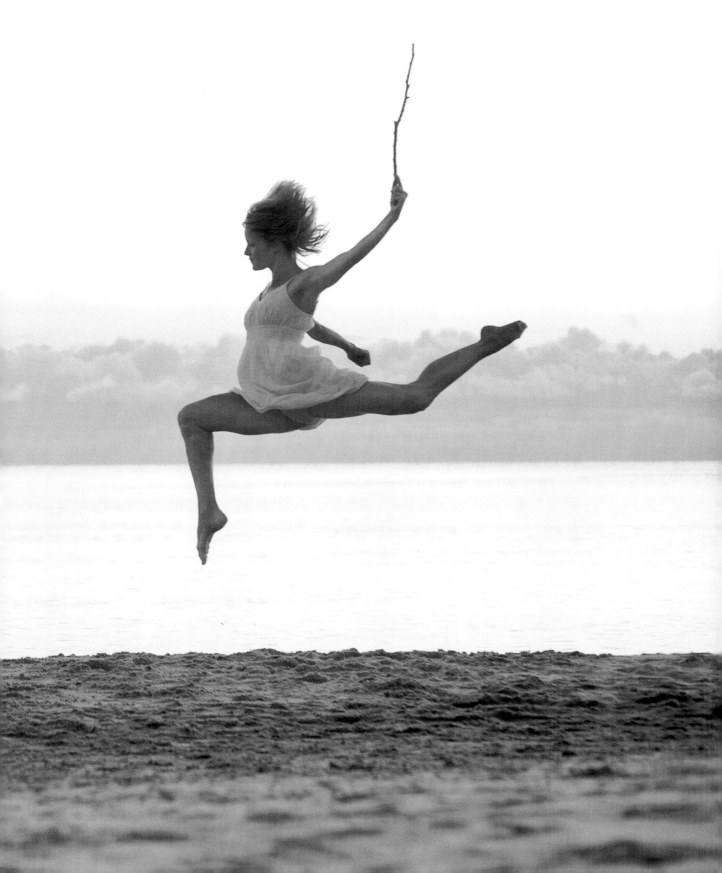

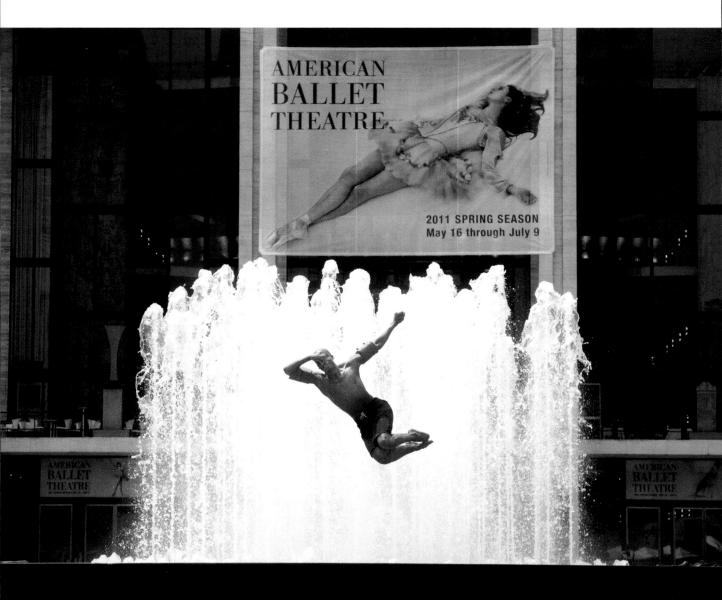

Making a Splash

Jermaine Terry

New York, New York

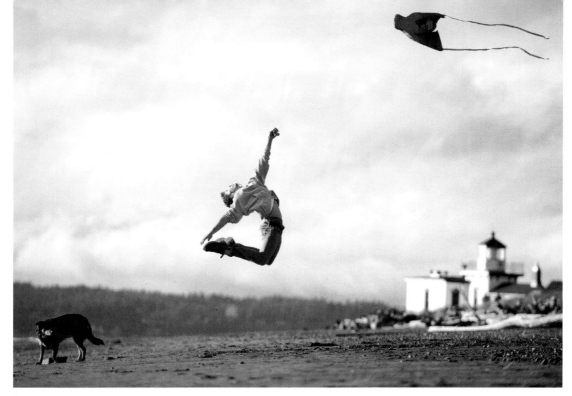

Blowing in the Wind
Sean Rollofson
Seattle, Washington

The Corner Pocket
Samantha Campanile
Aspen, Colorado

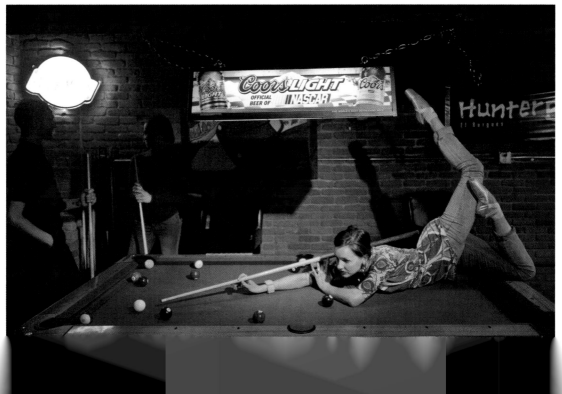

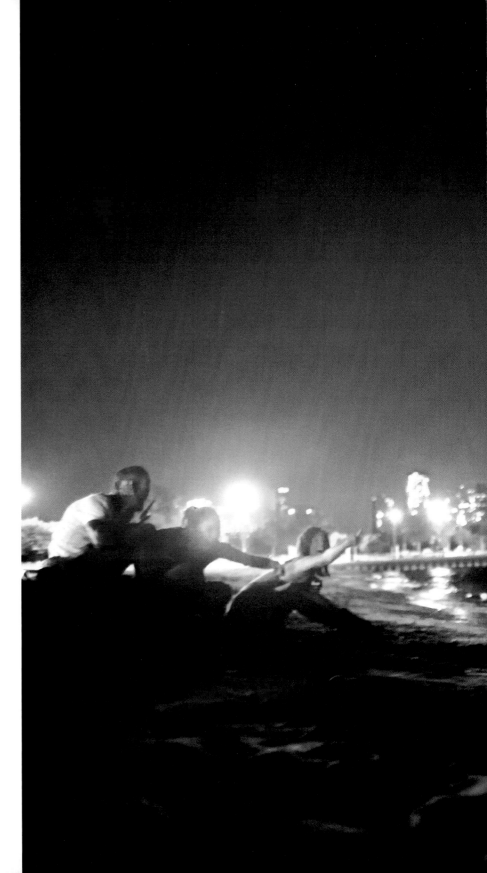

"Leap and the net will appear."

ZEN SAYING

Skinny Dip
Marissa Horton
Chicago, Illinois

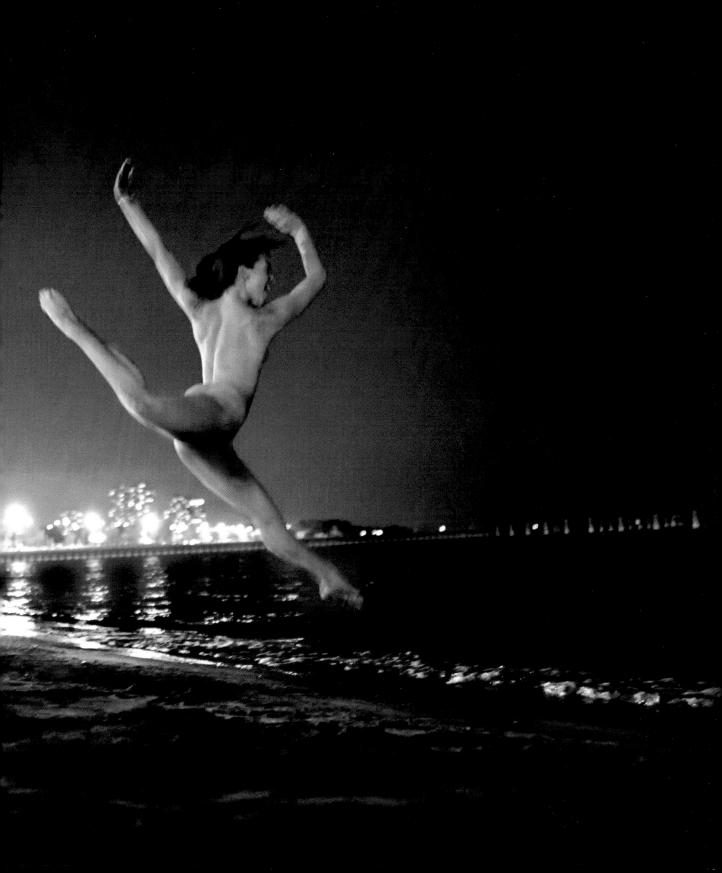

"If music be the food of love, play on;

Give me excess of it . . . "

WILLIAM SHAKESPEARE

Les Bons Temps
Rebecca Wilfer
New Orleans, Louisiana

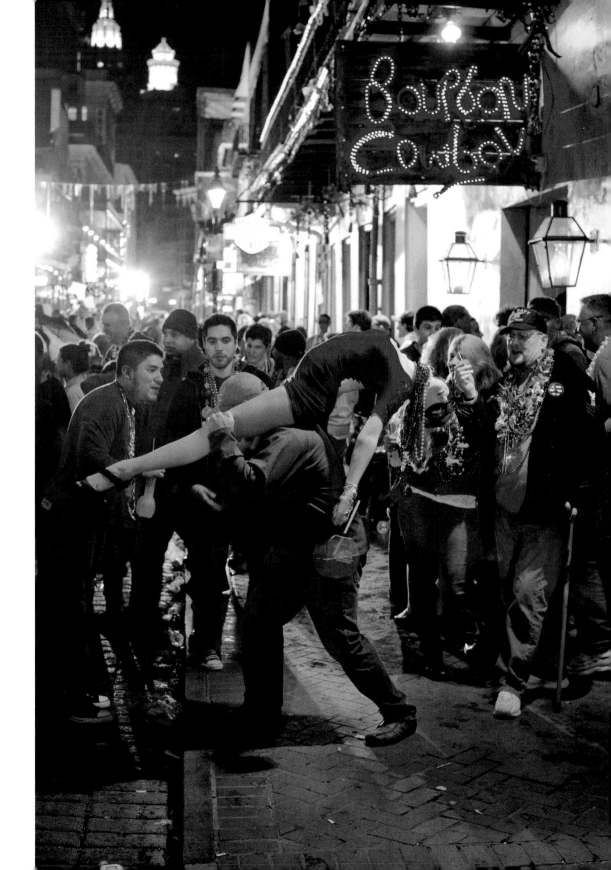

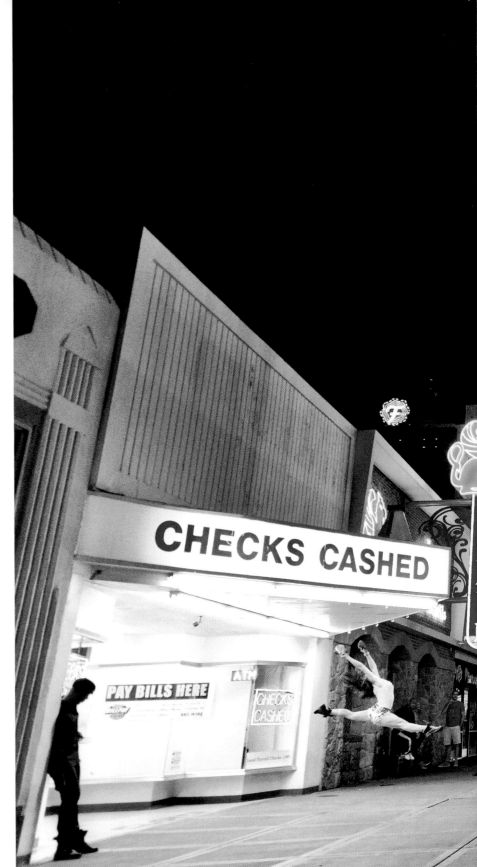

Rent Money
Colby Lemmo
Las Vegas, Nevada

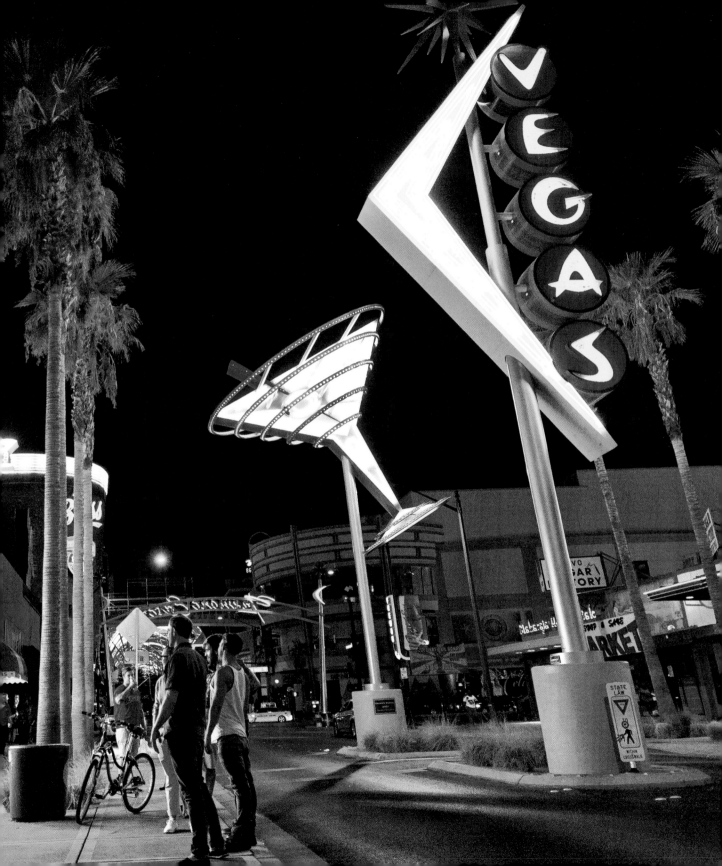

"Good humor gives good health."

GERMAN PROVERB

The Busker
Durell Comedy

New York, New York

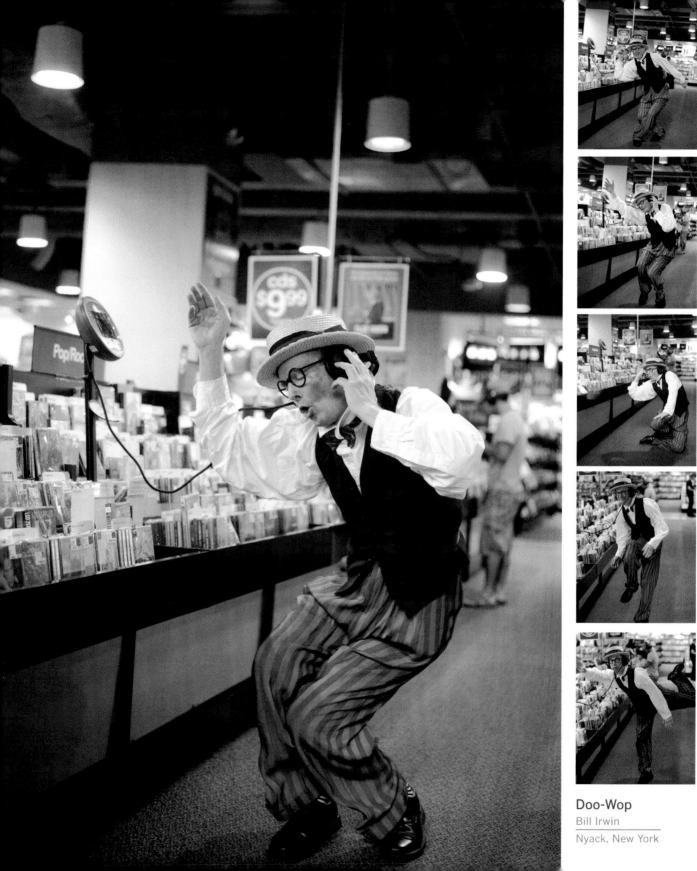

Doo-Wop
Bill Irwin
Nyack, New York

Swing Dance
Abby McDowell
Atlanta, Georgia

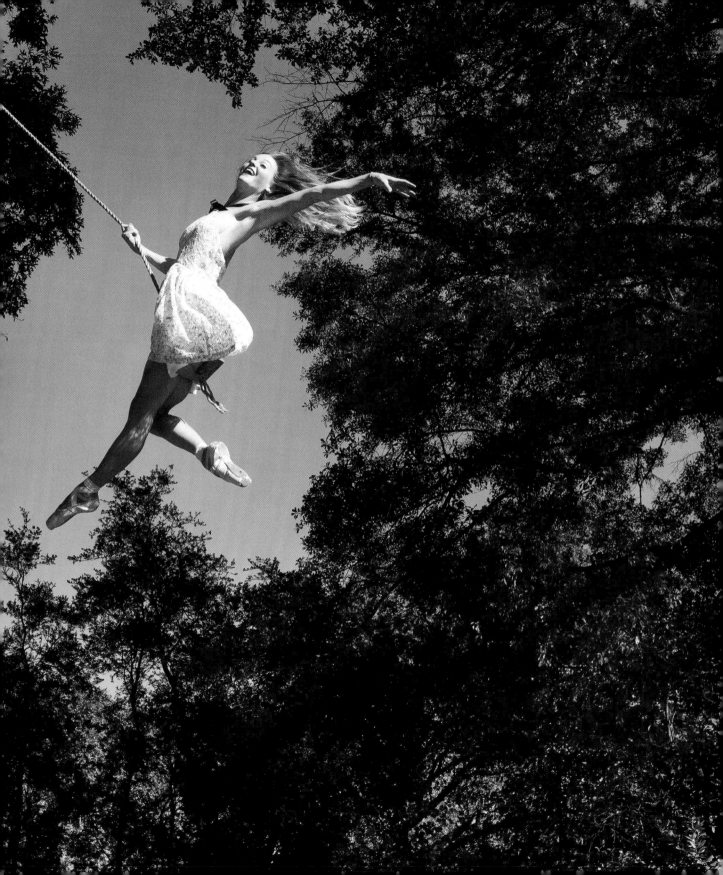

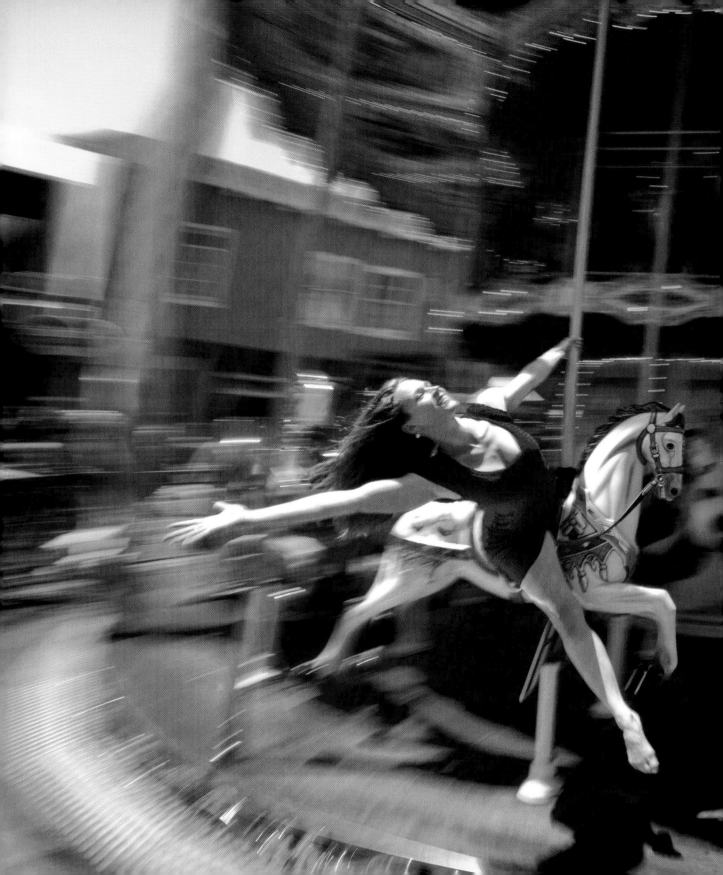

Brass Ring
Sharon Gallagher
San Francisco, California

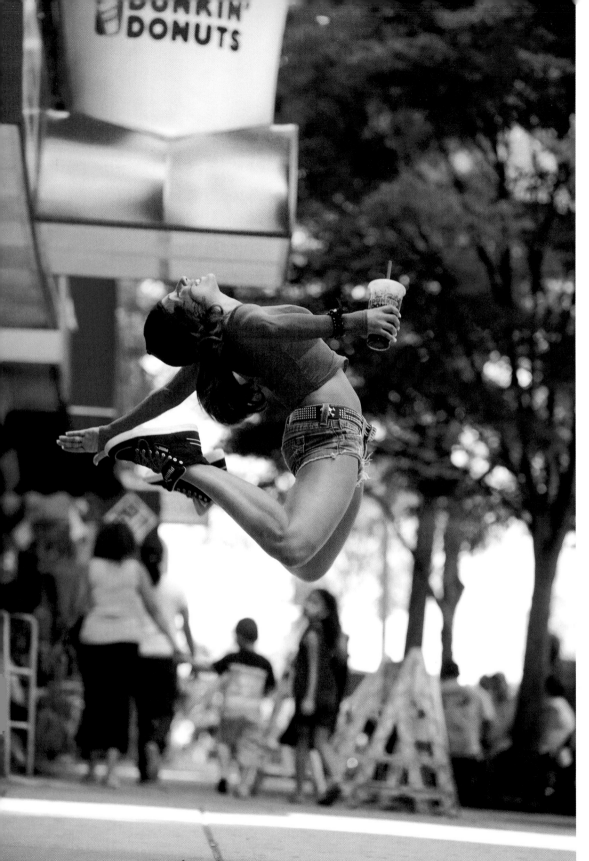

Caffeine High
Xiomara Forman
New York, New York

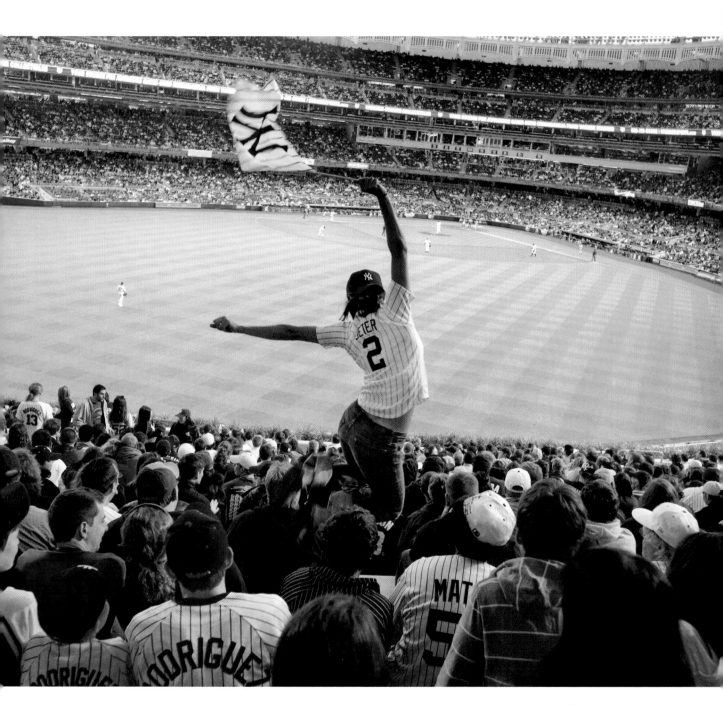

Diamonds Are a Girl's Best Friend

Parisa Khobdeh

New York, New York

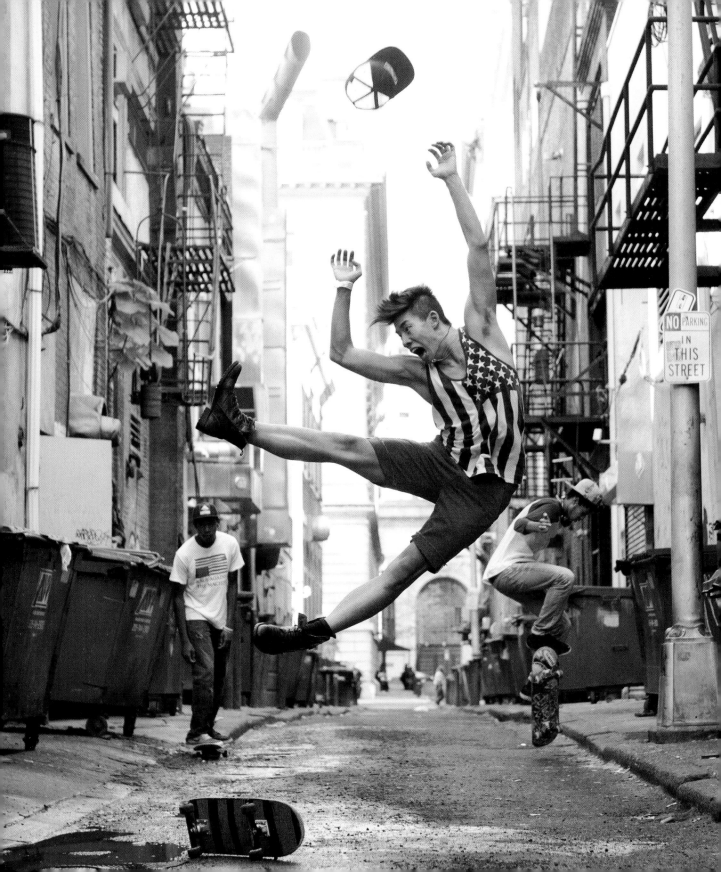

Catching Air
Miles Yueng
Philadelphia, Pennsylvania

"Falling down is part of life.
Getting back up is living."

ANONYMOUS

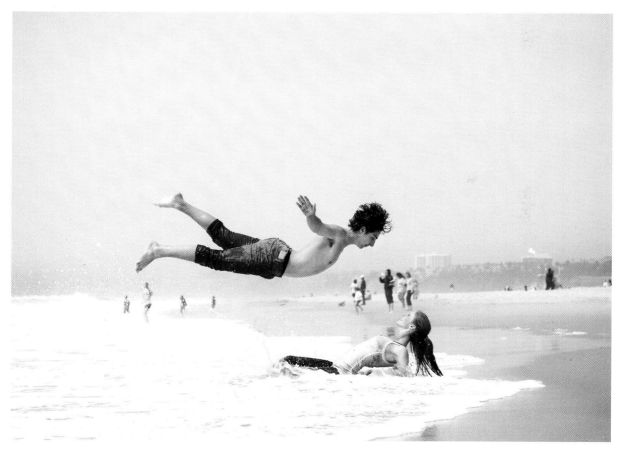

Body Surf
Jacob Jonas, Jill Wilson
Santa Monica, California

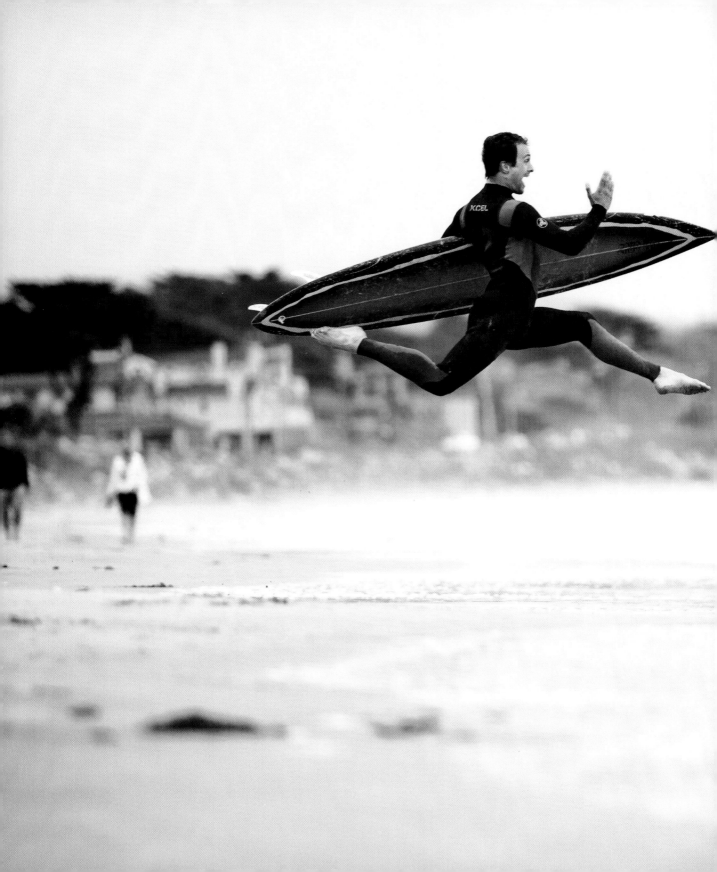

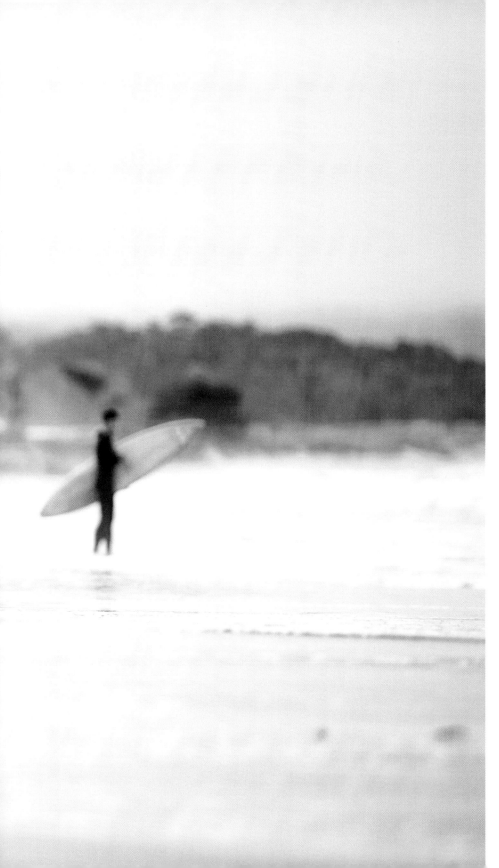

"Be happy.
It's one way of
being wise."

COLETTE

Cowabunga!
Brendan Barthel
Half Moon Bay, California

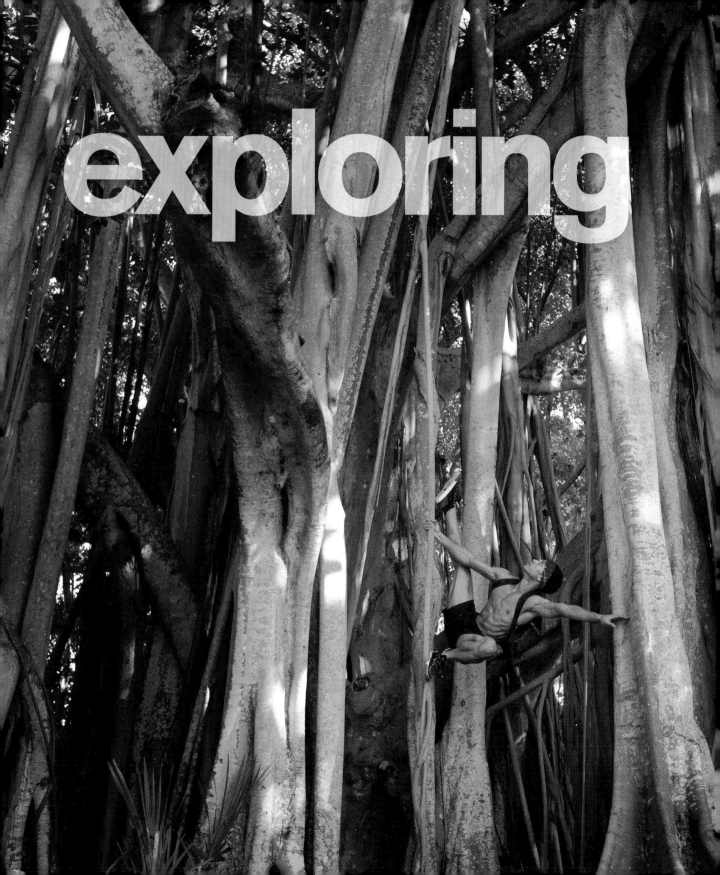

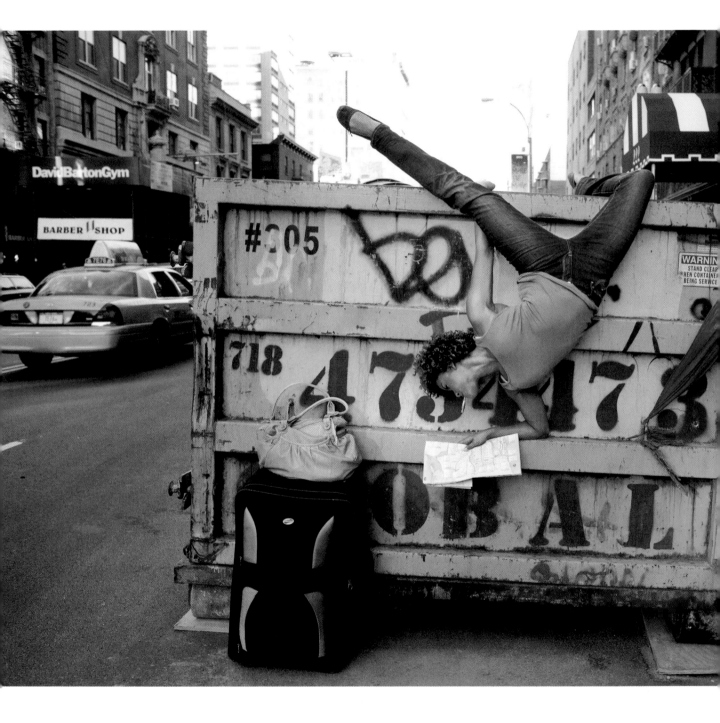

You Are Here
Kristina Hanna
New York, New York

H UDSON WAS THREE YEARS OLD WHEN SALISH was born. Lauren's contractions began late one night; by the next morning, she was deep into labor.

When Hudson woke up, I broke the news: "It looks like your sister will be coming today."

He thought for a minute, and then his shoulders sagged as a black cloud settled over his head. "Well, I'm a little scared," he said.

I had no idea how to alleviate a fear that I couldn't comprehend. I picked him up and held him in my lap, and we sat in silence. He's never been one to like cuddling very much, but that morning he wrapped his arms around my neck and gripped me for dear life.

After spending a few days with his new sister, the

cloud lifted. Hudson was excited. Buoyant. Relieved. Out of nowhere, he looked up at me and said, "I'm not scared anymore. I thought that when my sister came, I would have to be a big boy. But I'm not a big boy; I'm just a big brother."

He had been faced with a new reality for which he felt unprepared, and the mystery had frightened him. This may be one of life's greatest struggles. Often we fear the unknown when we could be anticipating its rewards. ❖

Sibling Rivalry
Simone Baechle, Josh Struebig, Lizzie Mackenzie, Jordan Struebig
Crown Point, Indiana

Le Backpacker
Nathan Madden
Montreal, Canada

Building America
Kelli Cubillos, Jamila Glass
Palm Springs, California

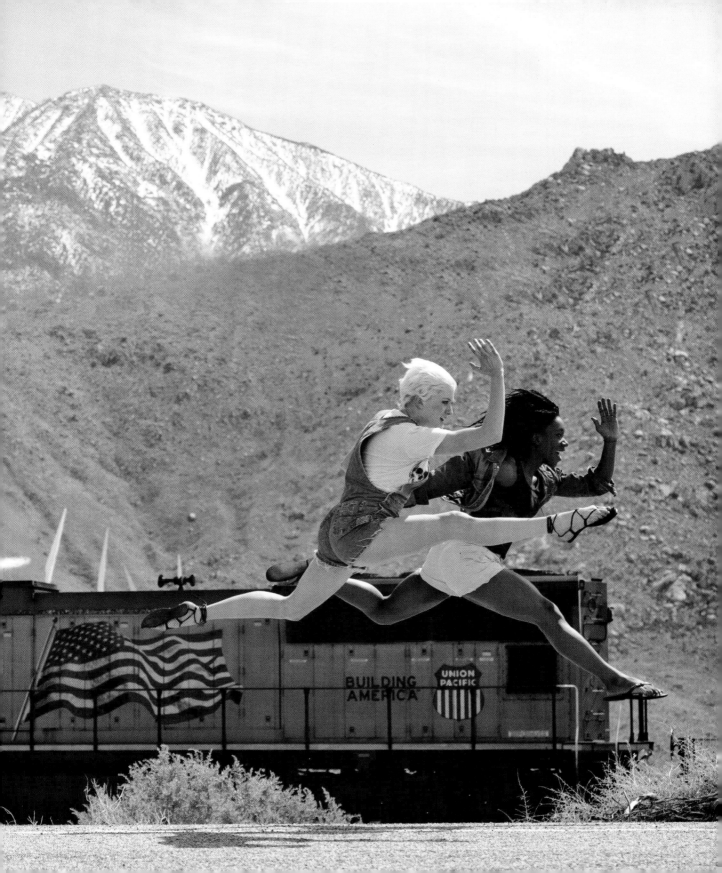

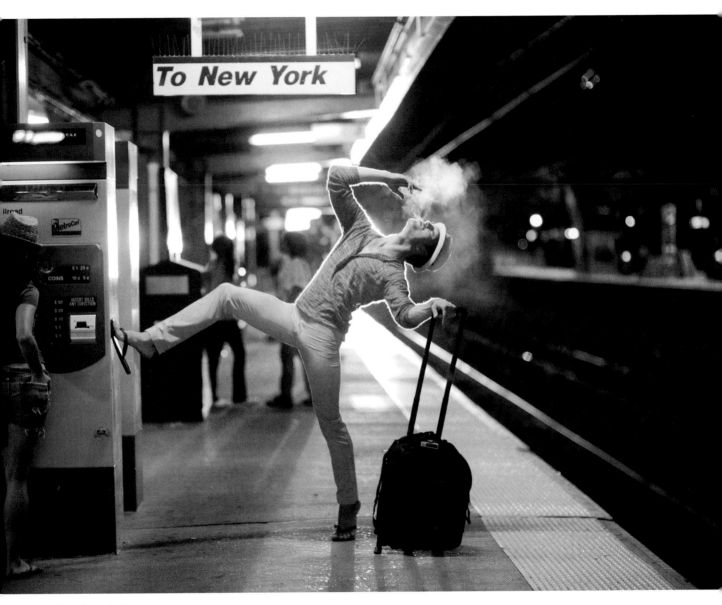

Vagabond Shoes
Eric Bourne
New Rochelle, New York

"To travel hopefully is a better thing than to arrive."

ROBERT LOUIS STEVENSON

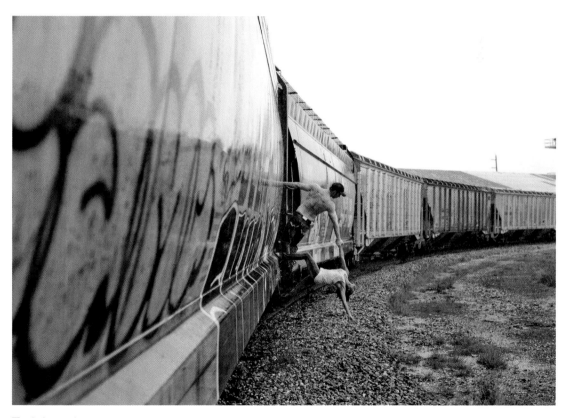

Trainhopping

Jared Doster, Tristin Ferguson

Houston, Texas

*"There are two ways of spreading light; to be
The candle or the mirror that reflects it."*

EDITH WHARTON

Ivy
Trisha Wolf
Princeton, New Jersey

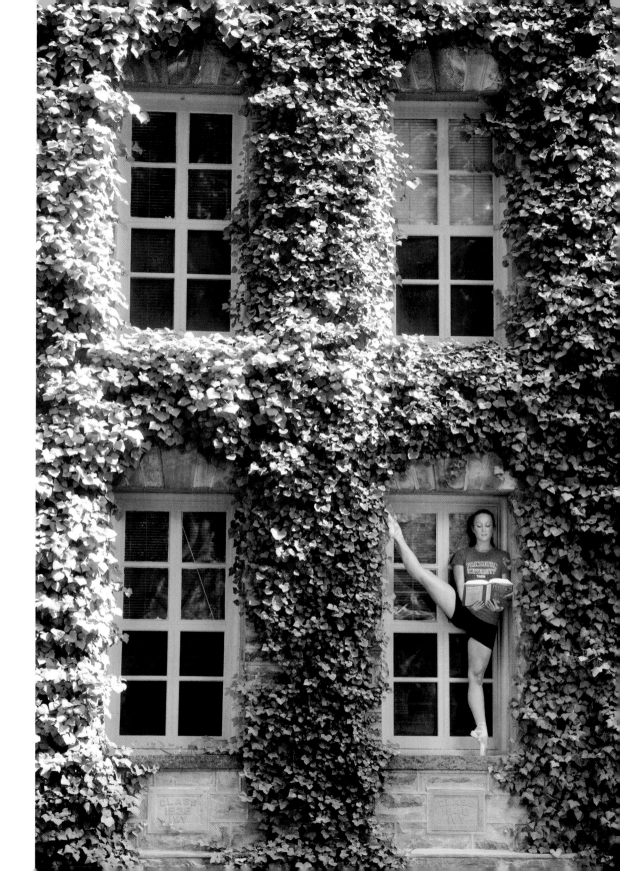

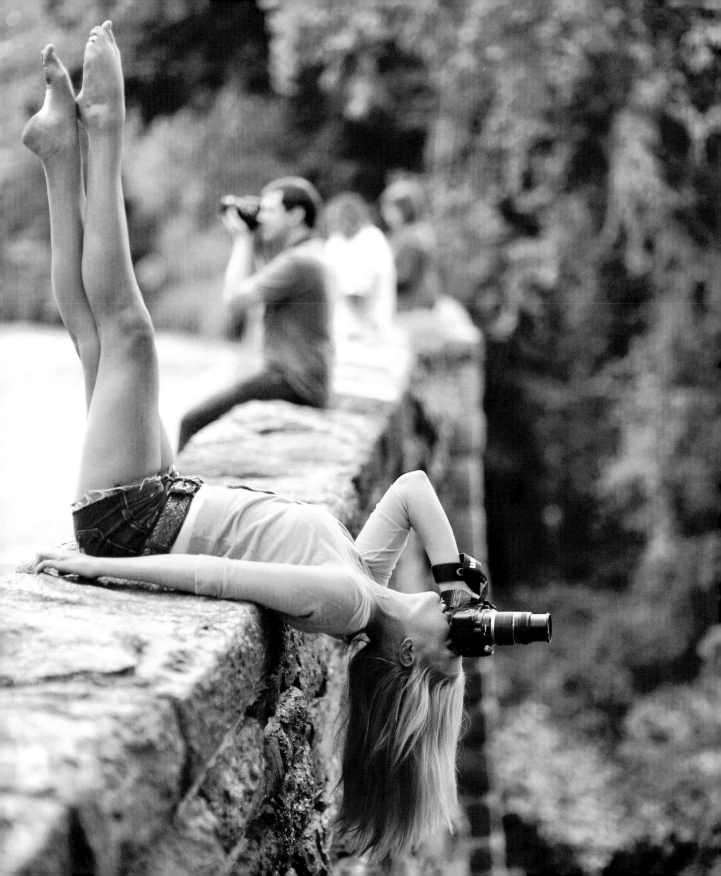

View Finder
Adrienne Hayes
New York, New York

On the Rocks
Jessica Fiala
Steamboat Springs, Colorado

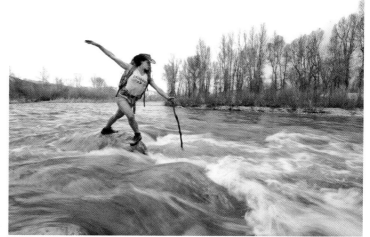

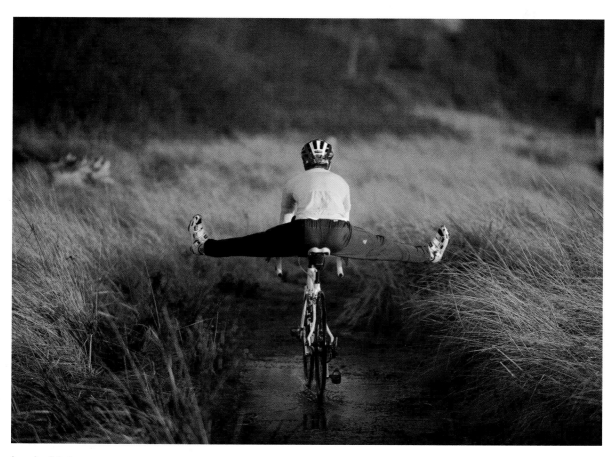

Look, Ma!
Kyle Davis
Seattle, Washington

"Ships at a distance have every man's wish on board."

ZORA NEALE HURSTON

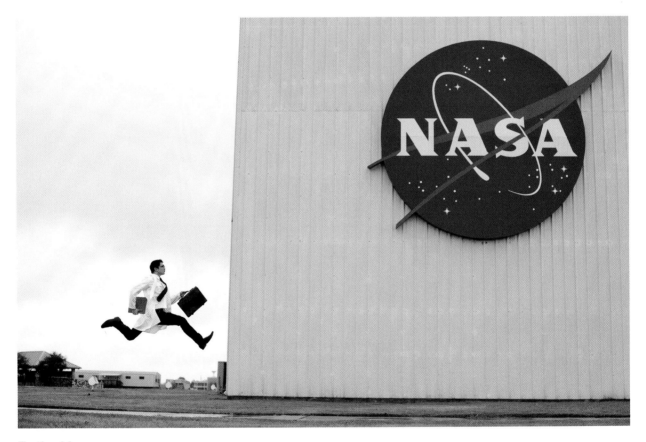

To the Moon
Charles-Louis Yoshiyama
Houston, Texas

Fill 'Er Up
Victor Ayers
Steamboat Springs, Colorado

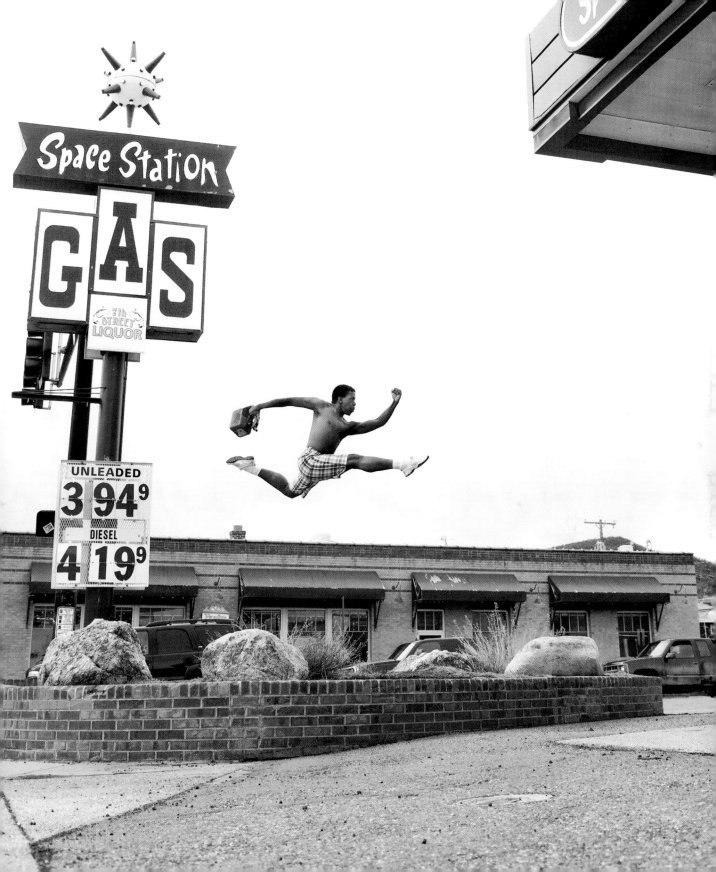

"Make voyages! — Attempt them! — there's nothing else."

TENNESSEE WILLIAMS

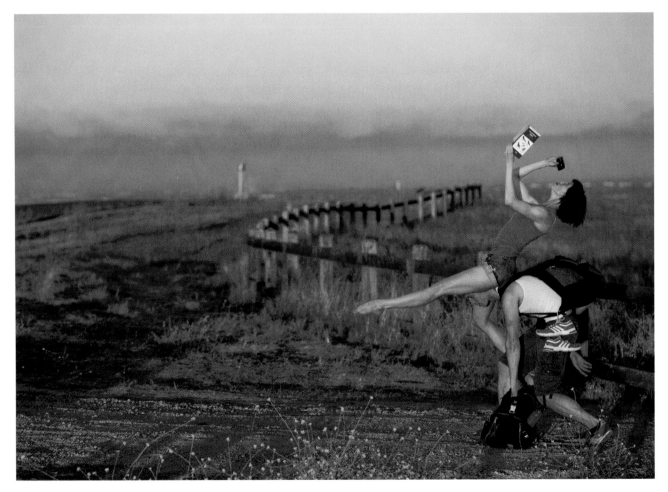

Bird Watching
Wendy Rein, Ryan T. Smith
Stanford, California

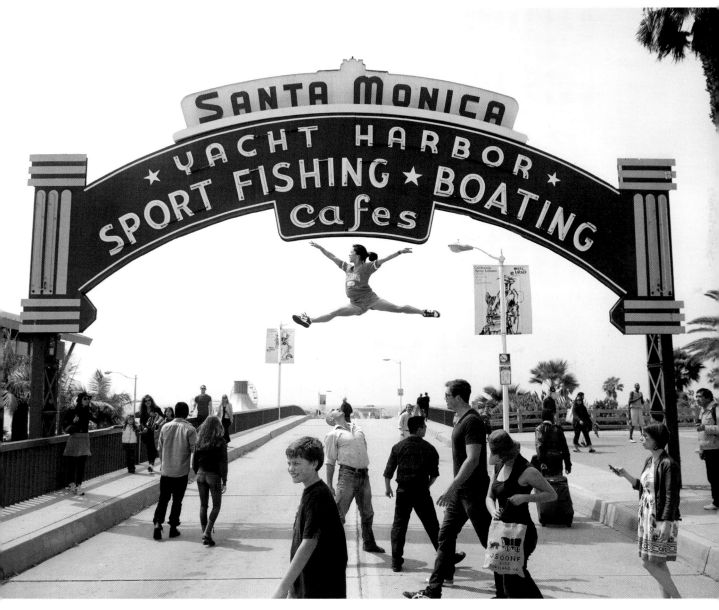

Pier Pressure
Marissa Labog
Santa Monica, California

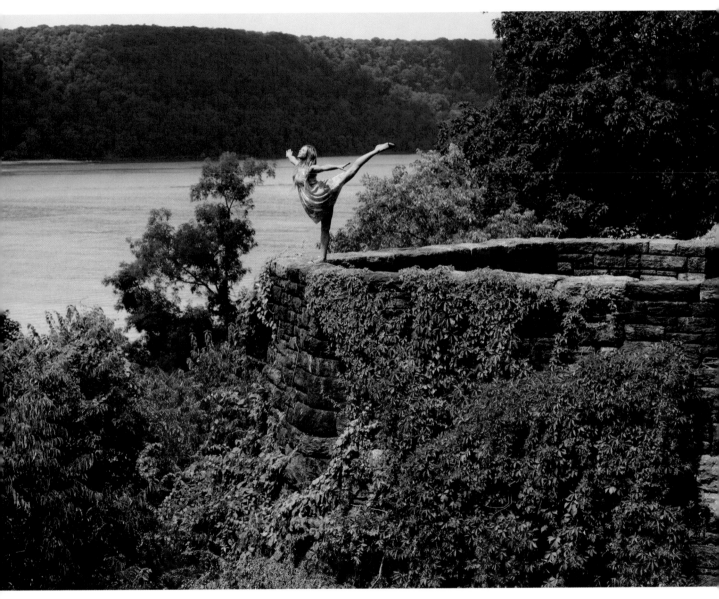

Vista
Evgeniya Chernukhina
New York, New York

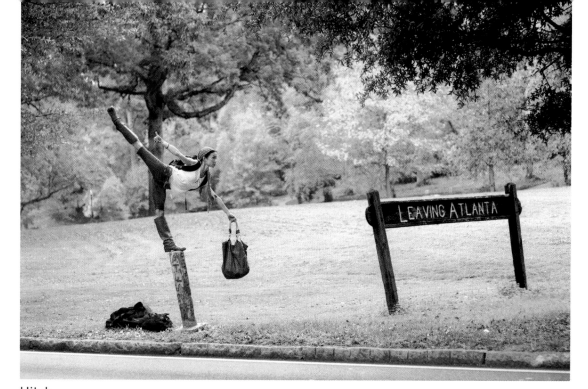

Hitch
Tara Lee
Atlanta, Georgia

Vantage Point
Dudley Flores
San Francisco, California

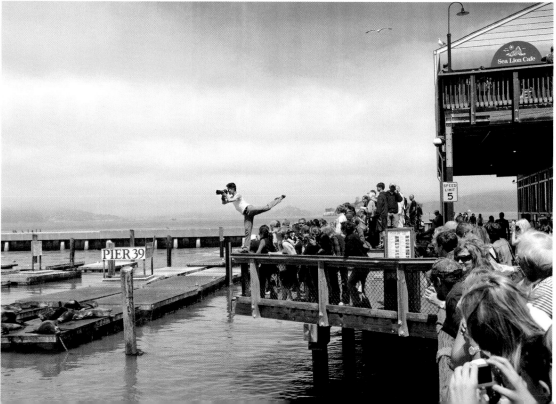

"Not until we are lost do we begin to understand ourselves."

HENRY DAVID
THOREAU

Vision Quest
Kelli Cubillos, Jamila Glass
Joshua Tree, California

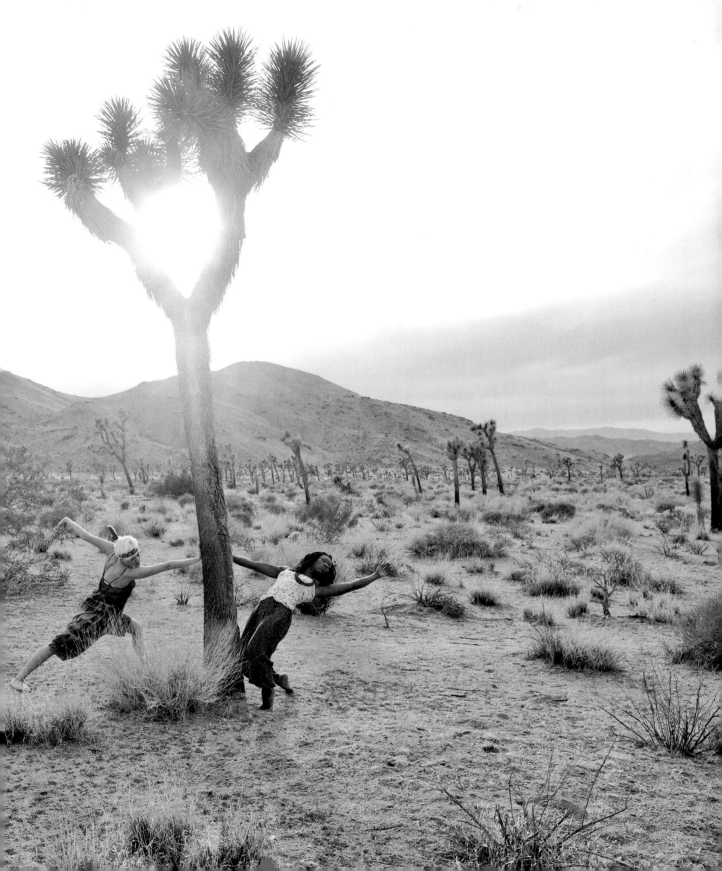

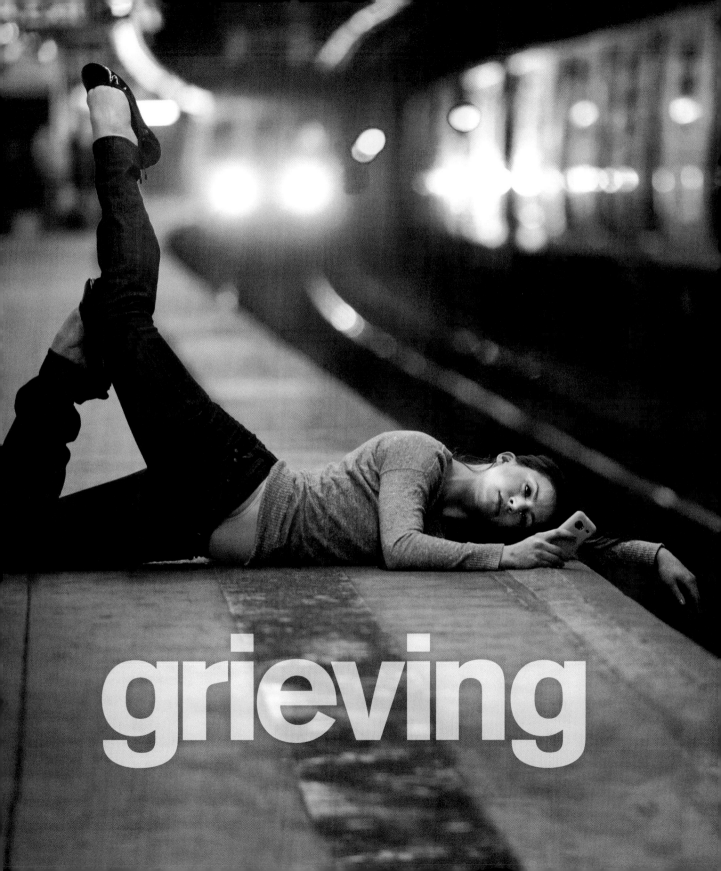

grieving

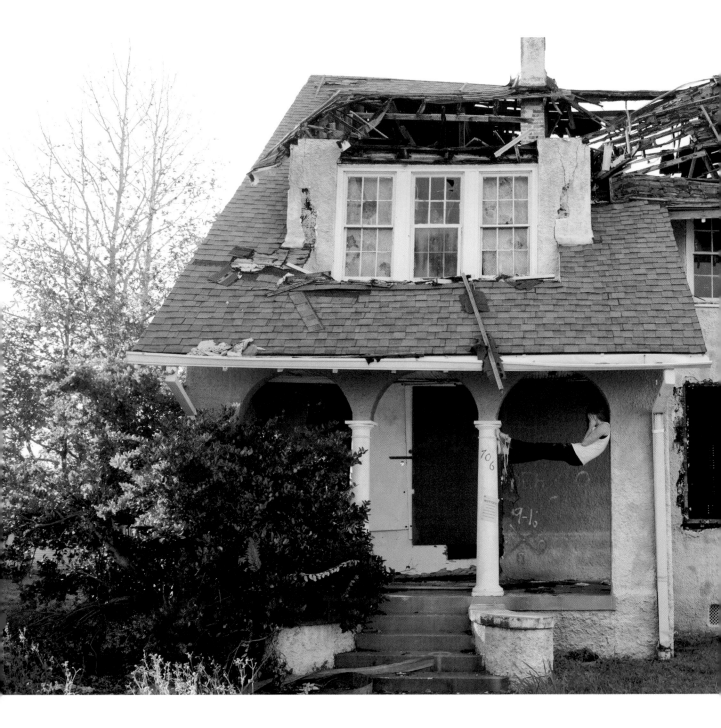

Condemned
Kristina Torres
New Orleans, Louisiana

"HUDSON, DO *NOT* WAKE UP YOUR MOTHER!" My son was protesting a particularly harsh parental decision of mine that involved limiting his sugar intake to something just south of diabetic. He stormed up the stairs, ready to burst into our room and tell Mommy.

"Hudson, I seriously mean it," I whispered frantically. "Do not open that door."

Salish had been born just a few months before. Mother and daughter were finally passed out together after an exhausting stretch of newborn intransigence. This could be catastrophic.

I watched as Hudson threw open the door and disappeared inside.

"MOMMY, DADDY IS BEING MEAN TO ME . . ."

"WAAAAAAAAAAAAAAAAAAAAAA!!!!!!!!!"

I entered into the utter chaos—Salish shrieking, Hudson crying, Mommy delirious. My anger was so overwhelming and absolute that I screamed the four words never before uttered in our home: "GO TO YOUR ROOM!"

Hudson was confused. Was this punishment? He'd heard about time-outs from his friends but had never experienced one himself. His uncertainty was quickly erased as he felt the force with which I picked him up and carried him away.

"I'M SORRY I'M SORRY I'M SORRY I'M SORRY," he screeched, stopping only to start crying uncontrollably. I put him on his bed and stared at him with barely restrained rage.

"Sit here until I come back."

"How long will it be?" he sobbed.

"I don't know."

As I left his room, I thought to myself, how awful a punishment is lying in bed, staring at the ceiling mural, maybe grabbing a toy and quietly playing? I thought he might even take a nap. I had no idea how terrifying the experience would be for him. Hudson stayed in the same position on his bed, crying so painfully that it was agonizing to hear. I waited as long as I could stand it before opening the door. He stopped crying and looked at me with heartbreaking vulnerability.

"Do you know why I'm so angry?" I asked softly.

He shook his head. As I explained, he blinked back tears and said nothing. When I finished, the tears began to flow again. His voice was quivering. In one desperate sentence he identified the foundation of human fear: "Do you still like me?"

He collapsed into my arms and cried for a long time. I held him tightly and promised my unconditional love. Finally, he looked up at me with red eyes and smiled.

"Daddy, want to play with my airplane together?"

"Of course," I said, smiling back.

It was over. He had released his emotions by thoroughly embracing them. He felt until there was nothing left to feel.

As adults we often confuse maturity with stoicism, thus losing our ability to process our grief. Of the many traps adulthood sets, the most destructive may be the belief that we should "buck up and move on" when grief sets in. We should take our time to feel the pain. Let it wash over us and not run from it.

When my mother died, I was unprepared for the emotions I felt. I had spent a lifetime learning to compartmentalize my feelings, learning to find an immediate distraction whenever sorrow threatened to derail me. Her death was sudden, and our relationship was complicated and unresolved. The pain was overwhelming. I shut it off immediately, allowing myself one day of mourning before returning to my routine. *One day*. I never said good-bye, I never grieved for her, and thoughts of her paralyze me to this day.

I wish being held could ease all the difficult moments in life. I wish a time-out and a thirty-minute cry would forever resolve our pain. But it doesn't. Yet honoring grief large and small—the situations we laugh about after an hour, the others we never fully resolve—helps remind us that intense feelings are natural. ❖

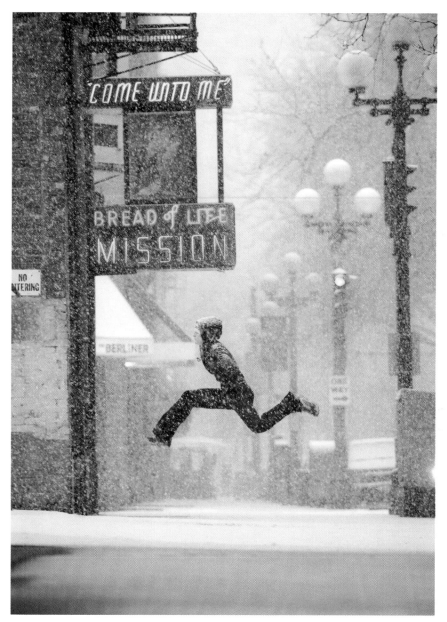

Out in the Cold
Marissa Quimby
Seattle, Washington

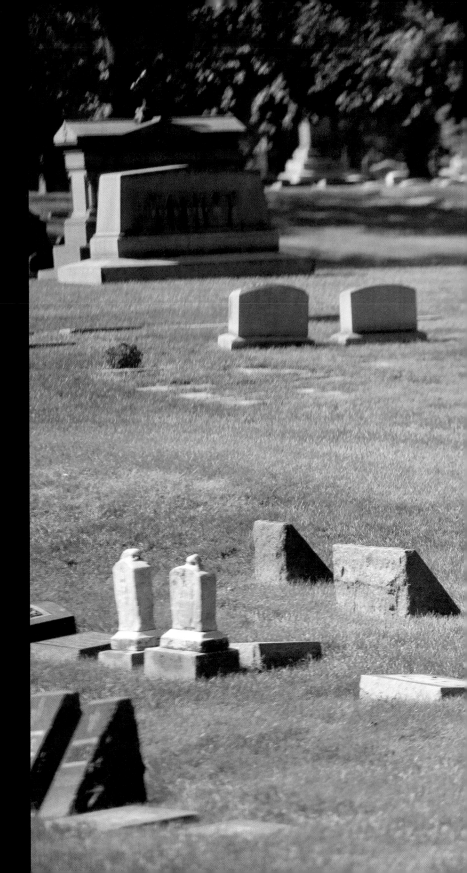

After
Chloe Crade
Chicago, Illinois

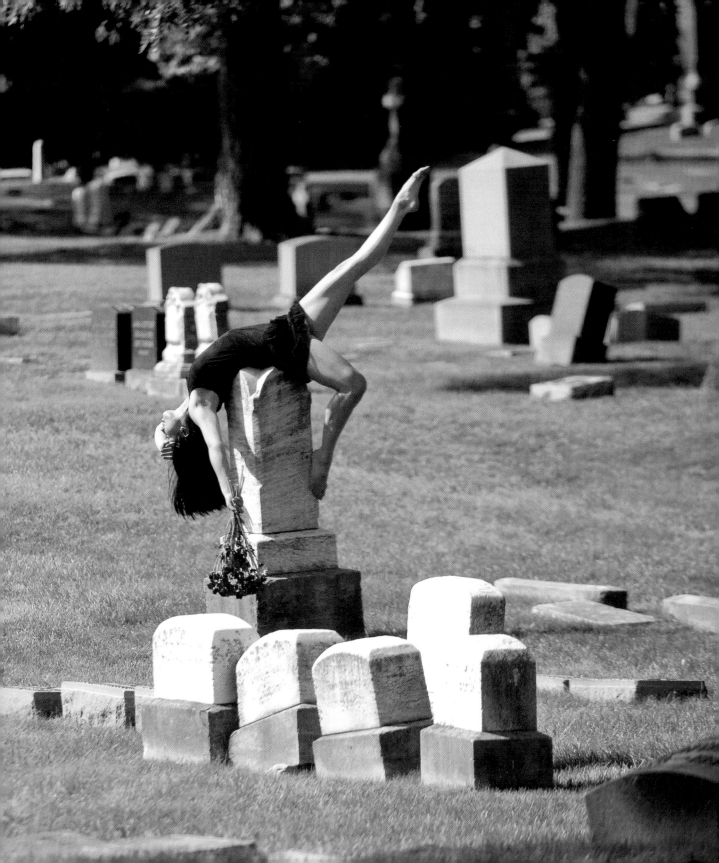

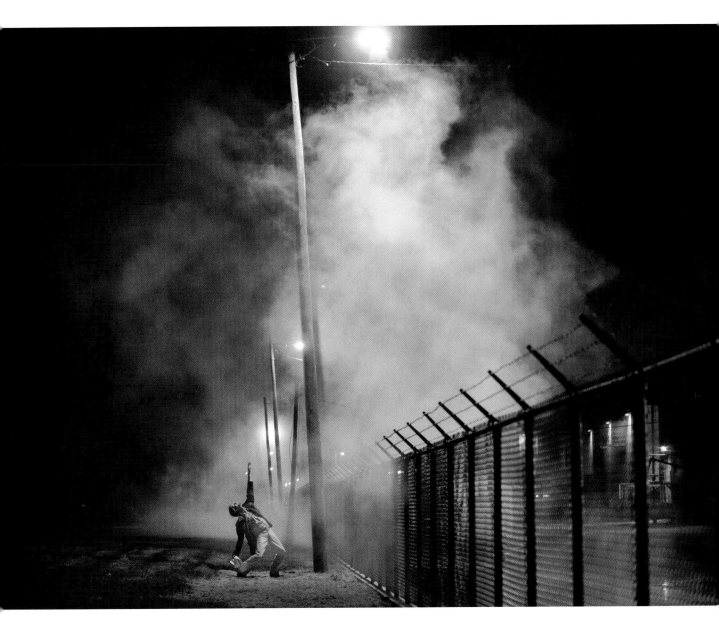

Slaughterhouse at Night

Monte Black

Greeley, Colorado

"There is no trap so deadly as the trap you set for yourself."

RAYMOND CHANDLER

Craving
Katherine Bolaños
Aspen, Colorado

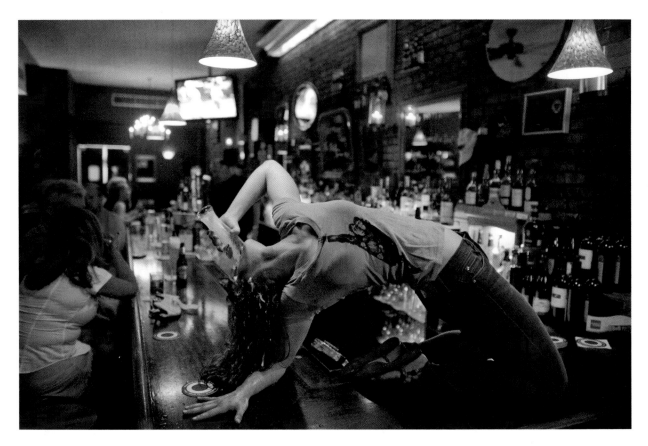

Just One More
Jennifer Jones
New York, New York

One Too Many
Steven Vaughn
Miami, Florida

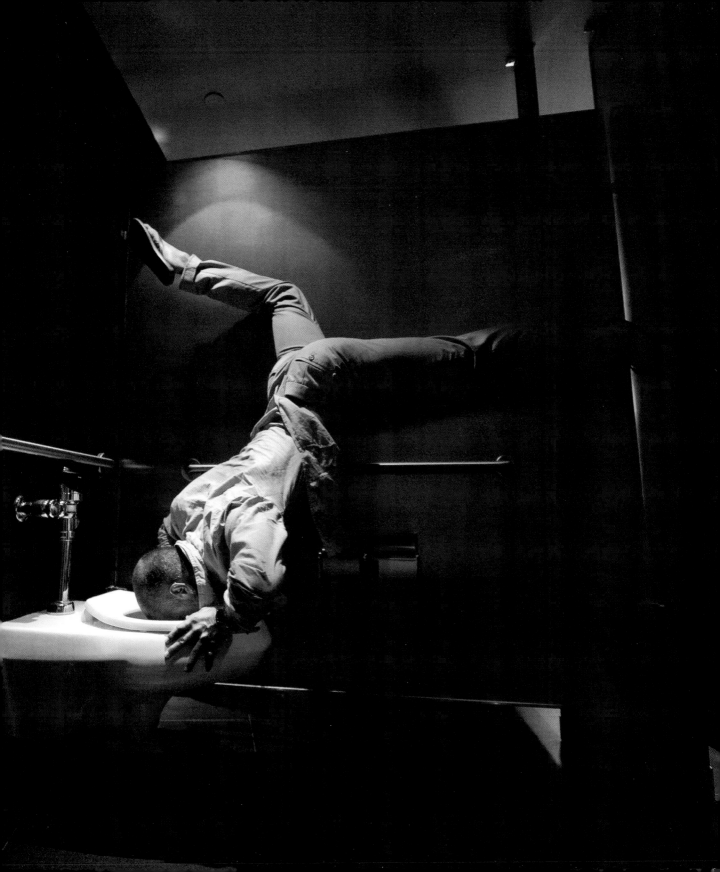

Moving On
Sarah Sadie Newett, Orlando Martinez
New York, New York

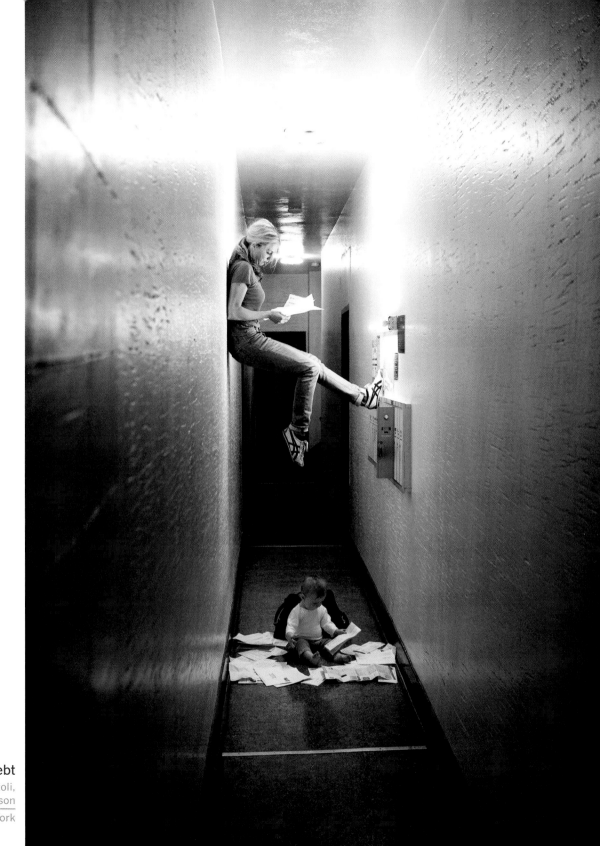

Drowning in Debt

Abby Silva Gavezzoli,
with her son

New York, New York

*"None but a coward dares to boast
that he has never known fear."*

MARSHAL FERDINAND FOCH

Running Scared

Julie Holcomb
Atlanta, Georgia

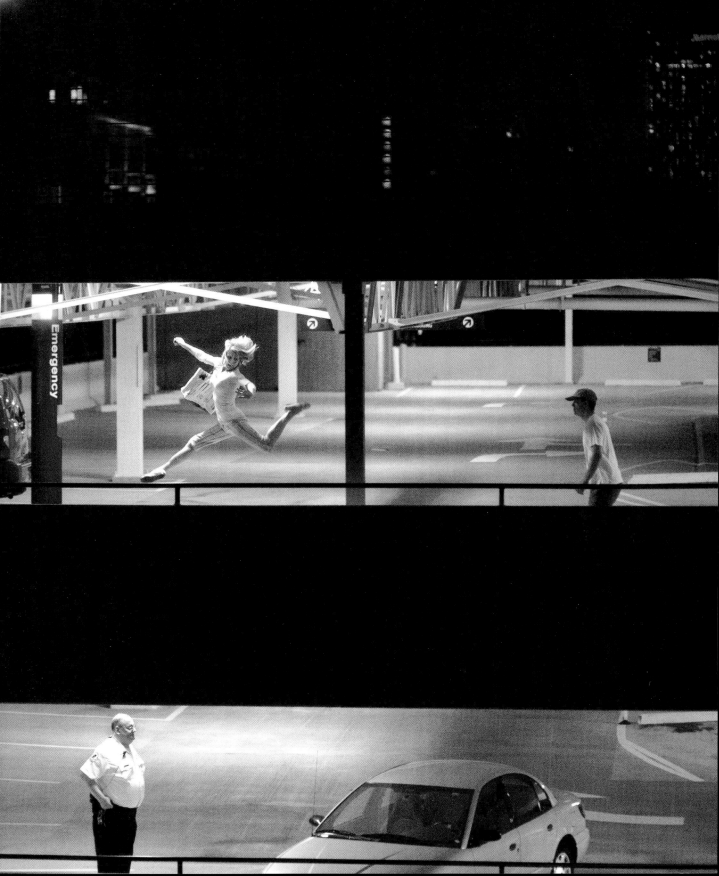

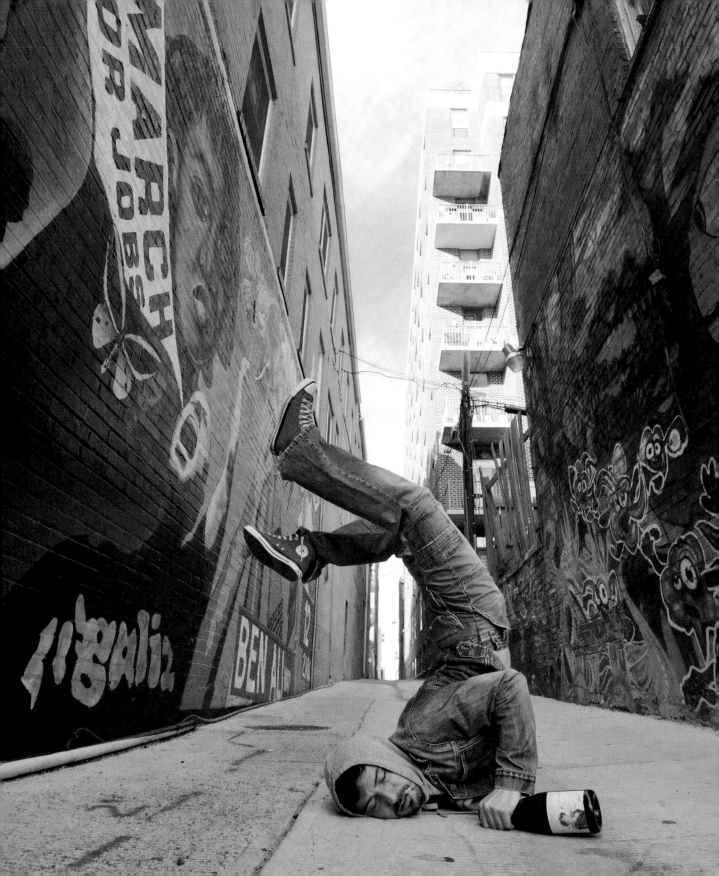

Hair of the Dog

Dario Vaccaro

Washington, DC

"Human life begins on the far side of despair."

JEAN-PAUL SARTRE

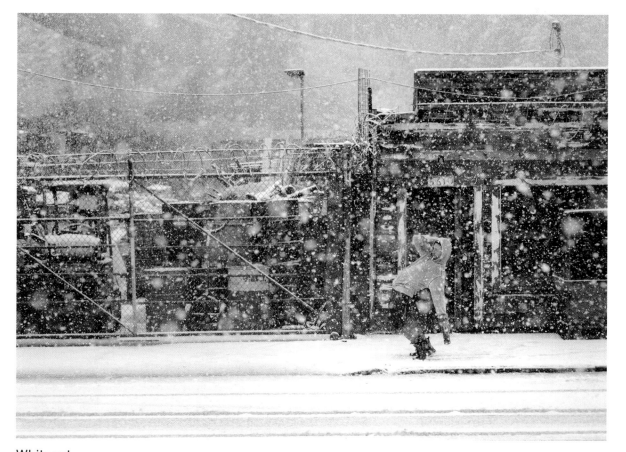

Whiteout

Ezra Thomson

Georgetown, Washington

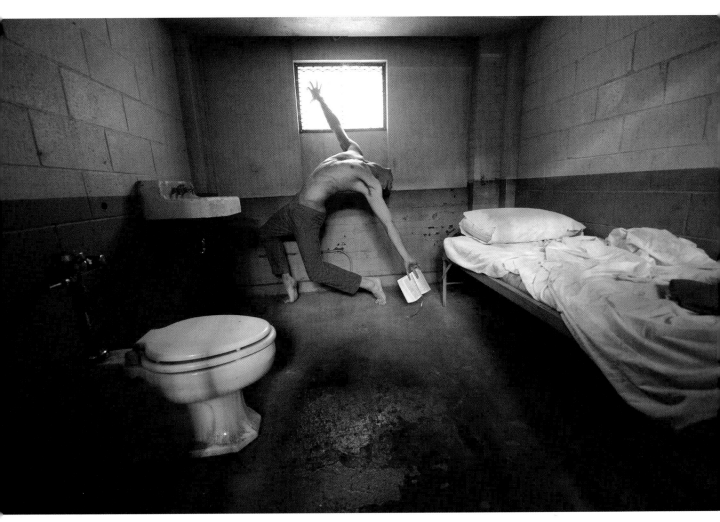

Forgive Me
Tommy Panto
Atlanta, Georgia

"Ever tried. Ever failed. No matter. Try again. Fail again. Fail better."

SAMUEL BECKETT

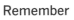

Remember
Andy Allen
Washington, DC

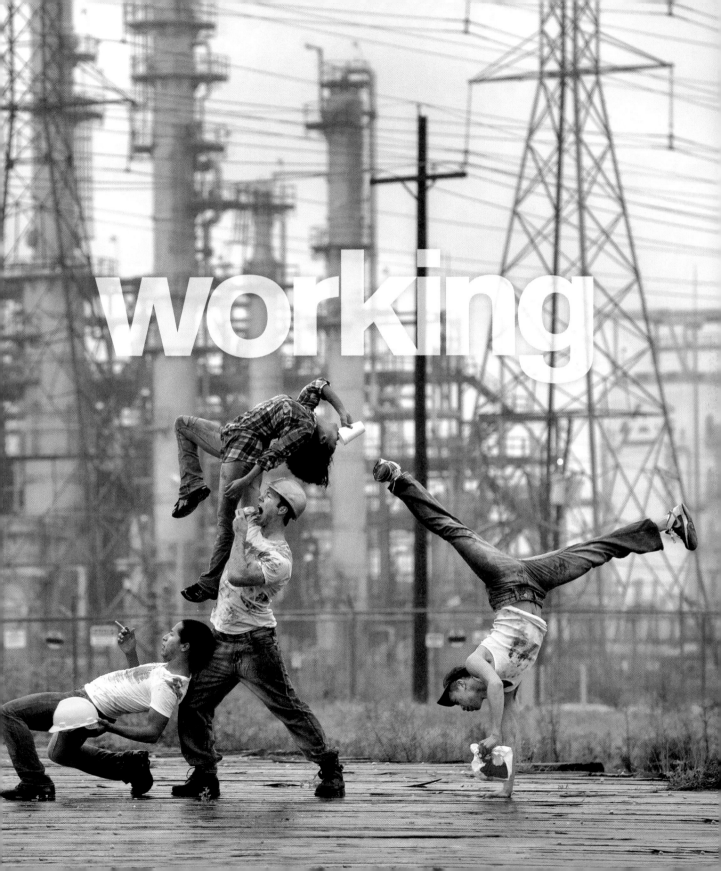

working

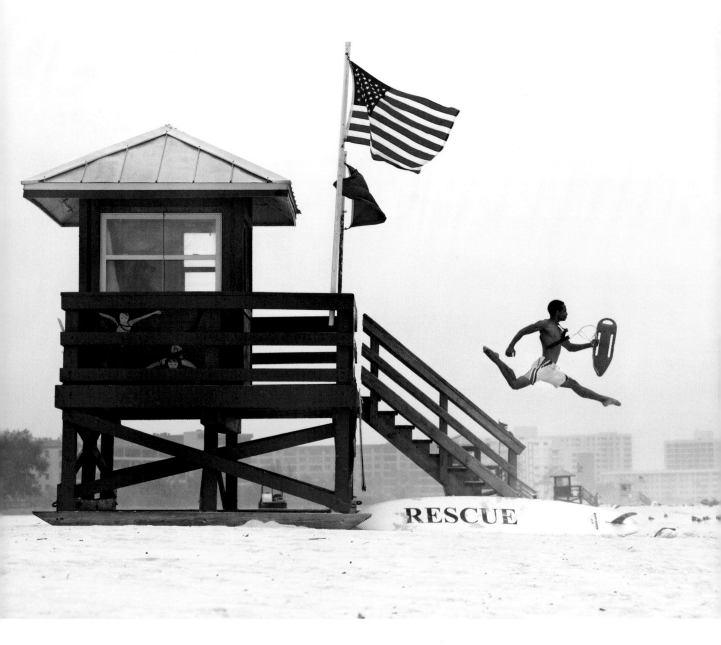

◀ Coffee Break

Jesus Acosta, Tristin Ferguson, Jared Doster, Shohei Iwahama
Houston, Texas

H ER LAUGHTER ECHOED THROUGH THE ROOM, the beautiful sound of unbridled joy. Lauren and I couldn't see the source of the laughter, but we felt the effect; it made us smile. It was particularly unexpected given our surroundings—we were sitting in the waiting room of a hospital. Lauren was there to undergo a series of tests, and we were feeling anxious.

Lauren's name was called, and she was sent to a small cubicle in the corner. Sally, a large woman with sparkling eyes and a huge smile, greeted us warmly.

"What a nice-looking young lady you are," she said to Lauren. Then she stared right at me. "How on earth did you get so lucky?" she wondered aloud before leaning back and once again filling the dreary room with

Save the Day
Ricardo Rhodes
Sarasota, Florida

her laughter. It was infectious; we both smiled and relaxed at once.

As she entered all the thisses and thats on Lauren's medical forms, she peppered us with questions and compliments. After ten minutes she knew that we had met in college and got married in Canada, that our favorite band is Great Big Sea, and that we want to bicycle across the country together. She made us feel special, and we bantered back and forth until it was time to go. She sent us off with hugs and well-wishes.

As we walked toward the examining room, we were smiling, even though not thirty minutes before we had been nervous and fearful. I'm sure that nowhere in Sally's job description does it mention cheerleading as part of her duties, but she wasn't reading from a manual.

It's tempting to be cynical and frustrated, to give up in the face of difficult odds, to do the least amount of work possible and collect a paycheck. Yet it doesn't need to be that way. Just ask a big-hearted receptionist at a small hospital, who sits at a tiny desk in a stuffy room, changing lives, each and every day. ❖

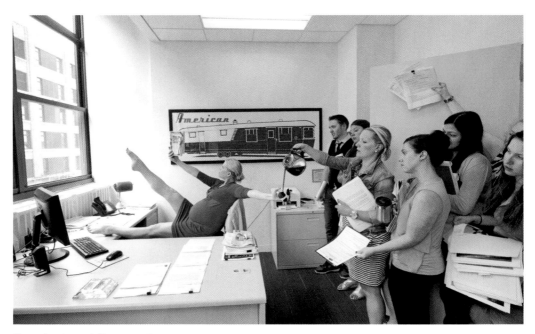

Barefoot and Pregnant
Selina Meere
New York, New York

Late for a Meeting
Robert Kleinendorst
New York, New York

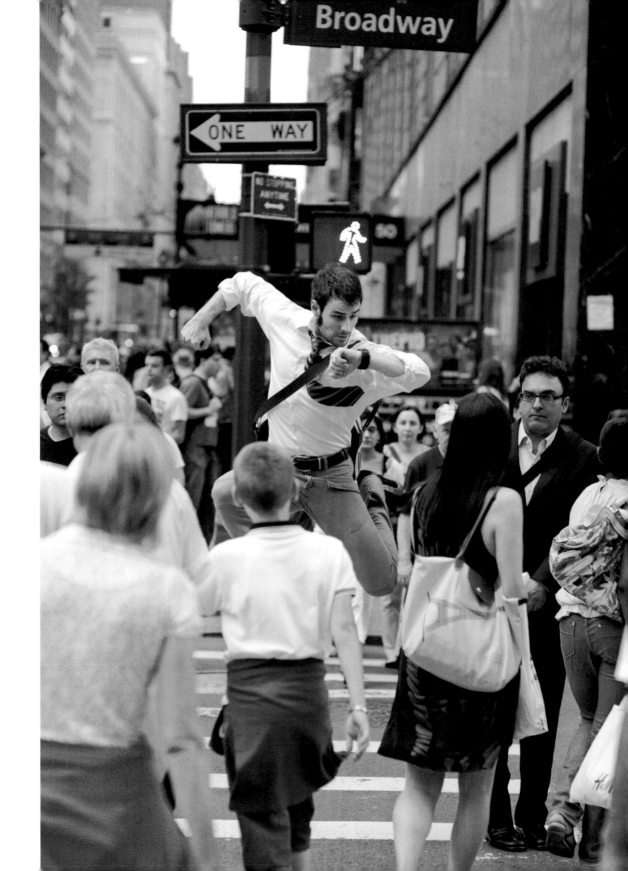

Work Boots
Kara Lozanovski
Chicago, Illinois

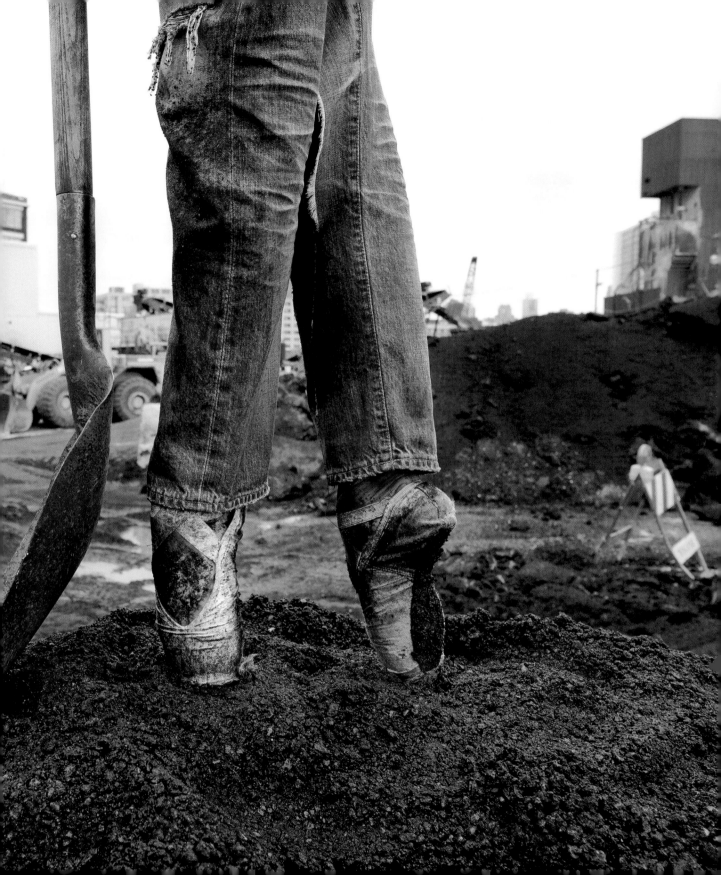

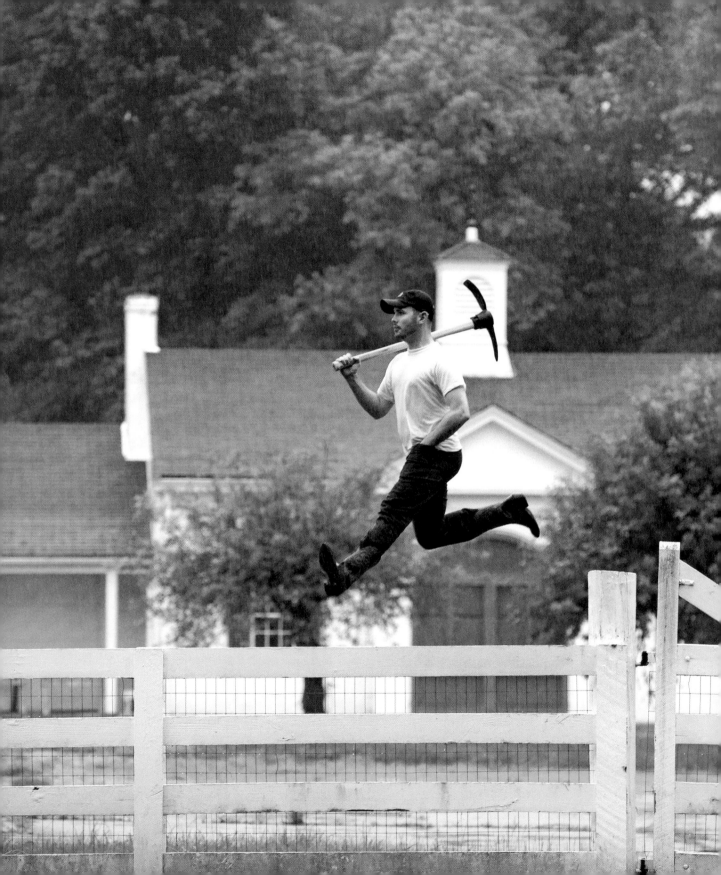

Dig It
Marc Kranz
Dover, Massachusetts

"We will walk on our own feet; we will work with our own hands; we will speak our own minds."

RALPH WALDO EMERSON

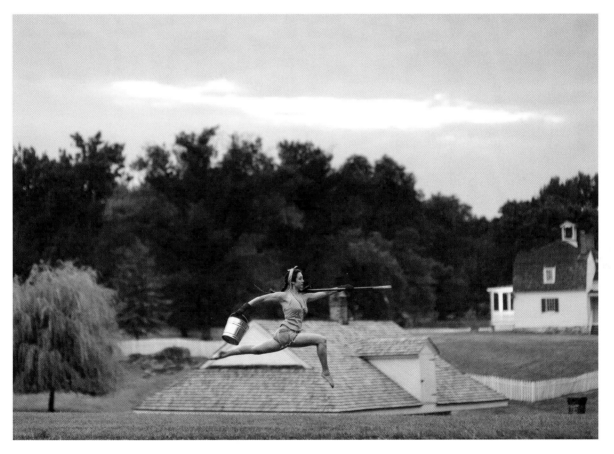

Twilight Chores
Rachel Bell
Towson, Maryland

"If you would create something, you must be something."

JOHANN WOLFGANG VON GOETHE

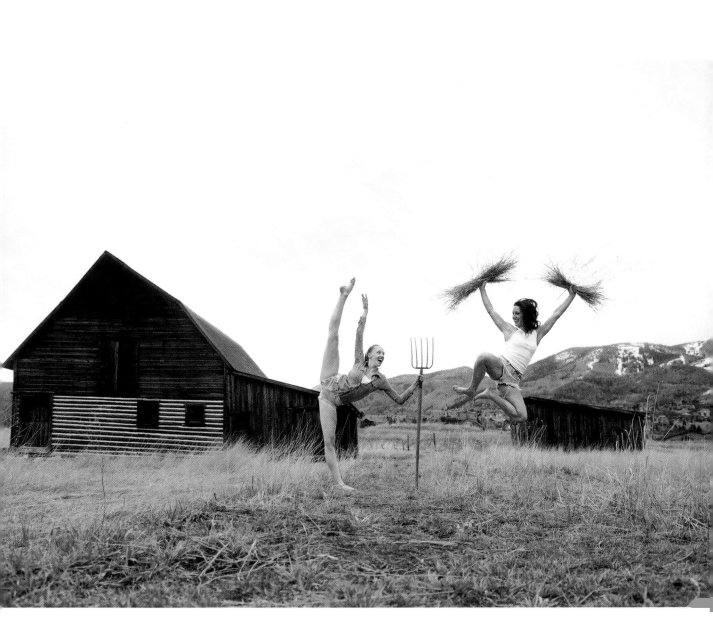

Making Hay
Rhiona O'Loughlin, Jessica Fiala
Steamboat Springs, Colorado

"If you want to be the best, baby, you've got to work harder than anybody else."

SAMMY DAVIS JR.

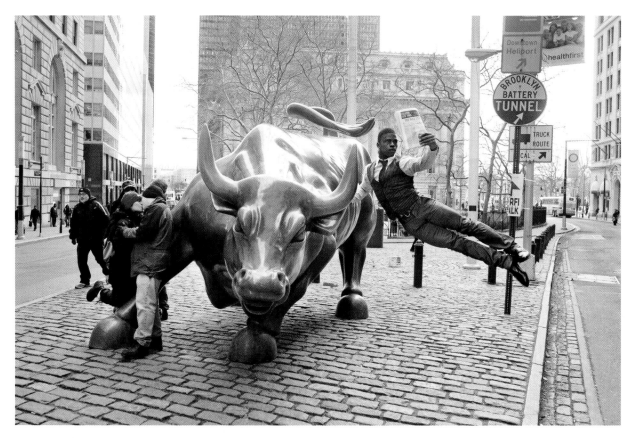

Taking Stock 1
Adé Chiké Torbert
New York, New York

Taking Stock 2
Adé Chiké Torbert
New York, New York

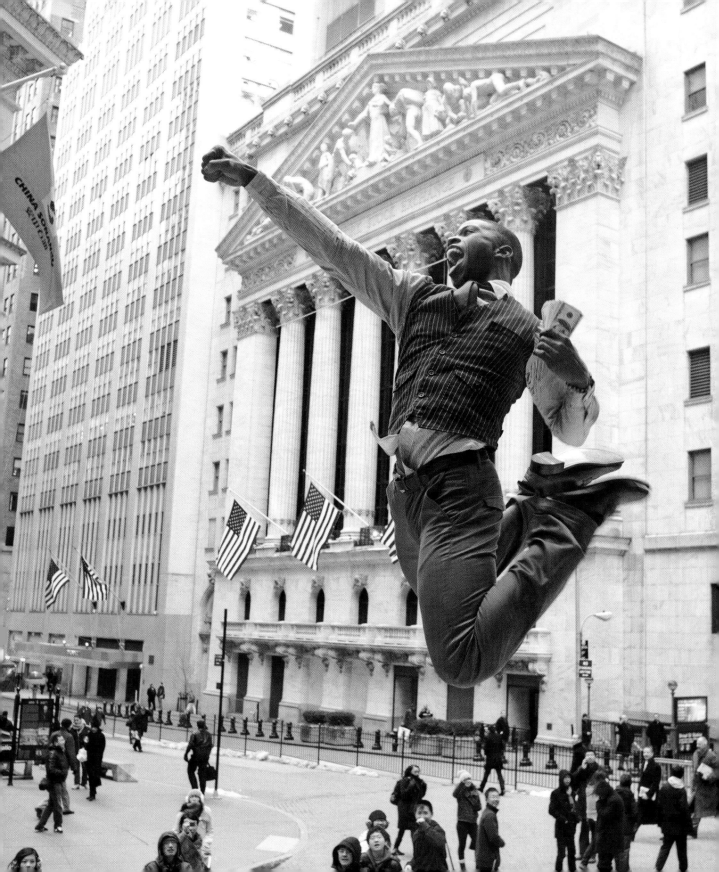

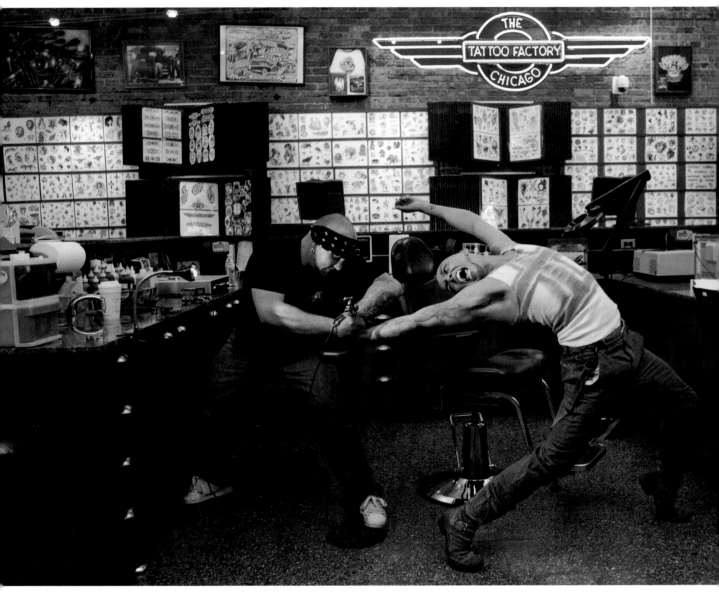

Inked
Francisco Aviña
Chicago, Illinois

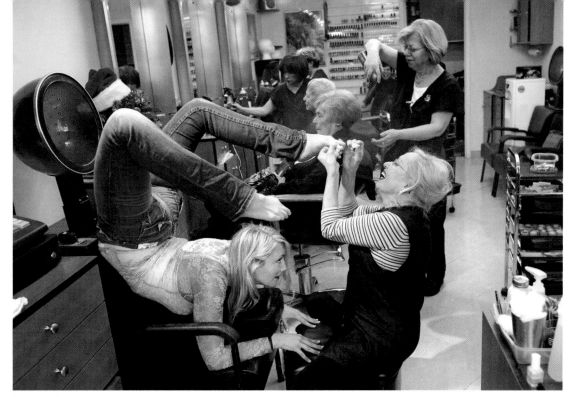

Mani/Pedi
Chelsey Klingsporn
New York, New York

Rise and Shine
Jake Szczypek
New York, New York

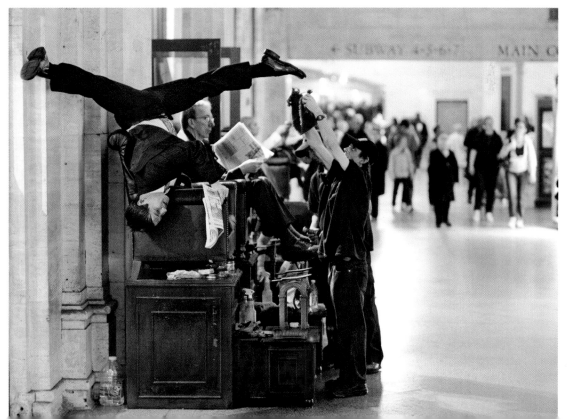

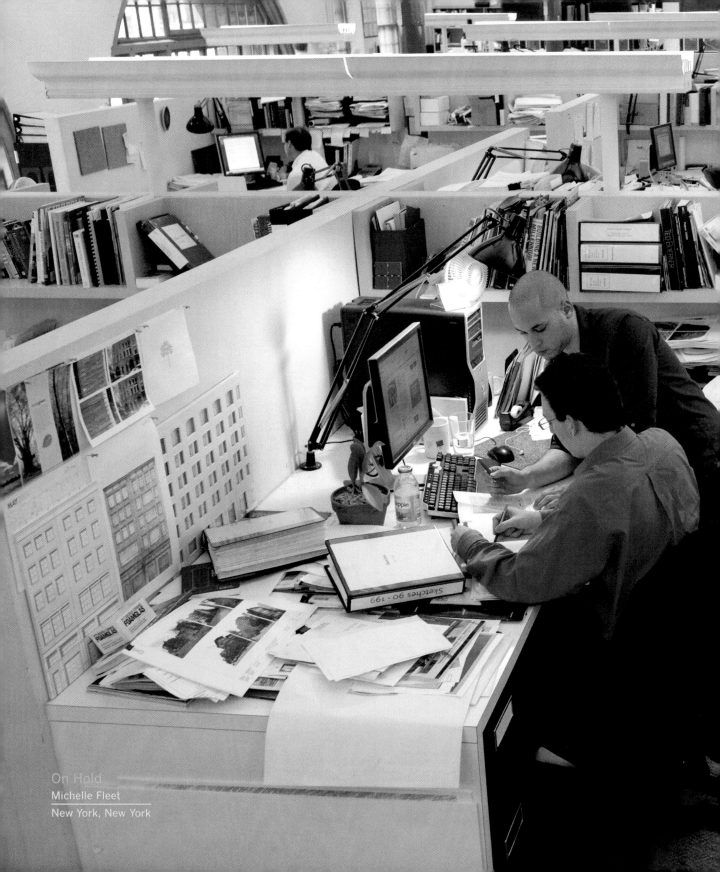

Saving Lives
Duncan Lyle
Boston, Massachusetts

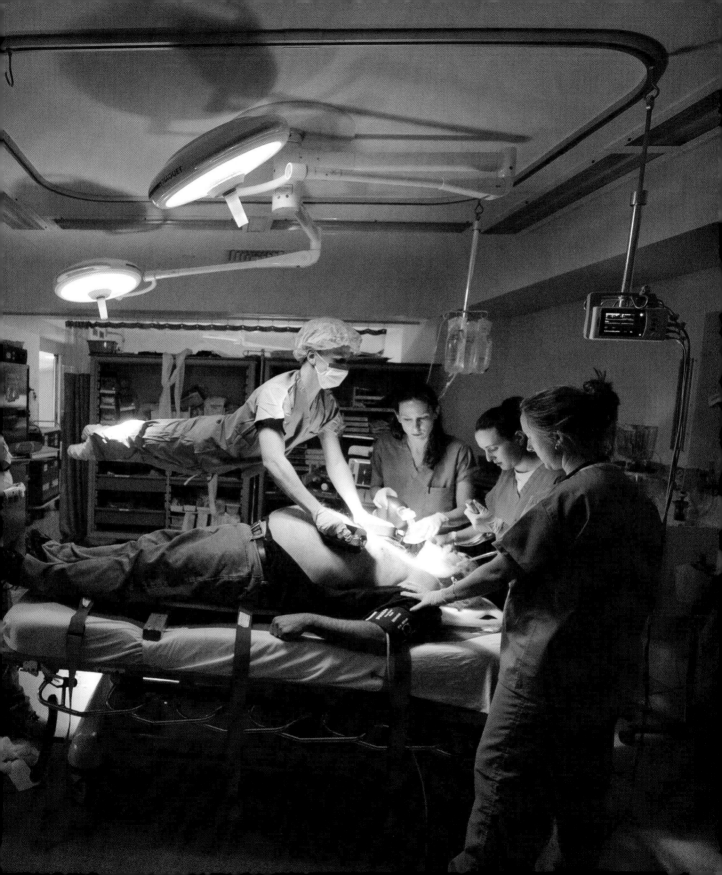

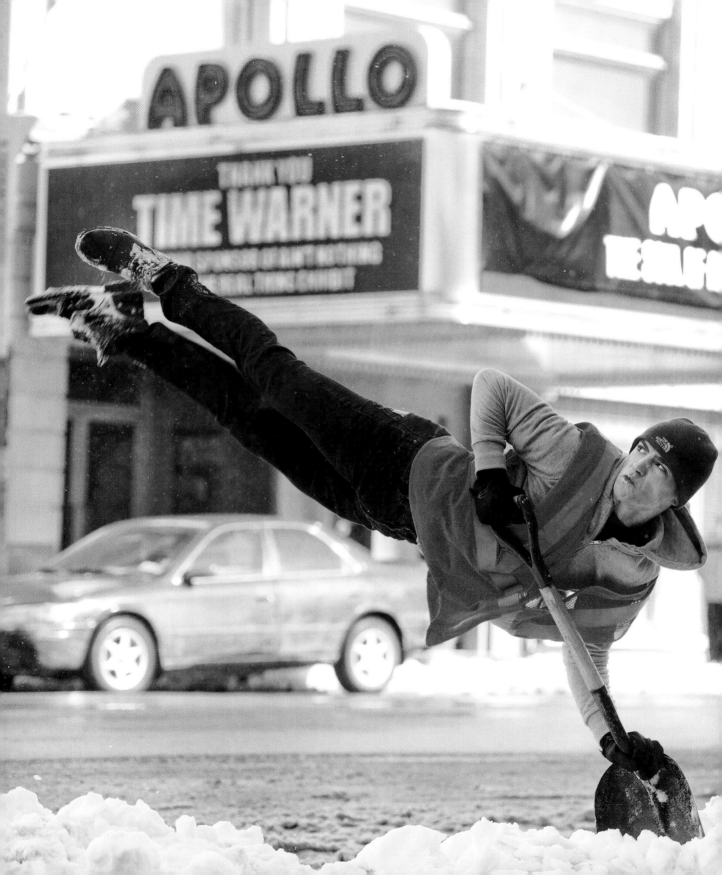

"It is wonderful how much may be done if we are always doing."

THOMAS JEFFERSON

Men at Work
Michael McBride
New York, New York

Transfer
Jeffrey Smith
New York, New York

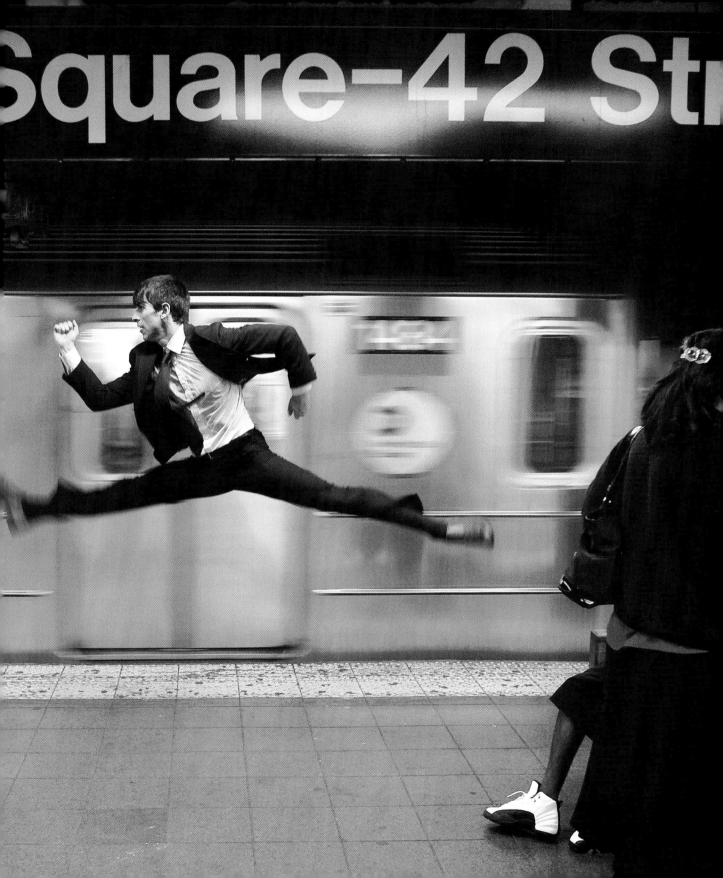

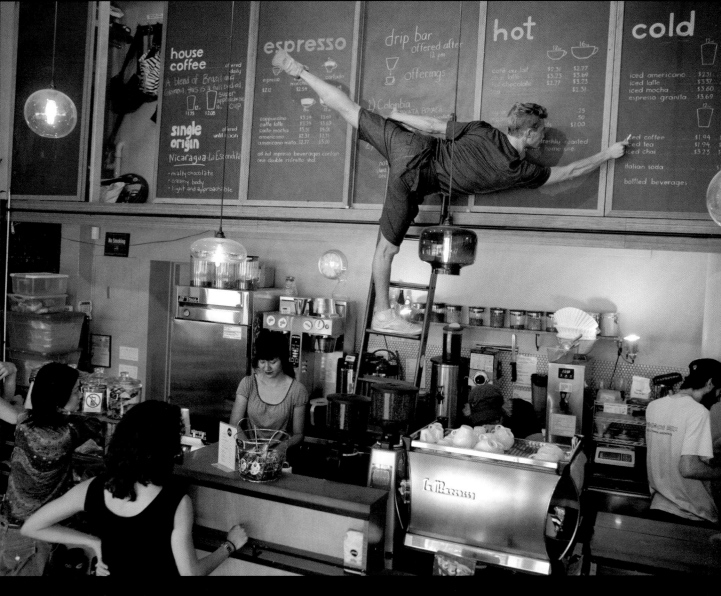

Today's Special
Kile Hotchkiss
New York, New York

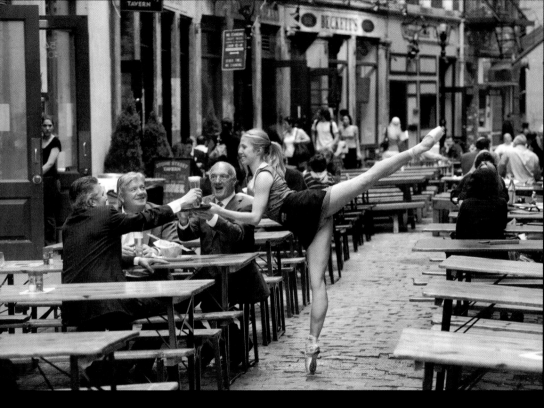

Happy Hour
Michelle Joy
New York, New York

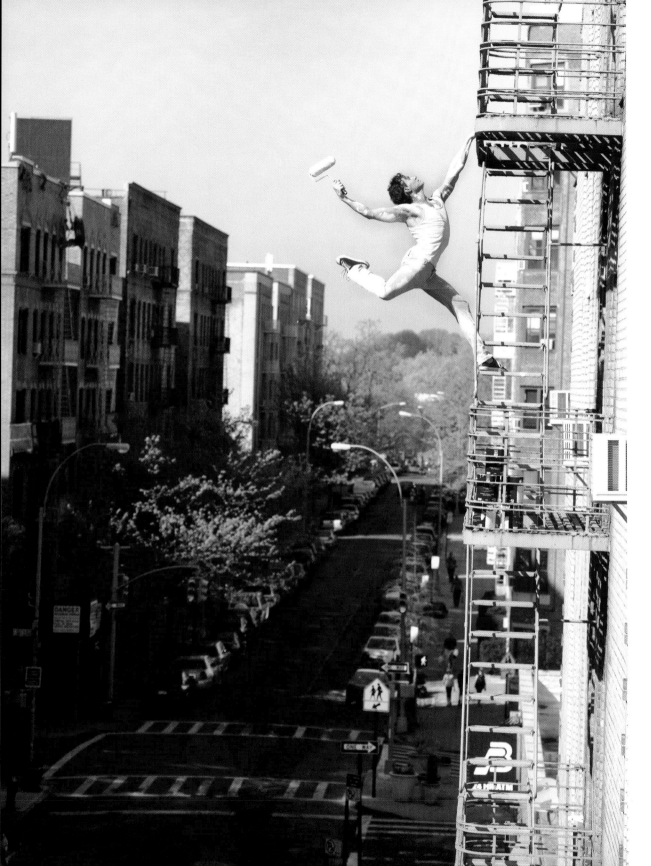

"Life begins at the end of your comfort zone."

NEALE DONALD WALSCH

High Roller
Luke McCollum
New York, New York

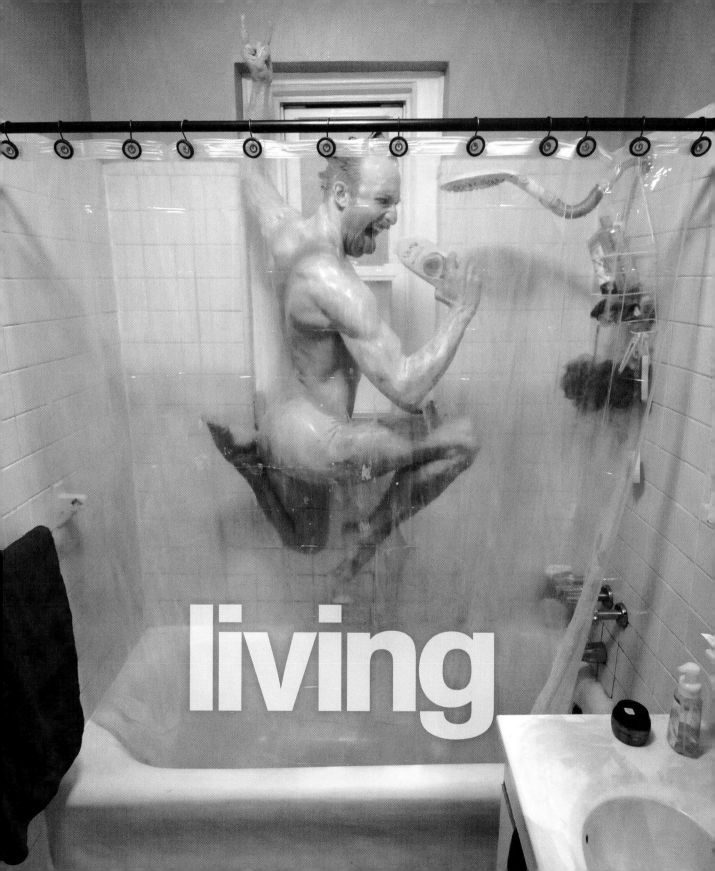

living

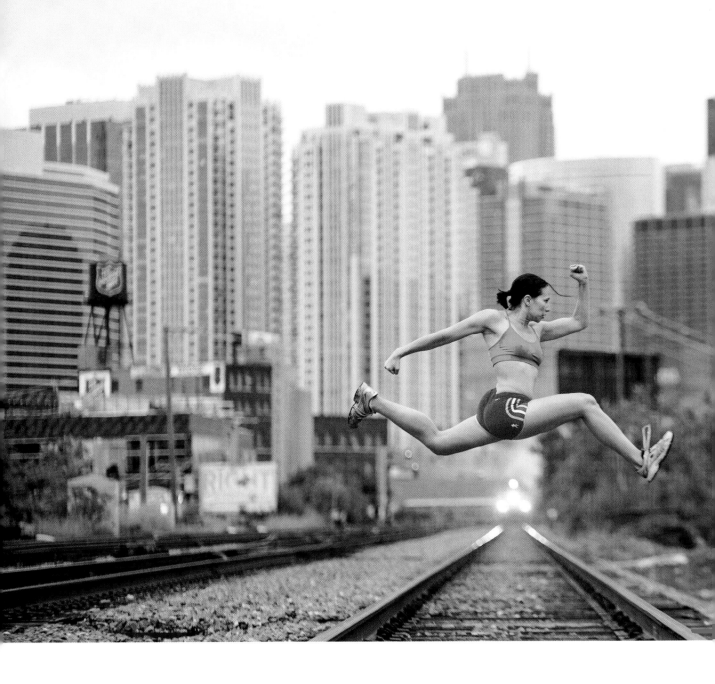

S OMETIMES YOUR ENTIRE PERSPECTIVE CAN shift with a single word, especially when it's uttered by a two-year-old.

"Ah-veen-tuhr!"

Mommy was running errands, so I was without my translator.

"What's that, Salish? What do you need?"

"Ah-veen-tuhr, Daa-dee!" she implored, tugging on my shirt.

Hudson looked up from his fire truck. "She wants to go on an adventure."

"Yah, yah, yah," she squealed, jumping up and down. "Ah-veen-tuhr, ah-veen-tuhr."

The three of us left the house and strolled into

Training
Erin Clyne
Chicago, Illinois

town, looking for adventures. When I began to get bored with the pace of our search, I reached into my pocket and realized I had forgotten both my iPhone *and* my wallet. Tragic! I was minus my favorite distractions—email and coffee shops.

We moved along slowly. They meandered while I paced. They explored while I fidgeted. We had nowhere to go, but I couldn't help longing for a destination.

A woman approached, clearly delighted with Salish. "Hi there, you little cutie." Salish stopped in her tracks. She looked the woman right in the eyes, pointed at me, and exclaimed, "*My* daa-dee!" Then she grabbed my leg and smiled. "Sit down, Daa-dee," she said. "Sit down."

And then it hit me: *This* was my destination. It was right in front of me, wearing a pink dress and a ponytail, beaming up at me. I had become so preoccupied with trying to do everything that I wasn't truly experiencing anything. I was suddenly filled with both joy and regret—joy for this wonderful gift I had received, and regret for having taken so long to open it.

Sooner or later we all feel the hand of time pulling us forward, and we start racing to get it all in. What begins as a light jog quickly becomes a sprint. Yet the faster we run, the less we see. I've been sprinting for about ten years, gathering some big treasures but sacrificing many little gems along the way. I want to start celebrating the gems—those moments I overlook in my rush to get to the prize that I *think* is waiting around the corner. If it happens to be there, it can wait. ❖

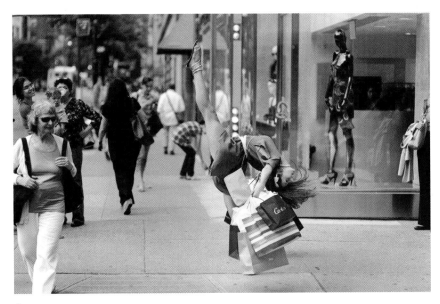

Spree
Arianna Bickle
New York, New York

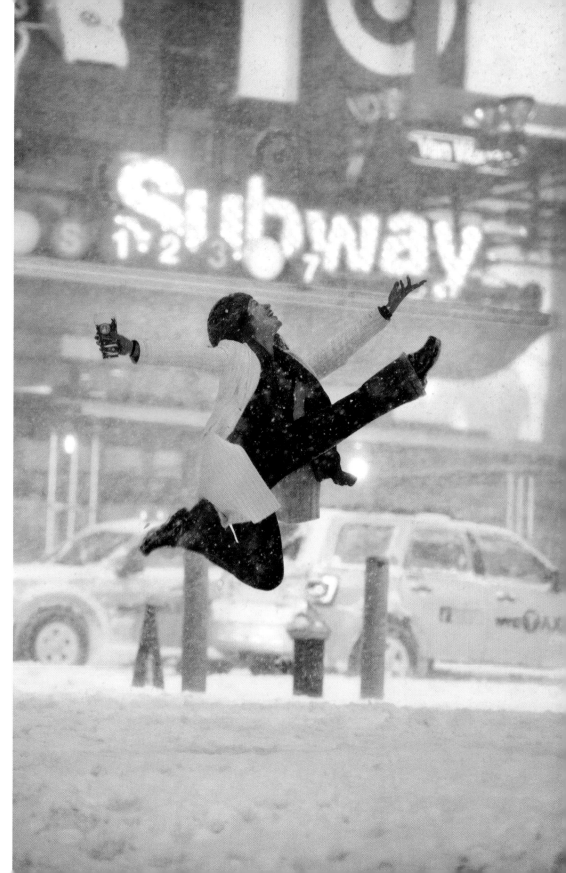

First Snowfall
Jennifer Jones
New York, New York

Stalled
Marielis Garcia, Anna Woolf
New York, New York

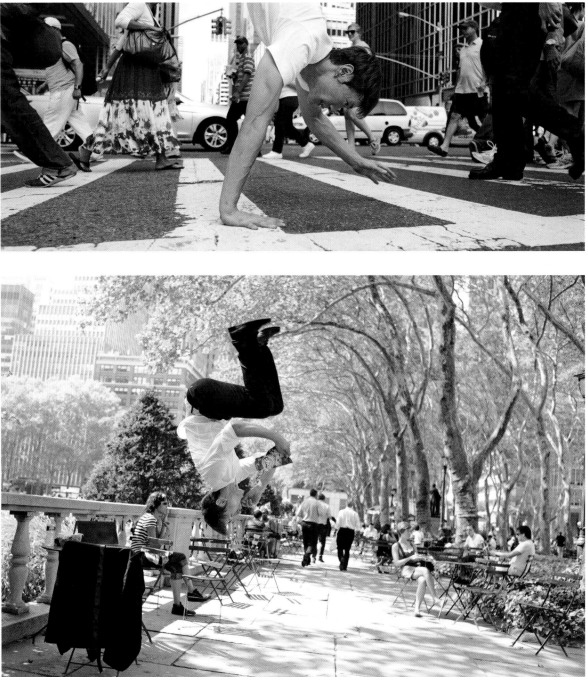

Crosswalk
B-boy Gentl Minsung Kim
New York, New York

<div align="right">

Park It
B-boy Gentl Minsung Kim
New York, New York

</div>

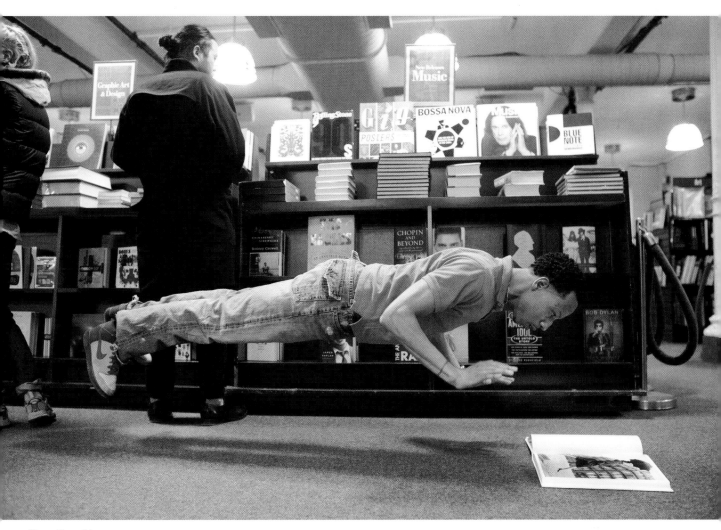

Reading Up
Durell Comedy
New York, New York

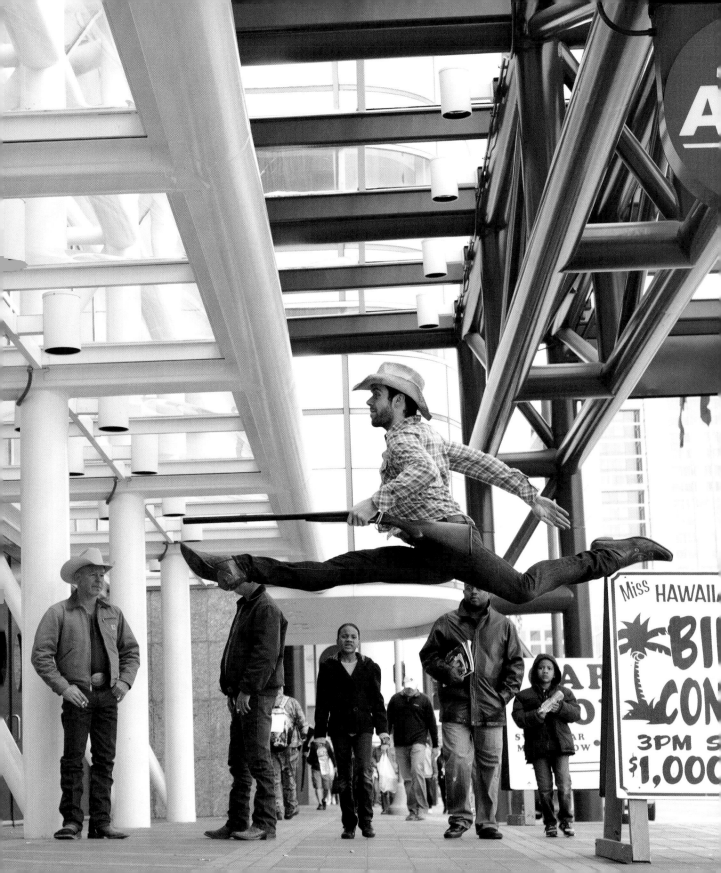

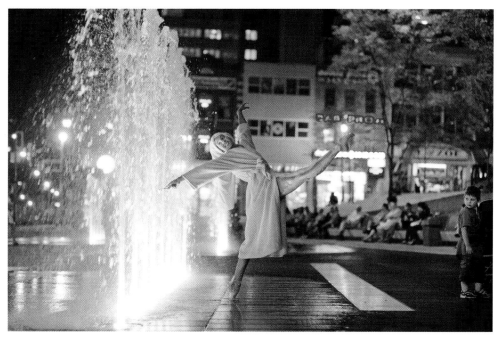

Close Shave
Alyssa Desamais
Montreal, Canada

Gotta Get Out of This Town
Skylar Brandt
New York, New York

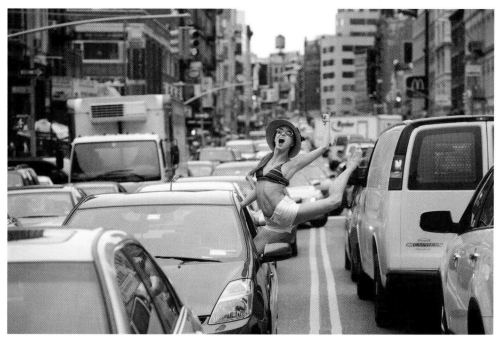

Go West
Connor Walsh
Houston, Texas

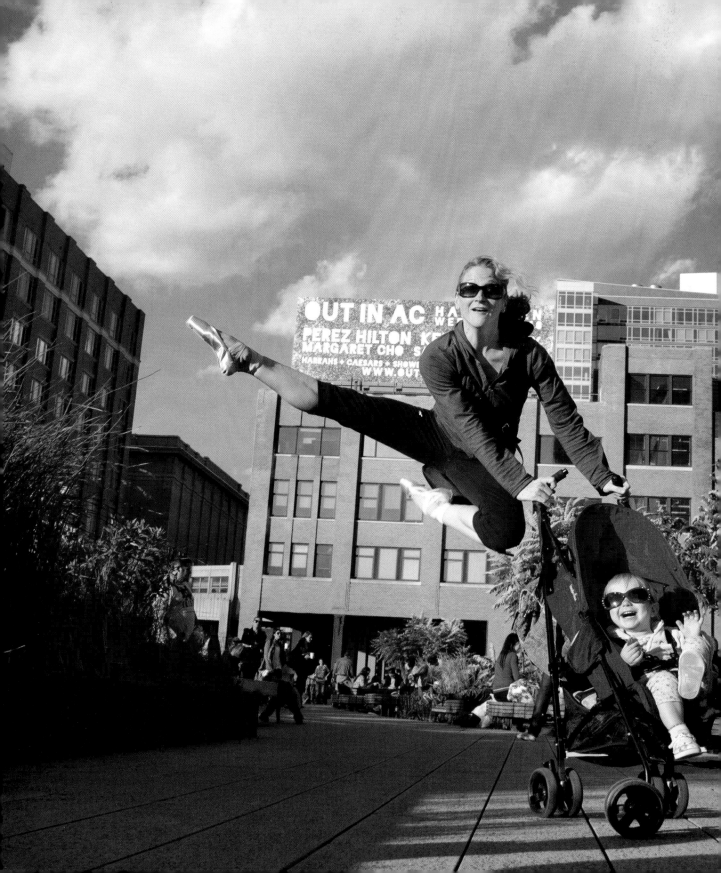

Stroller Boogie
Karin Wentz, with
her daughter
New York, New York

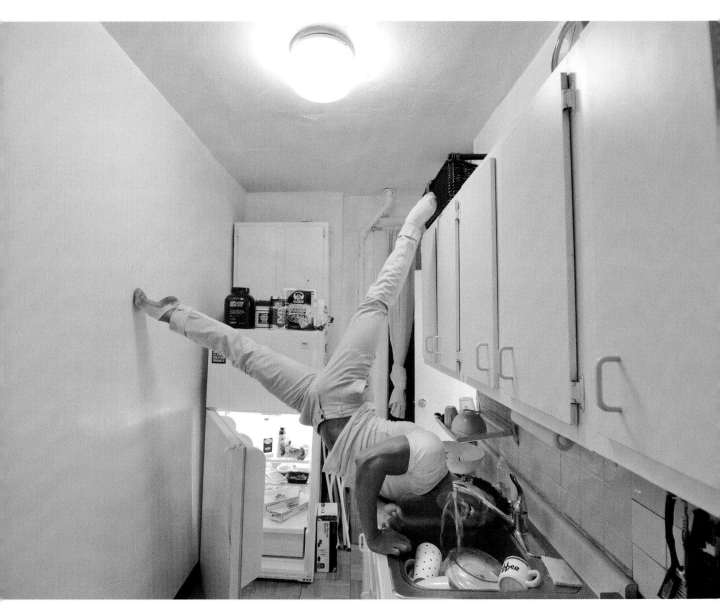

No Clean Glasses

Alex Wong

New York, New York

"Wisdom is ofttimes nearer when we stoop
Than when we soar."

WILLIAM WORDSWORTH

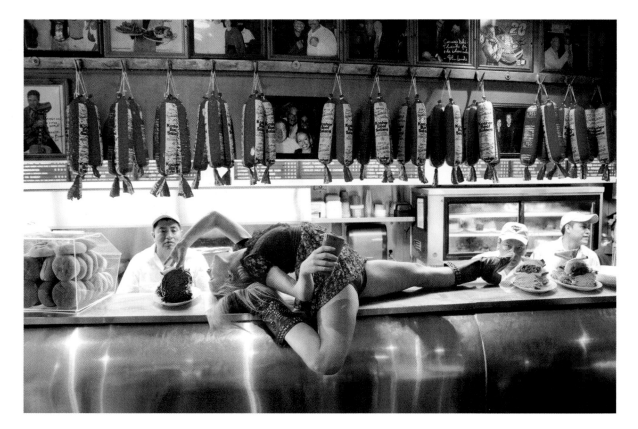

Counter Balance
Tenealle Farragher
New York, New York

"When I make a mistake, it's a beaut."

FIORELLO LA GUARDIA

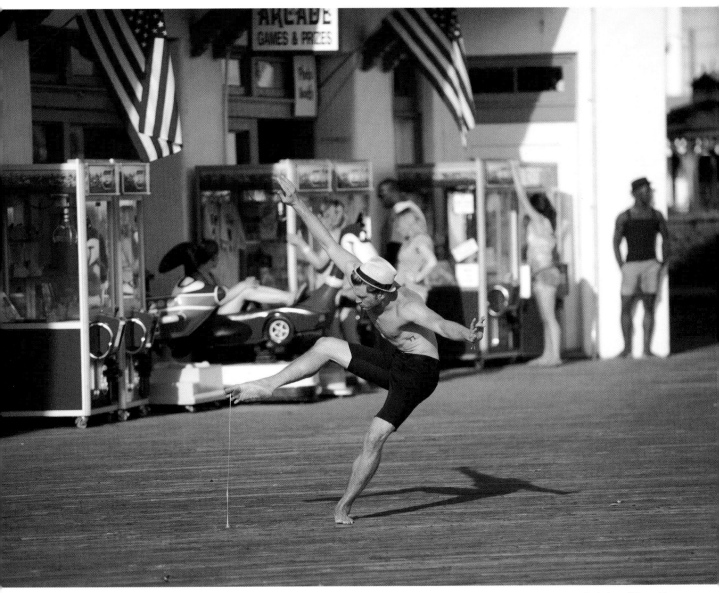

Sticky Situation
Eric Bourne
Rye, New York

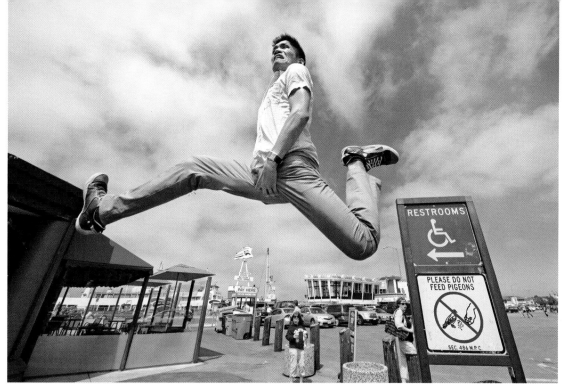

Nature Calls
Dudley Flores
San Francisco, California

Bumpy Ride
Allison Jones, Geoff Legg
New York, New York

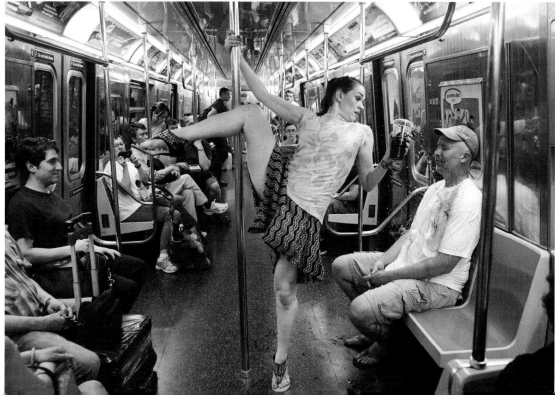

Head Over Heels
Aisha Mitchell
Nyack, New York

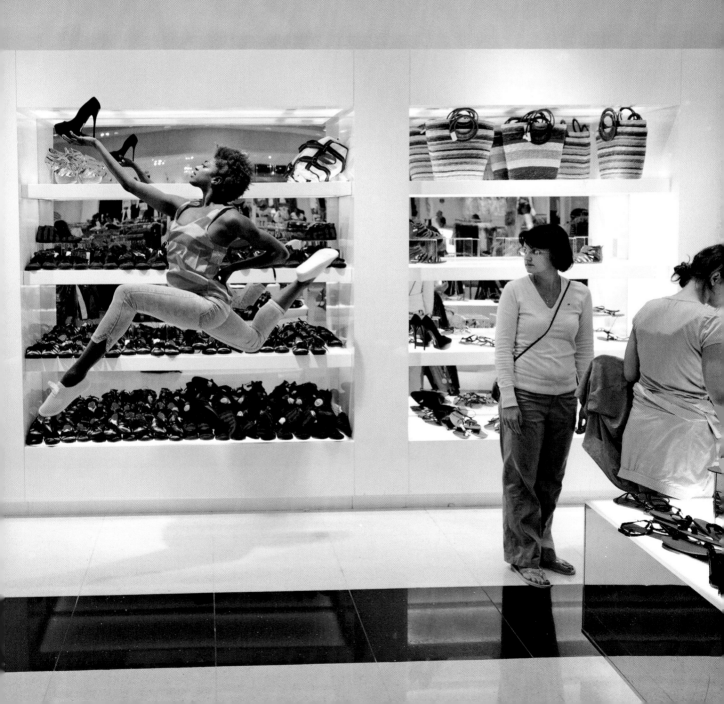

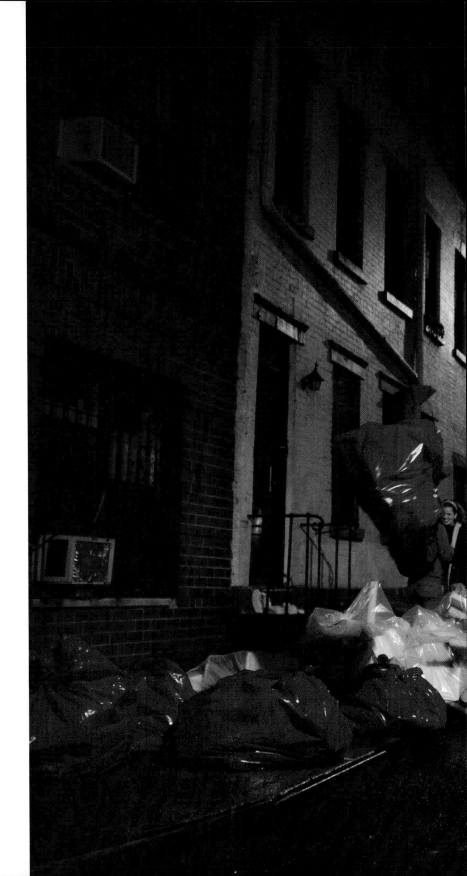

Garbage Night
Alex Wong
New York, New York

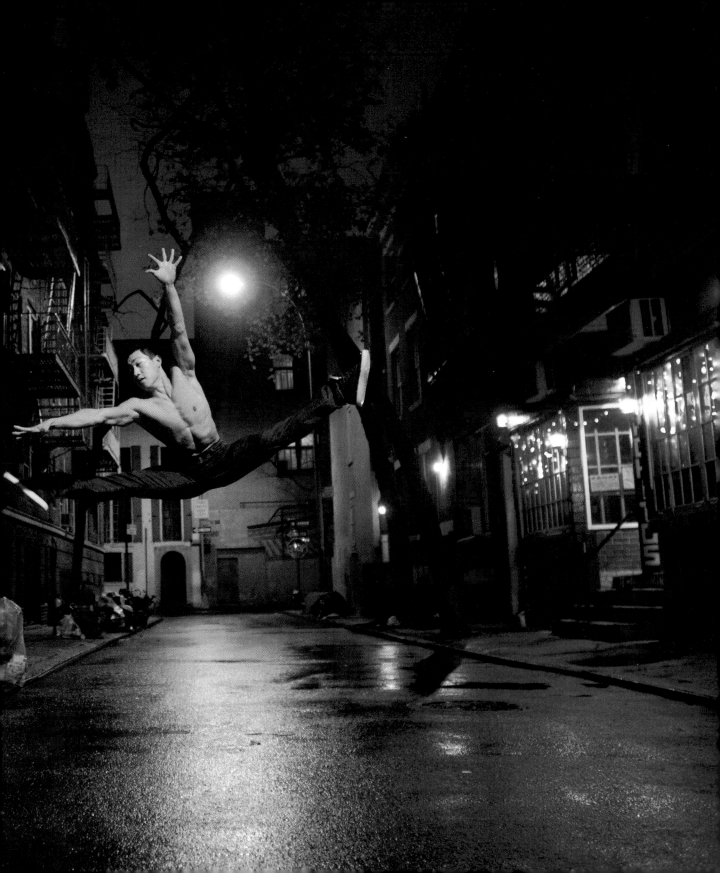

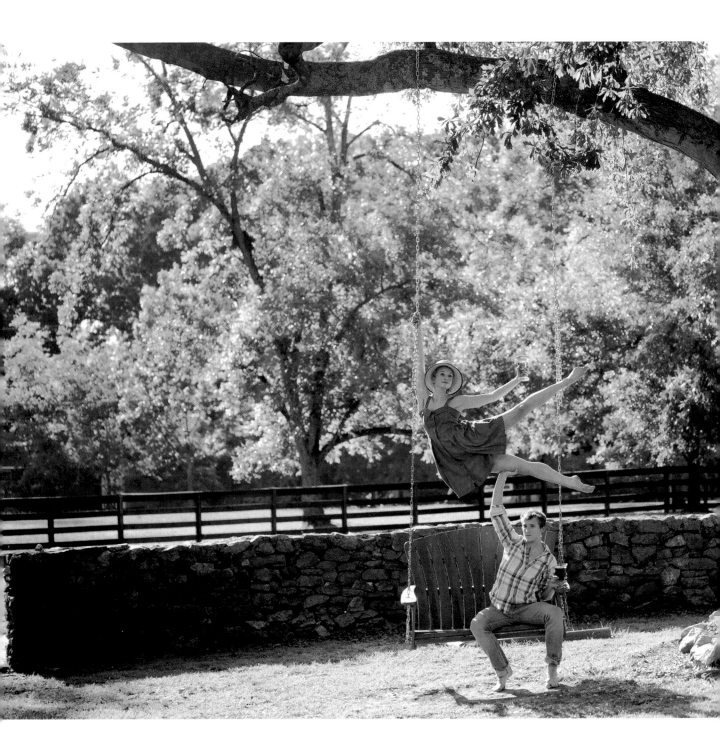

"*Happiness is full of strife.*"

JEAN ANOUILH

Alone Together
Claire Stallman, Jacob Bush
Madison, Georgia

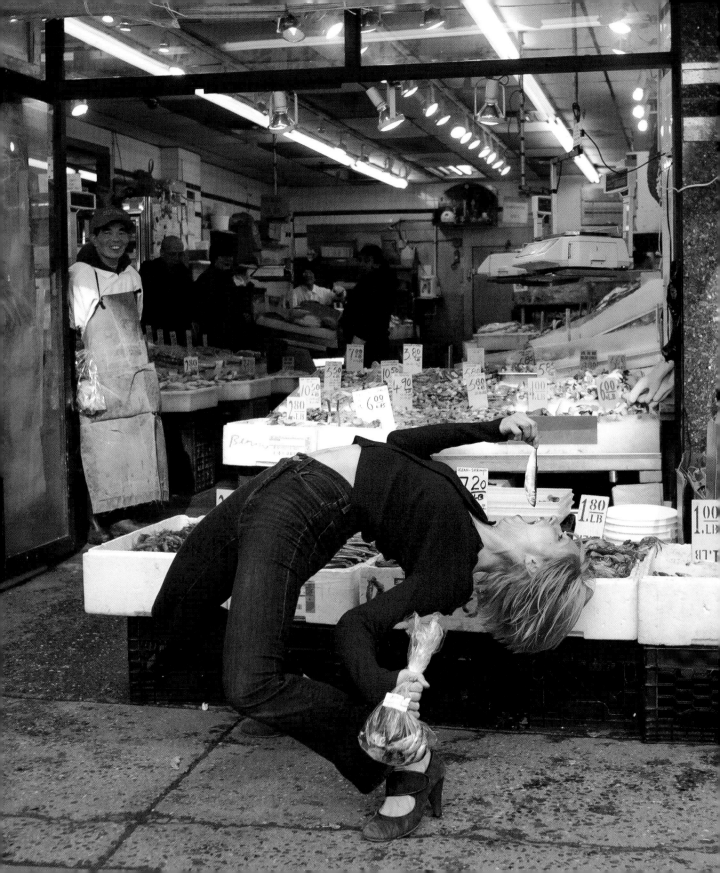

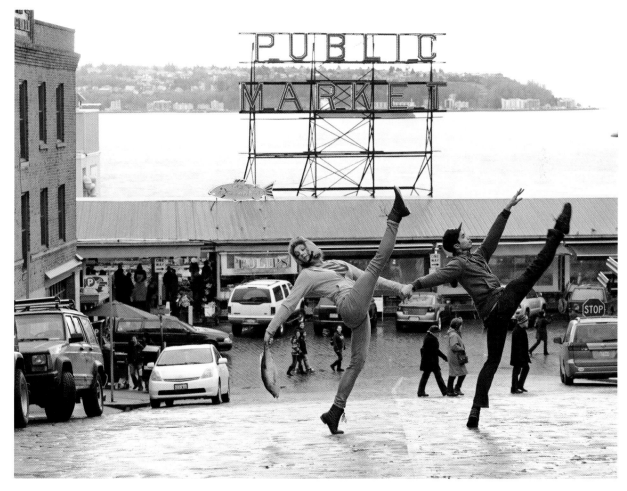

Dinner for Two
Sarah Pasch, Eric Hipolito Jr.
Seattle, Washington

Sushi
Heather Lang
New York, New York

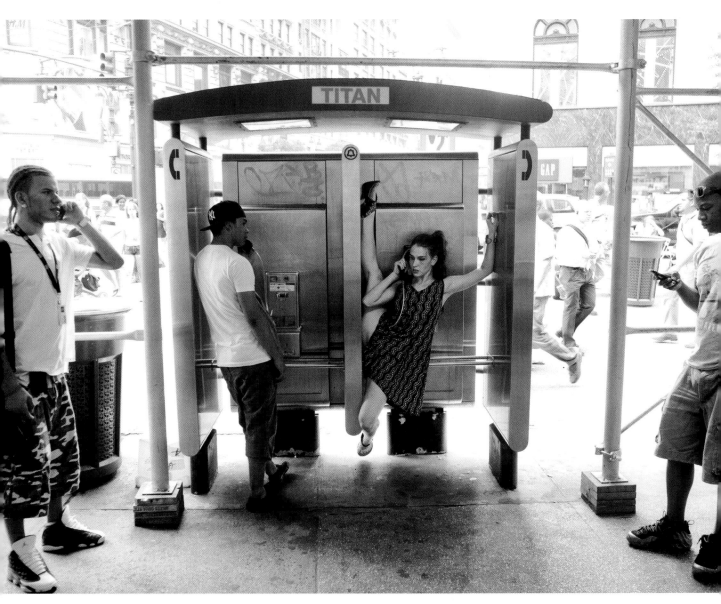

Smooth Operator
Allison Jones
New York, New York

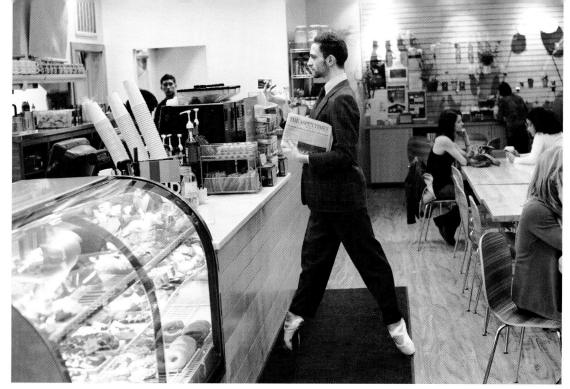

Morning Routine
Paul Busch

Aspen, Colorado

Sweet Reward
Isaac Mennite, Melody Mennite

Houston, Texas

"The only way to have a friend is to be one."

RALPH WALDO EMERSON

Friends
Bebe Neuwirth
Chatham, New York

Book Worm
Casia Vengoechea
New York, New York

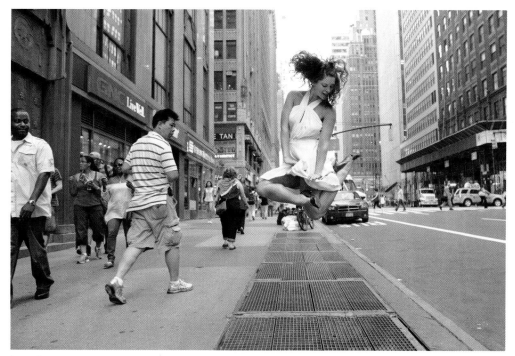

Iconic
Jennifer Jones
New York, New York

Sneaking a Peek
Christopher Perricelli
Chicago, Illinois

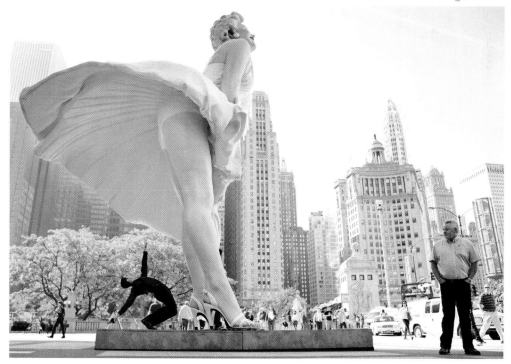

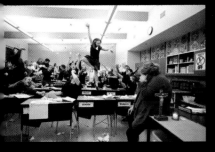
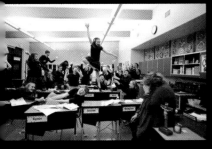
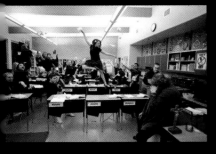

Substitute Teacher
Claire Conaty
Edmonds, Washington

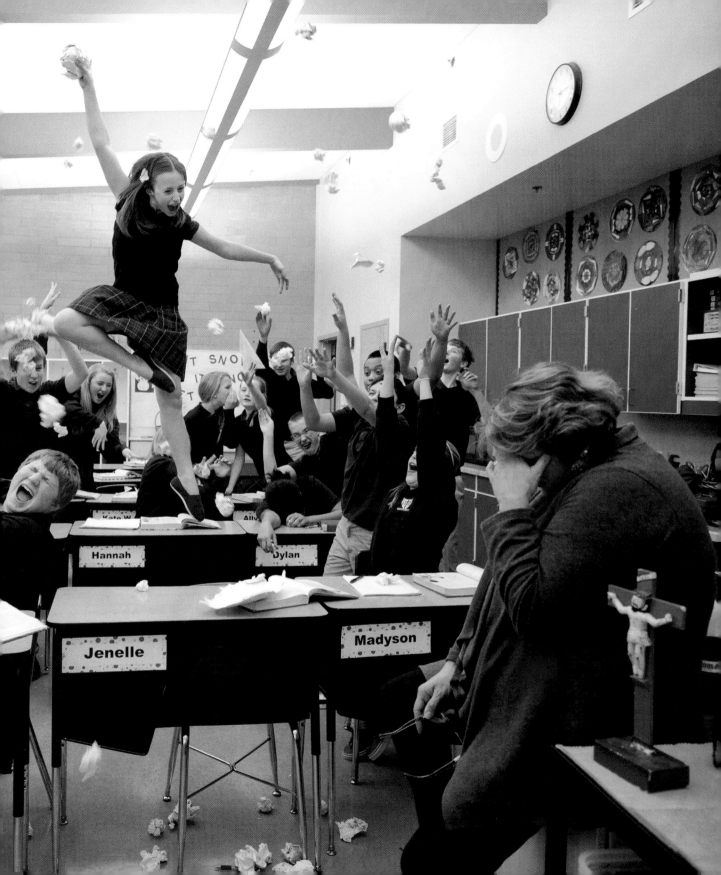

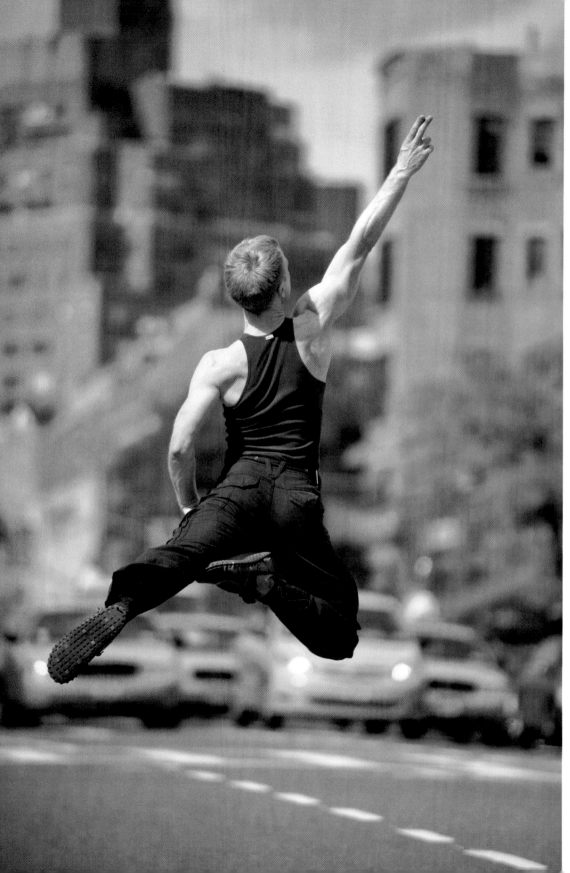

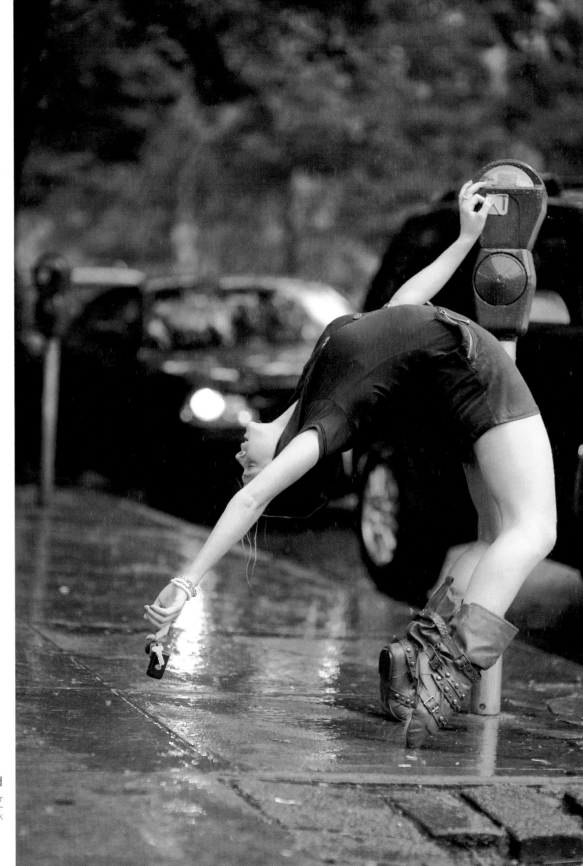

Meter Maid
Tenealle Farragher
New York, New York

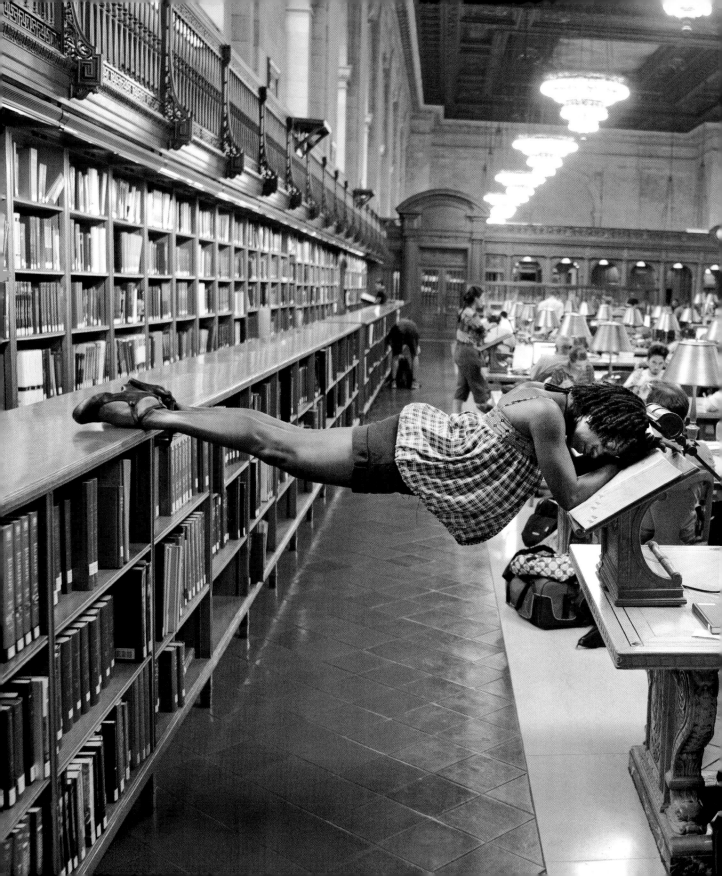

Cram Session
Michelle Fleet
New York, New York

"They have only stepped back in order to leap farther."

MICHEL DE MONTAIGNE

Joy
Evan Ruggiero
New York, New York

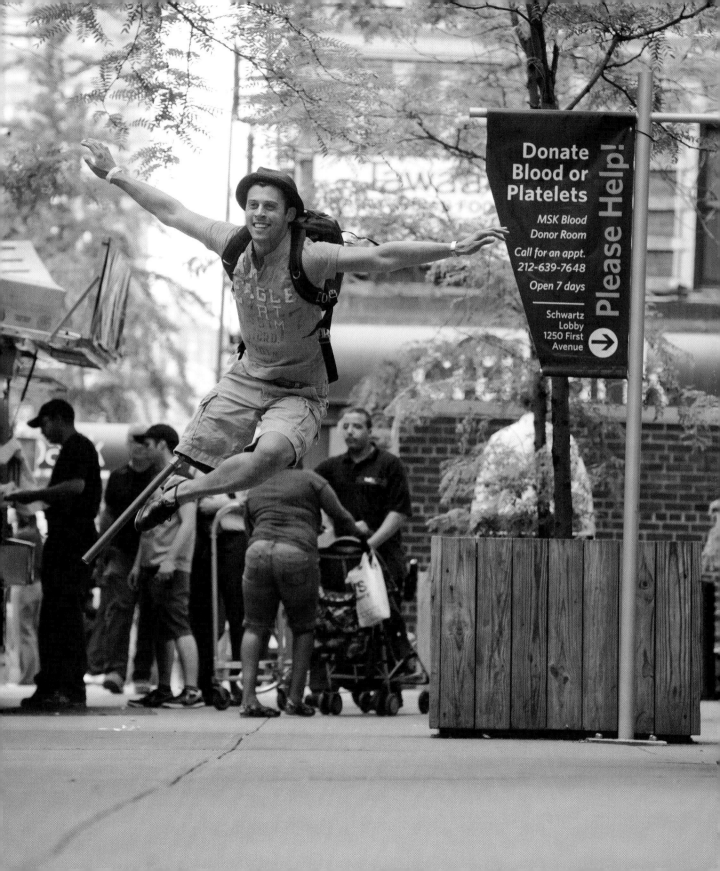

Donate
Blood or
Platelets

MSK Blood
Donor Room
Call for an appt.
212-639-7648

Open 7 days

Schwartz
Lobby
1250 First
Avenue

Please Help!

The Artist
Jordan Matter
New York, New York

Samantha Siegel

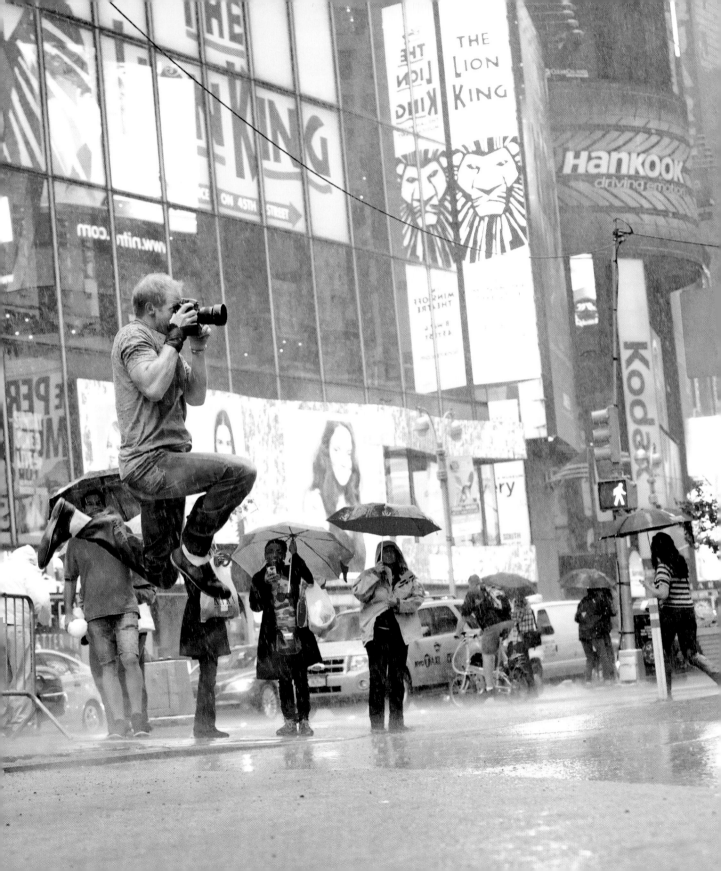

about the photographs

People often ask me how I got a particular shot—especially those featuring a spectacular location or an incredible pose. A lot of work went into each and every one of these photographs, and sometimes getting the shot was a real adventure. Here are some of my favorite stories from behind the scenes of *Dancers Among Us*.

the cover

Raindancer I photographed Paul Taylor Dance Company star Annmaria Mazzini prior to this shoot, but she had emailed me asking for another opportunity. I thought she had done great the first time, but she was insistent. "I can do better," she wrote. She certainly did! I knew a storm was coming and chose the exterior of Macy's as our location. In the span of thirty minutes, Annmaria did forty-five running jumps in heels during the downpour. Since this was one of my first shoots, I didn't have enough experience to comprehend the difficulty of jumping in these conditions. Inspiration for this image came from a famous fashion photograph by Richard Avedon.

dreaming

Light as a Cloud (p. 1) How did I get this shot? Jason did a running backflip—the slight blur of his right foot gives it away. I wanted him to levitate between the two trees, so he would look like a reverse hammock. An almost impossible request, but as I learned early on, these dancers are so talented that I'm limited only by my own imagination. Jason is a member of the Parsons Dance company. They are beautiful, strong, and fearless—a perfect combination for my needs. Jason flipped twenty-nine times and we nailed it just once, but that's all we needed.

Taken (pp. 2–3) I landed in Sarasota, Florida, at 2:00 p.m. By 3:30, I was at Siesta Beach, voted "America's #1 Beach" by the people who do that kind of thing. With me were four members of the Sarasota Ballet. Naturally, I had no plan, but a storm was rapidly approaching, giving the sky a dramatic blue hue. Seagulls were everywhere; soon the shot was obvious—let's feed the birds! Within minutes, we had a pose, but we were not expecting the onslaught of ravenous seagulls. It was creepy! My collaborator, Pamela Bob, captured the entire thing on video, which you can see at dancersamongus.com. It's worth checking out, unless you have a bird phobia.

Out on a Limb (pp. 6–7) I usually subscribe to the idea that it's better to ask forgiveness than permission; however, when I saw this majestic tree in someone's front yard, I couldn't bring myself to trespass, so I knocked on the door instead. Turns out, the president of Wellesley College lives there, and this photo now hangs in her home, feet from the tree itself. Sometimes asking for permission pays off.

Prayer (p. 9) When Casia struck the pose, I saw the light shining down on her, and I realized we had something very special, but I had to move fast. People were praying all around us, and the click of the shutter echoed loudly in the quiet of the church. I took only six frames. It's often about timing. Casia was just about to graduate from Juilliard and head off to join Nederlands Dans Theater 2, one of the most prestigious dance companies in the world. I grabbed her when I could; she makes beauty whenever she can.

Double Take (pp. 10–11) I had spent five full days shooting in Chicago, and I was exhausted. In two hours, I was due to board my plane, and I had no ideas left. I would have canceled, but Angela and Demetrius had been waiting all week to shoot. I'm so glad I didn't cancel. This was an extremely difficult shot to get. The crosswalk had to be packed, which only happened for a few seconds every minute. They both had to reach the peak of their jumps at the same moment, without getting blocked by

passersby. I wanted Angela's face to be framed in white and her expression flirtatious, while Demetrius needed to look surprised and thrilled. And we had twenty minutes to shoot.

Rise Above It All (p. 12) Michelle was one of the first Paul Taylor Dance Company members I worked with, and this shot represents the moment I realized that if I could think it, the dancers could probably do it. I asked her to create a pose that looked like she was casually sitting in midair. The most amazing thing about this image is that we took only five frames, and then the people got up and left.

Gonna Fly Now (p. 13) For me, re-creating the famous sunrise moment from *Rocky* meant waking up at 4:00 a.m. For Evgeniya, it meant not sleeping at all. In an hour and twenty minutes, she jumped—get ready for it—200 times. Look at that pose, remind yourself that she had no sleep at all, and then read that number again: 200 times! Evgeniya has been a competitive rhythmic gymnast since she was four years old, so that might explain her stamina.

Opening Night (p. 15) Parisa was one of my first and most committed dancers, but this shot was taken two years after we first worked together. The Paul Taylor Dance Company was moving to Lincoln Center, and they had hired me to shoot their 2012 promotional campaign. I was patiently waiting (not my strong suit!) for a sunset shot when the skies suddenly darkened and rain poured down in buckets. No sunset. Everyone scurried to safety, the shoot interrupted at a critical moment.

I remembered the expression "When life gives you lemons, make lemonade." I looked at Parisa and asked the question, though I already knew the answer.

"Will you dance in the rain?"

She didn't hesitate. "Let's go."

We ran into the downpour. I found a light source and asked her to stand in the spotlight.

"Now throw yourself back and kick your leg up to the sky. Again. Again. Again. Again!"

I heard voices around me. . . .

"She's going to be freezing."

"Have a towel ready as soon as we stop. And something hot to drink."

"She keeps falling down."

"Her leg is cramping."

"PARISA, ARE YOU OKAY?" someone shouted.

She didn't hear it. Or she didn't care. She stopped for a brief second, and then threw her body back again. When it was over, Parisa was the last one out of the rain. She was drenched. And exhausted. And beaming.

Hall of Fame (p. 18) I met Ricky at his apartment in Hollywood at 2:30 a.m., straight off my flight from New York. It was raining and I was haggard, but I couldn't miss an opportunity to photograph a celebrity from *So You Think You Can Dance*. Ricky said he wanted to do something crazy, and I saw the guitar in his living room. "How about lying in the rain in the middle of Hollywood Boulevard?" I asked. The entire shoot lasted nine minutes.

Sunset Salutation (p. 19) "Please shoot this as a silhouette! Please, please, please!!" I was trying to shoot the sunset directly on Jamila, and my friend Ivy Vahanian forced me to look the other way instead. Thank you, Ivy.

Om (pp. 20–21) My wife had suggested a levitating-while-meditating shot long before I took this one. It was a cold, windy day on Venice Beach. I had three dancers and no plan. Fortunately, I remembered her idea.

Surrender (pp. 22–23) Is this pose as unsafe as it looks? Yes, in more ways than one. Not only is Rachel hanging off a cannon at a great height, but we shot in 105-degree weather: That cannon was steaming hot. Just so you don't think I'm completely heartless, I found a very strong man sitting nearby and asked him to hide behind the cannon and hold her left leg. (He crouched in a way to obscure himself from the camera's view.) I entrusted Rachel's life to a complete stranger. Maybe I should take back that "heartless" comment.

Big Day (p. 24) This photograph features a real-life bride, a real-life maid of honor, and real-life parents. I waited two years for a dancer to get married! Thank you to Amsale Salon for allowing us access to their bridal shop during business hours; thank you to my favorite basketball team, the New York Knicks, for sharing your beautiful dancers; and thank you to Jessica for bringing your bridal lingerie—nice touch!

Wildest Dream (p. 25) Seriously, this is Kara's room. It's not a movie set, though it should be. This shot was not easy: She had to jump and immediately flip into this pose without hitting her head on the ceiling, levitate above the Zs while trying to look like she was snoring. She jumped sixty-two times before we got this shot. That glass of wine was not a prop.

Only in Seattle (p. 26) This was the beginning of an amazingly productive day of shooting. In one twenty-four-hour period, the weather changed from rain to bright sunshine to a gorgeous sunset to a record-setting snowstorm, and the prestigious Pacific Northwest Ballet gave me phenomenal dancers for every situation. The dancers and I conceived of this shot over several drinks the evening before, and I awoke the next morning to

pouring rain; it couldn't have been a more perfect setting. Initially, I took this shot without the umbrella, and then as we traveled to our next location I suddenly realized what was missing. We all went back and, as we were shooting, the wind bent the umbrella completely inside out.

My Time of Day (p. 27) This was my first attempt to photograph a dancer outside of New York City. It helps to have friends with beautiful property, especially when they're willing to give me sunrise access. Thank you, Rob.

The Pickup (pp. 30–31) It's hard to believe that this shot is completely spontaneous—the setting is just too picturesque. I was driving around rural Georgia with five dancers from Atlanta Ballet, looking for quintessential Americana. I had my mind set on an auto repair shop at dusk, but we couldn't find one. Ellen Ianelli, from the Madison-Morgan Convention and Visitors Bureau, volunteered her friend's vintage red pickup truck. When we got to the house, nobody knew how to start it. Racing to beat the sunset, we all pushed the truck onto a dirt road and popped the hood. By the time I figured out the pose, it was pretty dark, and the twilight gave the truck a beautiful glow. I managed to get just one image in focus before nightfall made it impossible to keep shooting.

loving

Wet Kiss (p. 33) Michael and Evita are an international swing-dancing sensation, so lining up our schedules proved to be very difficult. We finally found a day to meet at a coffee shop in midtown Manhattan. They had created this pose as a finale to one of their dances. When I saw it on their website, I imagined them in the rain in Times Square. To my great fortune, it was a dreary spring day. The storm lasted about ten minutes, and so did the shoot.

Adam and Eve (pp. 34–35) Rachel drove from DC to Maryland on three occasions to shoot with me. On this warm summer day, she brought her boyfriend, Mitch. My wife grew up in Towson and knew this property well. She suggested a shot of lovers picnicking under a tree. We picked flowers from a field behind the fence, and we discovered the pose relatively easily. Rachel jumped forty-six times, and this was the last shot.

She Said Yes (p. 36) Believe it or not, the idea for this shot was spontaneous. Buckingham Fountain is a famous Chicago landmark, but I had no plan when we arrived. Kathryn Yohe, my Chicago liaison and collaborator, immediately recognized the potential for a fantastic engagement photo. I didn't want it to compete with a similar shot I'd taken in Central Park, but the setup here was just too good to resist. Unfortunately, we didn't have a ring (one of the drawbacks to an impulsive process: I rarely have the right props handy). Carrie and Ricky had been dating for years, but she didn't (yet!) have a ring we could borrow. It was early in the morning and no stores were open, yet Kathryn disappeared and miraculously returned thirty minutes later with a box and ring. Since she had the idea for the shot and found the prop, was there anything left for her to do? Indeed: When a guard discovered us in the roped-off area in front of the fountain, Kathryn charmed him into allowing us to stay long enough to get this shot. Carrie jumped more than a hundred times before we stopped, and her enthusiasm never waned.

Quality Time (p. 37) Jorge is a world-renowned tango choreographer and dancer who travels endlessly for work. He came directly to Washington Square Park after flying all night, and he brought his beautiful family with him. We had met once before when I shot Chino's promotional photos, and I had been hoping desperately to photograph them all together—including their kids, Faline and Tao. Hours after this photo was taken, Jorge got on another flight. They shared some of their short time together with me, and for that I am very grateful.

Under the Boardwalk (pp. 38–39) Real-life couple Jacob and Jill came up with this pose in about three minutes. It makes me wonder if they actually kiss this way. This shoot was very sentimental for me: I lived in Los Angeles for several years as a teenager, and I spent lots of time under similar boardwalks. The way I remember it, my body looked just like Jacob's.

I Left My Heart in San Francisco (pp. 40–41) On my last night in San Francisco, I met several dancers for some evening photos. I had missed my opportunity to shoot the Golden Gate Bridge, and this beautiful giant heart by Jeremy Sutton seemed like a golden opportunity. I spent an hour trying to position Oliver and Jamielyn at every point around the heart before one of the other dancers said, "Why don't you just put them behind it?" Eight minutes later we had the shot.

My True Love Gave to Me (p. 42), Chivalry Lives (p. 43), and Keep Me Warm (p. 43) "Chivalry Lives" displays the frigid conditions the dancers suffered through for this shoot, but it was actually the warmest of the three days featured on these pages. The temperatures were so brutal that all the shoots lasted less than ten minutes, with "My True Love Gave to Me" taking only twenty-five seconds. Nicholas and Vanessa are with Ballet Hispanico, Leah with the Metropolitan Opera, Dario with Parsons Dance, Michael with Alvin Ailey American Dance Theater, and Ellenore was on So You Think You Can Dance—not exactly novices freezing their buns off for art.

Getaway (p. 45) Here's a good rule of thumb for anyone who wants to take a photograph in a famous hotel lobby without permission: Do *not* show your hand until the final moment. In this case, I made the rookie mistake of revealing my camera as I entered the Plaza Hotel. I was immediately approached by security; so much for my dreams of a chandelier-bedazzled staircase shot. The guard did inform me that I was free to shoot outside the building, which turned out to be a much better location anyway. As Alexander Graham Bell said, "When one door closes, another door opens."

Mama's Boy (pp. 46–47) I met Sun at the train station in DC the day before New Year's Eve 2011. Surprisingly, his mother, Hongxia Liu, was with him, and they were both wearing orange—irresistibly cute. I suggested a shot of Mom pulling her grown-up son across the street like a little boy on his way to a doctor's appointment. Sun dances with the Washington Ballet, so my expectations were high, but I still couldn't believe the pose he came up with. As you can see from the outtakes, we got this perfect positioning only one time.

And Don't Come Back! (pp. 48–49) I have two children, and I would never say that one is my favorite; I love them equally. That's how I feel about the photographs in this book as well: They are all my babies, and I love them equally. *But* I have a special place in my heart for this image, and I love it just a little bit more—not because it's better, but because it was a pure gift of serendipity.

I planned to meet several dancers at the Golden Gate Bridge to start a long day of shooting, but at the last moment I changed the location to the Painted Ladies, a famous row of Victorian homes overlooking the San Francisco skyline. I have no idea why I did that—that location hadn't even been on my radar.

I set up my first shot in a park adjacent to the houses. For the scenario, I borrowed a dog and tennis ball from a nice man named George whom I met in the park. After we finished shooting, I asked him where he lived. Turned out he owns the blue Painted Lady, and he agreed to let us shoot inside his famous home. I was stumped for a concept, but fortunately Kaitlin came up with the spectacular idea of a woman kicking her boyfriend out of the house.

The scenario was great in the abstract, but very difficult to achieve. Kaitlin and Brendan had to nail their poses and expressions while the clothing stayed bunched together, flying directly at Brendan's head. We tried it many times, but it was feeling impossible. Also, the window was a dead spot, and the shot was missing an element of humor. I asked George if I could borrow his dog again. Somehow he got the dog to sit on the window seat, from where he glanced at Brendan for exactly three

seconds. In that moment everything in the photograph came together perfectly. We got one frame. You can see why this is my favorite—just don't tell the others.

Uh-uh (p. 50) I was in Miami for a corporate shoot at the Fontainebleau Hotel, and Parsons Dance was coincidentally in Miami as well. How lucky for me! They were available for only one evening, and we used the hotel grounds for all the shots. This boardwalk leads from the swimming pool to the beach, and it looked so romantic that it was the perfect setting for a shot of unrequited love.

The Last Straw (p. 51) Paul Taylor dancers Annmaria and Robert had been dating for several years when I took this photo at Fish Restaurant. They were very happy with the image, saying it was a perfect representation of their relationship. They broke up six months later.

Off Your Feet (p. 52) This is another of my wife's many great ideas, shot in the famously gay Castro District of San Francisco. I love how the dancers' soft, sweet kiss is juxtaposed with the edgier signs around them. Once I decided on this spot, the shoot took us about an hour, so we put on quite a show.

Moonlight Sonata (p. 55) As I was setting up the shot that became "Uh-uh," the clouds suddenly cleared and we all saw this beautiful full moon. The lights on the boardwalk illuminated the beach below, but focusing was still very difficult. It was much darker than it looks. Fortunately, Eric and Christina were able to hold very still as I struggled with the sharpness.

Cutting In (p. 56) Taken in the famous Bleau Bar at the Fontainebleau Hotel, this was another image from my evening with Parsons Dance. I had the idea of a drunk woman passed out on her date's arm while he explores his options, and Sarah had the perfect pose and outfit to complete the story. Beautiful people tend to attract other beautiful people, so it wasn't difficult for us to find Sarah's partners in the photo.

3 a.m. in Vegas (pp. 56–57) I spent a long day shooting in San Francisco, then hopped on a plane for an overnight adventure in Las Vegas. I've found that adrenaline mixed with a near deadly dose of caffeine can get me through anything. Even though this shot was taken at 3:00 a.m., it wasn't even our last location for the night. We drove all over the Strip, and there was no shortage of locations for this particular scenario. You may recognize the flowers from the shoot in San Francisco's Castro District earlier in the day, although the streetlights have rendered them a different color.

Hello, Sailor (p. 60) During the annual Fleet Week, thousands of sailors descend upon Manhattan; their presence makes

the Memorial Day holiday all the more special. With Alfred Eisenstaedt's iconic V-J Day photo in our minds, Eran and I tried this pose with several different sailors until we spotted this gentleman and ran to catch up with him. He was apprehensive at first, but the enthusiastic support of his girlfriend saved the day.

Stepping Out with My Baby (p. 61) Carmen and Gus are revered in the dance and theater worlds, and I felt more than a little lucky to have an opportunity to work with them. But Carmen was performing eight shows a week on Broadway in *A Streetcar Named Desire*, so she had limited time and energy for the shoot. And Gus was recovering from back surgery and walking with a cane. Backflips seemed unlikely, but an elegant and intimate pose was my goal.

They graciously agreed to meet an hour before Carmen's call time at the theater. After a couple of failed ideas took up most of our time, I found myself with just ten minutes remaining. The expression "stop and smell the roses" popped into my head, and an idea suddenly came to me: I would use the blur of activity that defines Manhattan to underscore the beauty of a simple embrace. I set my camera's shutter speed at 1/25 of a second to achieve the motion blur. During the brief shoot, more people stopped and commented on them than on any other dancers I had photographed over the years.

S.W.A.K. (pp. 62–63) After many months of shooting had frequently separated me from my family, I was looking forward to a stress-free ski vacation in Colorado. Or was I? By spring 2012, I was addicted to the excitement of shooting *Dancers Among Us*, and I couldn't resist the urge to find dancers everywhere I went—even in a small community like Steamboat Springs. I posted about the trip on my website and, to my great surprise, four terrific dancers from Colorado Springs offered to travel the long distance to work with me.

Once they arrived, we all went for a drive to find our first location. We took a wrong turn and discovered this stunning landscape. The property was part of a huge, beautiful ranch, and the owner generously allowed us access to the top of his mailbox (and later to his entire ranch). As if on cue, the cows stood up and started grazing. Twenty minutes later, they were all clustered and lying down, but we had gotten the shot.

playing

Cool (p. 65) Eran is one of my original Paul Taylor dancers. She called me to say the fire hydrant by her apartment was turned on, and people were playing in the water. I arrived right behind the police. I begged them for thirty seconds before they shut it off. They took my request literally—I got four shots, and this was the last one.

Slam Dunk (p. 69) FaTye's life story is inspiring: Raised in the NYC foster care system, he discovered a talent for performing after he was heard singing in the high school hallway; he was finally taken in by a loving family when he was sixteen. His enduring spirit lives in this photograph.

A Good Catch (p. 72) This was fun! To see how we got this shot, watch Travis Francis's video at dancersamongus.com. I'll give you a hint: Eric and Lloyd dance with two of the best modern dance companies on the planet (Martha Graham and Parsons Dance, respectively), and they played a very active role in Dayla's levitation.

Swing for the Fences (p. 73) Coaching T-ball has its advantages, not the least of which is giving my son, Hudson, a cameo appearance as the catcher. At six years old, Lucia is the youngest dancer featured in this book.

Fetching (pp. 74–75) 5:15 a.m.: SWEET JESUS, YOU'D BETTER BE AWAKE. My Chicago collaborator and tour guide, Kathryn Yohe, is meeting me downtown at 5:30 a.m., and her text says it all. We're doing a sunrise photo with Jessica Deahr of Chicago Dance Crash. The idea is called "Walk of Shame." We meet near a bunch of bars.

I immediately don't like the location. Maybe I should have done some preproduction. The clock is ticking. Sunrise is scheduled for 6:46 a.m.

"Is Lake Michigan nearby?" I ask.

"Four blocks to the east."

I decide to abandon the walk-of-shame idea, and get a sunrise shot on the lake instead. I have less than an hour to figure out exactly what that shot will be.

6:03 a.m.: We arrive to magical light on the lake. The cityscape is breathtaking, and I have no idea what to do. How do I find a pose that equals the beauty of this moment? We still don't have our dancer—she is looking for parking. I really should have done some preproduction.

6:14 a.m.: Jessica arrives. In a frantic effort to create a scenario, I borrow someone's coffee cup. She strikes a pose and is immediately swallowed up by the cityscape behind her.

6:16 a.m.: I consider settling for a beautiful pose next to the lake instead. I hate the idea, because it's just so obvious and it has been done a million times already. Why, oh why, didn't I do a little preproduction?

6:21 a.m.: Is that a dog in the water? Kathryn runs over to the owner and works her persuasive magic. The dog's name is Cooper. We decide on a game of fetch. This just might work.

6:26 a.m.: Jessica is terrified of big dogs and keeps dropping the stick in sheer terror. Eventually, she warms to him a little,

and we shoot for twenty straight minutes (except when Cooper is running around in circles or chasing other dogs—tick tock, Cooper!).

Now if only Cooper would stop and look at her.

6:48 a.m.: Bingo! It happens only once but we get the shot. Cooper stands up, ready to fetch. He looks right at Jessica. She nails the pose, the stick in perfect line with her leg. A sailboat magically appears on the horizon. The gathering clouds are illuminated with a predawn glow.

Preproduction is for sissies.

Les Bons Temps (p. 81) Rebecca drove ten hours with her family to volunteer for *Dancers Among Us*, and she came adorned with festive accessories. This was my first experience with Mardi Gras, and it was filled with photographic opportunities. I settled on this scenario as a way to highlight Rebecca's impressive back bend, and I asked her father if he could carry her—I didn't think he would want to outsource that job.

Doo-Wop (p. 85) Bill is a celebrated actor, dancer, and performance artist, and the greatest vaudeville clown of his generation. I was thrilled to work with him. Given his easily recognizable face, we had to shoot quickly. In four minutes, I took more than a hundred shots as Bill improvised a classic vaudeville dance. Later, he dressed as a circus clown and walked through the mall. I wish I could have included those photos as well!

Swing Dance (pp. 86–87) I thought this would be a relatively easy image to get, but we had to shoot 237 frames before I was satisfied. Abby kept twisting in the wind, so the angle was never right. Her hands were raw and red by the end, but you can't see any discomfort in her expression.

Brass Ring (pp. 88–89) This was my first experience with a very wide-angle lens, which I borrowed spontaneously from a local photographer. The blur is not created by Photoshop—I was panning the camera along with the carousel. Not exactly easy: I took a hundred shots and got ten in focus.

Caffeine High (p. 90) I was shooting head shots for Xiomara when we stopped to get an iced coffee near my studio. When I saw the enormous drinks available for purchase, the image of a dancer in the throes of over-caffeinated bliss popped into my head. Fortunately, Xiomara is an amazing dancer, and she was wearing the hot-pink shirt and shoelaces, which just happened to match the sign perfectly. The unexpected element came when a little girl, wearing the exact same shade of pink, walked into the frame and looked right at Xiomara just when she hit the peak of her jump.

Diamonds Are a Girl's Best Friend (p. 91) Parisa attempted nine standing jumps on crowded bleachers in just one minute of shooting. This is Yankee Stadium—I'm surprised we even got that many chances.

VIP Treatment (pp. 92–93) I had been trying for months to make this shot happen. It all centered on Marcella; she often flies by helicopter to the Hamptons, so she made a few calls. Late the night before the shoot, we got the thumbs-up: HeliFlite would generously loan us a helicopter . . . for twenty minutes! If we went over, we'd have to pay a $10,000 rental fee. *Gulp!*

A few more details to keep in mind: We couldn't control the direction the helicopter would be facing; that was up to the wind. And the blades would be turned off—absolutely, no exception, nonnegotiable.

"But it would be so amazing. She's flying through the air under the blades. It will add this element of drama, and . . . "

Somehow that argument didn't sway them.

I wanted Marcella to look like a socialite on her way to the Hamptons, and she pulled off the styling perfectly. But the idea was still incomplete in my mind. It was missing an element, and I couldn't put my finger on it. (I am not exactly a regular at heliports.)

"Your helicopter is ready."

I turned to see a pilot straight out of Central Casting. *Now* the shot was complete. We ran outside and started shooting. Dripping in the sweltering heat, Marcella did thirty standing jumps in five minutes.

We hid in the helicopter for a break from the heat. Marcella was wiped out. We reviewed the photos and saw several we liked.

As we were patting ourselves on the back, relieved that we got the shot so quickly, the pilot said casually, "How about this aircraft carrier floating by? Might look good in the background."

Fleet Week was ending, and the sailors were passing by at that very moment, pulled by a tugboat. We had five minutes left to shoot, and they would be gone in about two. We scurried back into the heat. Marcella shifted into gear, propelled by the drama of the moment.

Everyone was ecstatic. We finished in time, and the setting was unbelievable. An aircraft carrier passes that heliport only twice a year, and we were there to capture it.

Body Surf (p. 95) This position was not achieved by a running jump—Jacob could never have gotten any speed in the water. Instead, he pushed himself straight up from the sand, extended his arms, and then caught himself before landing on Jill. It was a very impressive feat to witness, especially because he did it twenty-three times in under ten minutes.

Cowabunga! (pp. 96–97) I was in San Francisco when I received a tweet from a stranger: @JORDANMATTER: YOU SHOULD DO A SURFING SHOT AT HALF MOON BAY.

Whoever you are, thank you!

exploring

In the Banyans (p. 99) I was in Sarasota shooting at the FSU/Asolo Conservatory for Actor Training, and I spotted this particularly impressive Banyan tree. I sent a text to the Sarasota Ballet director, Iain Webb, asking for a dancer who could scale the tree. He sent me Ricardo, whom I had photographed successfully the day before on Siesta Beach. I only had a twenty-minute lunch break to capture this image. Ricardo was holding a vine that was swinging back and forth, and it's the only thing keeping him from falling to the ground. It took tremendous strength to stay up there for fifteen minutes.

You Are Here (pp. 100–101) I knew early on that I wanted to get out of the "pretty picture" box that defines many dance photographs, but it wasn't always easy to do. Kristina is a beautiful woman, so shooting her hanging from a Dumpster with a cigarette in her mouth wasn't exactly my first instinct. Taking this photo reminded me that beauty comes in all forms, and it inspired me to continue looking for less glamorous settings and scenarios.

Le Backpacker (p. 103) A relaxing family vacation became an intense work trip when I stumbled upon a dance studio while exploring Montreal. I was so excited to find a wealth of beautifully trained dancers, and I just couldn't resist. Since Hudson and I went for daily adventures on the subway, it seemed like an obvious choice for a photograph as well. Nathan jumped seventy times in the span of forty minutes while Hudson fell asleep on the platform floor behind me. Not my proudest parenting moment.

Building America (pp. 104–105) As I drove with Jamila and Kelli to Joshua Tree, California, I was fascinated by the vast wind turbines littering the landscape outside of Palm Springs and knew I had to include them in a photo. We took this practice shot as I waited for the train to clear the frame. I was so preoccupied with the wind turbines that I didn't even see the magic of the passing train. I took forty-five more images, always waiting as the trains flew by. Sometimes we don't see what's right in front of us.

View Finder (p. 110) This was the first of many photographs I took that could be titled, "Will you risk your life for me?"

To the Moon (p. 112) I spent more than an hour shooting Houston Ballet dancers Charles-Louis Yoshiyama and Kelly Myernick in Rocket Park at the Johnson Space Center, only to discover this shot ten minutes before I had to leave for the airport.

Fill 'Er Up (p. 113) and Pier Pressure (p. 115) Like all the photos in the book, these two images are absolutely, positively not digitally altered, despite many people's assumptions to the contrary. Can Victor really jump fifteen feet in the air (he did drive several hours from Colorado Springs for the shoot, so maybe he was feeling particularly energetic after being cooped up)? Can Marissa really jump twenty feet in the air? "No," is the answer to both questions, but somehow they got up there. In Victor's case, he leapt off the brick wall (which is still pretty darned impressive!). In Marissa's case, she was tossed in the air and then caught by two dancers posing as passersby: Nick Factoran (the thrower in the red shirt) and Jones Welsh (the catcher in the white shirt). This was a trick I wanted to photograph for years, and I finally found the dancers able to pull it off.

Vista (p. 116) This image is filled with serenity, but behind the scenes it was chaos. It takes impressive composure to hold this pose on an uneven ledge one hundred feet off the ground, so we were all feeling anxious. All of us except Evgeniya—she was as calm as she looks.

Vantage Point (p. 117) Before having Dudley balance precariously on a narrow railing over freezing water, I gave him one crucial piece of advice: "If you fall, hold my camera really high and start frantically kicking your legs."

Vision Quest (p. 118–119) A dancer who shall remain nameless gave me the idea for this photograph. We were discussing location options during my trip to LA. I wanted to shoot at Joshua Tree, but I was concerned about the five-hour round-trip drive. "You should totally go. It's beautiful. I just got back—I spent the weekend tripping on mushrooms with my friends." Having never "tripped" myself, I relied on the landscape to guide me. For about an hour I felt lost in the desert, but seeing the sun peek through the tree gave me sudden inspiration. The sun moved quickly and gave us only a couple of minutes to shoot, so Kelli and Jamila started improvising—sans psychedelics.

grieving

Bad News (p. 121) Lisa hired me to shoot dance promo shots while she was in college. I love photographing dance students—they're still crazy enough to do anything. I got this idea after shooting a much safer series of classic dance images on the platform moments before (notice the leotard under her sweater).

We shot twelve frames in six seconds as the subway approached.

Condemned (pp. 122–123) I took a brief trip to New Orleans to shoot two photographs: Mardi Gras and the Ninth Ward. Eight years after Hurricane Katrina, there was still no shortage of wrecked houses. It's a sobering sight—rows of reconstructed homes interrupted by devastating loss and abandonment. I hoped to create an image that would honor the unimaginable pain associated with this tragic event.

Out in the Cold (p. 125) "Seattle Weather: January 2012 Snowstorm Could Be Worst In Decades" (Huffington Post, 1/17/12). Of all the story lines I imagined for my trip to Seattle, a major snowstorm was not one of them. It hit Seattle just hours before I was scheduled to leave, so I didn't have much time to take advantage of this tremendous opportunity. Marissa and I drove (slowly) around, looking for something special. Driving through near whiteout conditions, we made a wrong turn. This mission sign was all I could see, and it was perfect. I asked Marissa to jump like she was running for safety. It was almost impossible to focus the camera through the snow. Marissa did 135 difficult jumps in twenty-five minutes, and she would have kept going—but my hands stopped functioning before her legs did. Seattle filmmaker Lindsay Thomas documented this shoot; the video can be seen at dancersamongus.com.

After (pp. 126–127) "Your images are so happy, but life isn't always joyful. We need photos that show people's struggles and hardships as well."

I was speaking with Susan Bolotin, editor in chief at Workman Publishing, and the rest of the design team. We were discussing the photos I would attempt in Chicago. I understood exactly what she meant, but I didn't want to hear it.

I knew what I had to do. I had to say good-bye to my mother. She had died just months before, and I hadn't given myself a moment to grieve.

"Maybe a graveyard. There's usually a beautiful one in every city. . . ." Now everyone at the table was discussing the merits of a mourning photo. I smiled and nodded my head. Inside I was filled with dread.

When I arrived in Chicago, I asked the innkeeper for some good locations to shoot. He mentioned just one—Graceland Cemetery.

I met Chloe at Graceland on a sunny afternoon. I asked her to bring flowers. We sat on the expansive grounds and discussed loss. A friend of hers had recently died, and she was feeling raw and vulnerable as well. We wanted to honor our memories with dignity—to create a simple image with resonance.

As I photographed Chloe draped across a gravestone, I felt exhilarated by the creative process—photography is my protective blanket. When I looked at the image later that evening, alone and undistracted in my hotel room, I broke down and cried uncontrollably.

The photograph is the beginning, not the end, of my grieving process. I'm not ready to say good-bye.

Slaughterhouse at Night (p. 128) The stench hits you before you reach Greeley, Colorado, and when you arrive in town it's overpowering. It's the smell of animal slaughter. I was there for another photography job, and to my delight I met Monte, a cowboy turned dancer from Wyoming. We went for a late-night drive, and we discovered smoke emanating from behind the fortressed gates of the slaughterhouse. I've shot in many conditions over the years, but nothing has compared to that penetrating odor of death. If I close my eyes, I can still taste it.

One Too Many (p. 131) Thanks to Mary Barrett, I had full access to Fontainebleau, one of the most beautiful resorts in the world. So where did I choose for my first location? The bathroom, of course. Steven is a Parsons dancer, and he embraced this idea immediately. He spent ten minutes with his head in the toilet and didn't vomit—kudos to the resort's cleaning crew.

Drowning in Debt (p. 133) Abby, a former member of Parsons Dance, is executing a terribly strenuous pose that looks effortless, just months after giving birth to her child, Marcello, below. I discovered this location when I photographed someone in the building, and the sense of claustrophobia I immediately felt gave me the idea for this image.

Running Scared (p. 135) This parking garage was visible from my hotel room in Atlanta. We all feel vulnerable at times in our lives, and this seemed like the perfect setting to explore that emotion. Is she being harassed, or does she just fear the possibility? (To keep the ambiguity, I didn't want Julie's husband, playing the part of the stranger, to look overtly threatening.) During the shoot, we communicated with cell phones; once she jumped, I would review the image and give her notes. After a few minutes, a security guard approached, looking for an explanation for her odd behavior. He added an extra element I hadn't anticipated, and I wanted him in the photograph—close to her, but tragically out of reach. Julie asked him to go down one level and stand there, which he did for about thirty seconds. Fortunately, we got this shot before he continued on his rounds.

Hair of the Dog (p. 136) Dario is a star; he has danced with Twyla Tharp, Parsons Dance, and Cedar Lake Contemporary Ballet, and dance photographer Lois Greenfield has featured him in many of her calendars. Despite this résumé, he got on a bus in New York City at sunrise, rode five hours to DC, and waited several more

hours for his opportunity to shoot. When he finally got in front of the camera, I asked him to be a drunk passed out in an alley—not the most glamorous pose of his career. But he loved it!

Forgive Me (p. 138) How on earth did I get access for this photo?

It all started when I got arrested after a fight with two hoodlums who were threatening a ballerina. I ended up in a cell with Tommy Panto, a dancer with Atlanta Ballet. I bribed the guards to sneak in a camera, and we took this shot before being transferred to a maximum-security prison. They felt I was a threat to the other inmates, so they confined me to lockdown until my attorney could get me out on bail.

Do you have any idea how much I wish that were true? The real story is much less sexy.

I actually owe it all to Mariette Edwards, a celebrated career coach who brought me to Atlanta to photograph some of her corporate clients. I agreed to the job so I could shoot for *Dancers Among Us* as well. Mariette took on the responsibility of suggesting locations, and she casually mentioned that her friend works at Special Projects, a set and props warehouse. "Among other things," she wrote, "they have a jail cell."

I flipped out. I had been lusting after a prison shot for months.

We were given access to the costume shop and had been told there were several orange jumpsuits. We desperately scoured the endless rows of costumes and only discovered orange scrubs. The shirt was too small, but the pants looked pretty good.

We were brought to the location. I was tingling with adrenaline. Not only was it authentically grimy in every way, but the sunlight pouring through the window filled the cell with a haunting glow. It was perfect.

It was an auspicious beginning to my day. I went on to shoot six more dancers and created some very exciting photos, but there is really nothing like your first prison experience.

working

Coffee Break (p. 143) I awoke to a rainy morning in industrial Houston. The overcast mood served my needs perfectly. I drove around the Texan city of Pasadena with members of NobleMotion Dance, looking for oil rigs. They are all pretty heavily fortified, so we really lucked out when we found an open pathway in a sea of oil refineries. I asked the dancers to roll around in the mud while I got donuts and coffee. It's hard to imagine that we shot such a complex pose in ten minutes, but the rain destroyed our props very quickly. Fortunately, the dancers weren't as vulnerable to the elements.

Save the Day (pp. 144–145) A dolphin led me to this location. Literally. I had just finished shooting seagulls on Siesta Beach with four members of Sarasota Ballet (see pp. 2–3) when it started to rain. I wanted another photo, and I saw a dolphin swimming close to shore. I started running toward it, gesturing frantically for the dancers to follow, hoping I could somehow include the beautiful mammal in the background. Instead, I ran right into this picturesque lifeguard station. The rain was pouring down, and the wind was gusting wildly, but Ricardo kept climbing the stairs and jumping. Just as the storm reached its peak and I thought we would have to stop, a lifeguard walked nonchalantly into the frame and dropped off his rescue board. He exited as quickly as he had come. Ricardo took up his position . . . and the shot was saved.

Work Boots (pp. 148–149) My wife gave me a great idea: a ballet dancer *en pointe* at a construction site. I assumed Kara would be standing in front of a warehouse on her lunch break, but a wrong turn by the cabbie landed us at an asphalt factory instead. We couldn't have been luckier. We scoured the grounds and found an abandoned shovel. I asked Kara to roll in the mounds of oil and tar, and she happily complied. I shot two hundred images of Kara's full body, featuring very impressive leg extensions, before I saw what the tar had done to her pointe shoes. I decided to simplify my approach to the photograph by isolating her feet instead.

Dig It (p. 150) Marc dances with Luminarium Dance in Cambridge, Massachusetts. He embodies their risk-taking style, so they must be pretty exciting in performance. We shot this image in the pouring rain. The pickax was very heavy, and the ground was quite slippery. On his first jump, Marc launched himself off the fence, slipped in the mud, and *landed hard on the pickax*. It was a scary moment until he stood up, smiled, and said, "Let's try that again." Which he did, sixteen more times! When I finally got the pickax lined up with the white cupola in the background, we called it a day.

Taking Stock 1 & 2 (pp. 154–155) Working with Adé was my first exposure to the *So You Think You Can Dance* phenomenon, and I was pleasantly surprised. I wanted to provoke the crowd to gawk while he jumped, so I called out his name and I immediately got the reaction I needed.

Saving Lives (pp. 160–161) My friend Kevin Ban is an emergency physician at Beth Israel Deaconess Medical Center in Boston; through him, I got access to their emergency department. Welcoming me with open arms were volunteers, nurses, residents, and security personnel. It was unbelievable.

Fortunately, it was a slow night in the ER. I asked the

staff for a triage room, a bunch of residents in scrubs, a heart monitor, and a defibrillator. They made the room look completely authentic, down to the mess on the floor, the activity around the patient, and the placement of the defibrillators on his chest. Jim Hennessy, a local photographer who was along for the ride, was kind enough to volunteer for heart failure. Duncan Lyle was a dancer with Boston Ballet who was about to move to American Ballet Theatre in New York City, so I allowed myself to dream—maybe he could do the impossible and jump high enough to seemingly levitate over the patient like a guardian angel.

Sometimes dreams come true.

Men at Work (pp. 162–163) I met Michael, a dancer with Alvin Ailey American Dance Theater, in Harlem with the intention of shooting the famous Apollo Theater façade. I realized immediately that I didn't have a shot. The pure morning snow had melted, the light was too bright, and there was nothing interesting going on except a potential confrontation between some laborers. There was lots of screaming in the street. As I watched the altercation, all I could think was, "That's a really cool vest he's wearing. It matches the Apollo sign. And he has a shovel." So I headed over to the group.

"Hi, my name's Jordan. I'm a dance photographer. Can one of you lend me your vest and a shovel?"

You just never know until you ask. I got a vest, a shovel, and two workers to join the shot (after I promised sandwiches for the entire crew). Michael came up with an unbelievable pose, and I sprawled out on the wet sidewalk to take a few quick shots. "This will only be a couple of minutes," I promised.

Thirty minutes and one hundred photos later, I was satisfied that we had a nice selection of images. Michael was getting sick of falling in the snow, and my jeans were frozen to my butt. It was time to buy lunch!

Caleb Custer created a very fun video of this shoot. It can be seen at dancersamongus.com.

Transfer (pp. 164–165) This photograph changed the direction of *Dancers Among Us*. I showed my friend and collaborator Jeremy Saladyga several of my early images featuring the Paul Taylor dancers in relatively isolated scenarios. "Where's the 'among us'? These shots need more people, more activity." So I called Jeffrey Smith, my original inspiration, and asked if I could photograph him again. When I took this image, I understood what the project could become. Thank you, Jeremy.

Today's Special (p. 166) I'm an admitted coffee snob, so if I was going to do this shot, it had to be with the best. Thank you to owner, Jonathan Rubinstein, for behind-the-counter access to Joe Coffee, home of my favorite latte in New York.

Happy Hour (p. 167) Even though saying yes generally means investing more time and effort in something (which is probably why people say no so frequently), good things usually happen when I say yes.

This lesson was very clear when I shot Michelle on Stone Street in New York's financial district. I asked three young guys to pose in the shot with Michelle. They had loosened their ties and were drinking beer, so I assumed they would be up for the experience. They were apprehensive and returned my business card as if they didn't want the product I was selling.

I was lost. I wanted young men in the photo, and there were no more to be found. Then I heard a very New York accent: "You want us tuh pose wid her?" Three men—not young—wanting to grab a quick shot with their arms around a pretty blond dancer before heading back to the office. My first reaction was to ignore them, my second was to say no thanks, but I acted on my third. I said yes.

"Sure, guys. But we need to set it up. Call the office and tell them you'll be late. Let's order some beers. Don't eat the fries—they're props. No, you can't touch her—this is art!"

I borrowed an apron from a waitress and had Michelle wear it. Given the (how do I say this delicately?) slight difference in age, it made more sense that she'd be serving them beer rather than drinking it with them.

I shot quickly before the guys got bored. Michelle is a beautifully trained dancer with the Metropolitan Opera, and she nailed her pose every time. The guys started improvising, taking the beer off the tray and thoroughly enjoying themselves. Their joy shows in the photo.

I'm lucky I said yes.

High Roller (p. 168) This image of Luke hanging off my studio's fire escape prompted my publishers to ask about my liability insurance and, in truth, of all the dangerous scenarios I created for *Dancers Among Us*, this was by far the scariest. But Luke, who had danced with Cirque du Soleil in Las Vegas, was willing to push the limits. My heart pounded for hours after the shoot.

living

Rock Star (p. 171) I mentioned a singing-in-the-shower idea to Matt over the phone, and when I arrived at his apartment he was fully prepared. He had purchased a clear shower curtain and added a sticky mat to the bottom of the tub for a safe landing. At the time of the shoot, Matt was starring in the off-Broadway sensation *Sleep No More*, so he certainly couldn't risk injury. Still, he jumped eighty times before my camera got too steamed up to

function. Matt seemed completely comfortable with the nudity, but with that body, what would you expect?

Training (pp. 172–173) I was considering using an interior location for Erin's shot—a very cool design studio in industrial Chicago. But when I looked out the window and saw elevated train tracks, I changed the plan. Fortunately, Erin had workout clothes with her. Access wasn't easy, and once we were on the tracks I had no idea if they were functional. Erin jumped seventy times over the deserted tracks, and the shot looked pretty cool. And then we heard the horn of the oncoming train . . . magic! We tried several trains before I got this image. Kathryn Yohe captured the terrifying adventure on video, which features a very upset engineer with an extremely loud horn. The video can be seen at dancersamongus.com.

First Snowfall (p. 175) "Stay inside! Don't travel! Armageddon is around the corner!" *Warnings by every news organization on December 26, 2010.*

As the "Blizzard of the Century" blanketed the East Coast, with whiteout conditions on all the roads and public transportation at a standstill, it was probably not the greatest idea to leave a warm house and drive twenty-five miles to Times Square.

But that's just what I did.

Jennifer, who was fresh off a holiday performance with the Mark Morris Dance Group, matched my insanity. She was on one of the last planes to land at JFK Airport and, minutes later, she grabbed a subway to Times Square.

I wanted the photo to feel celebratory, so I asked Jennifer if a jump was possible. She didn't feel safe—slippery conditions, sixty-mile-per-hour winds, frigid temperatures, and she was wearing clogs—so we tried a standing pose. We reviewed the images, and we knew it could be better.

Jennifer agreed the pose had to be a jump, and she threw caution—and herself—to the wind. She jumped more than fifty times in impossible conditions. The snow was getting thicker by the minute, and her body was exhausted and frozen, yet this image was the very last one we took.

Park It (p. 178) How many backflips does it take to get the attention of park security? Apparently, the answer is twelve.

Reading Up (p. 179) Here's how this shoot came to happen: Durell, a member of the prestigious Limón Dance Company, saw me interviewed on television, saying that I had worked with all the major dance companies in New York City. This understandably ruffled his feathers. He posted a comment on Facebook that basically said, "No, you haven't!"

Later, we met outside Barnes & Noble and discussed ideas for

the shoot. I asked Durell if he could levitate over a book. The fact that he'd never tried it didn't stop him from nailing it on the first practice run in the parking lot. I ran around in circles, giddy with excitement—this could be really cool!

We found an empty stretch of carpet in B&N and set up the shot. After about two minutes, we were asked to stop.

"You have to get permission from corporate headquarters to take photographs."

Instead of leaving, we moved to another floor and tried again. There was a book signing about to start, featuring Joy Behar of *The View.* A crowd had gathered. I wanted to crash the stage, but Durell wasn't feeling it, so I reluctantly asked permission to shoot Durell on the podium, entertaining the audience.

"You have to get permission from corporate headquarters to take photographs."

We went around the corner and hid from public view. Security was focused on Joy, so I saw an opportunity. We took thirteen images in under three minutes. As I mentioned earlier, it's better to ask forgiveness than permission.

Corporate headquarters, do you forgive me?

Go West (p. 180) "You got a gun in that bag?"

I was at the Houston Gun & Knife Show with Connor Walsh, principal dancer with Houston Ballet. I was desperate for a photo, but the huge sign above our heads was a little problematic:

NO GUNS! NO CAMERAS!

"No sir, I don't have a gun."

He stared down at me. I'm 6'3", so that's not easy to do.

"You got a camera?"

I briefly considered lying, but he was standing like eight inches away from me, staring me right in the eyes and not blinking.

"Yes, I have a camera."

"Is it a small one?"

"No actually, it's pretty big."

He stared for a few more seconds.

"Just don't use it in here."

Connor was looking a little apprehensive. I already had three confrontations with law enforcement that day, so I was feeling nervous as well. We went outside to discuss our plan. I wanted to give it a try: "Let's just do it. What's the worst that can happen? I don't think the guns are loaded."

Before we could go back inside, I saw a cowboy proudly crossing the street with a rifle in his hand. I jumped at the opportunity. "Excuse me, sir, can I borrow your gun for a photograph?"

He looked dumbstruck. I tried to explain that I was traveling the country photographing dancers in everyday situations, but

we weren't connecting.

"No, you'll run off with it," he said as he walked away.

"No I won't," I shouted after him. "I'll give you my wallet as collateral."

Surprisingly, it worked. He handed me the rifle, which was deceptively heavy. He even agreed to pose in the background, smoking a cigarette. Connor jumped for about twenty minutes before we headed into the gun show for another photo. Due to the legal restrictions I mentioned above, I'm not at liberty to reveal what happened once we got inside. But I can say this: I won't be sneaking any more cameras into gun shows.

Stroller Boogie (pp. 182–183) Karin retired from the prestigious American Ballet Theatre once her baby, Madeleine, was born, but she was still in great enough shape to jump sixty-four times while I waited for her daughter to do something fantastic. It was worth the wait!

Counter Balance (p. 185) Here's a photo that certainly required permission, which I received enthusiastically from the owner of the Carnegie Deli, known for the biggest pastrami sandwiches on the planet. I'm sure the fact that I had the widely circulated New York *Daily News* documenting the shoot had nothing to do with the easy access—it must have been my winning smile. Initially, I was shooting from a different angle, but the paper's staff photographer, Robert Sabo, alerted me to this perspective instead. Thank you, Bob!

Bumpy Ride (p. 187) Years ago, I was so excited to get my first cell phone that I couldn't wait to play with it. I was on the subway doing just that, holding a coffee. The train stopped suddenly, and I spilled my coffee all over the woman next to me. I wanted to re-create that moment now—a dancer stumbling (gracefully, of course) on the subway, spilling her coffee on an innocent bystander.

We had one chance to get the shot—ONE CHANCE! A single frame! After that, Geoff would be stained with coffee, the ground would be wet, and the passengers would be freaked out.

We rehearsed the pose for thirty minutes. Allison was getting tired. The passengers had been watching rehearsal and were looking concerned. It was time to roll the dice.

I asked Allison to practice one last time, just to set it in stone. All of a sudden, my camera stopped focusing. It just stopped. There was nothing I could do.

We waited ten infuriating minutes. My Nikon was being temperamental, focusing about half the time. People were starting to get off the train. The subway would be empty soon. Now was the time.

I asked Geoff to appear asleep. I hoped Allison's position would be right, her eyes would be open, her expression would look shocked, and the coffee would be arcing in a steady stream, splashing Geoff in the face at the exact moment I released the shutter. Oh, and I hoped the camera would decide to focus.

"Here we go, everyone. Remember to get your leg up, Allison. Hit him hard with the coffee and look surprised. Geoff, you ready? One . . . two . . . three . . . GO!"

Splash! Coffee everywhere. The train pulled into the station. Our moment had passed. I held my breath and looked at the photo.

They nailed it! Everything I wanted, and more. One take. In focus. Unbelievable!

Garbage Night (pp. 190–191) I was in Miami shooting *Dancers Among Us* when I saw this tweet:
@JORDANMATTER: LOVE YOUR PHOTOGRAPHY AND WOULD LOVE TO SHOOT WITH YOU ONE DAY!
—@ALEXDWONG

I continued shooting. Ten minutes later, I received this email from Samantha Siegel, my social media consultant:

"I see that Alex Wong has reached out to you about shooting for *Dancers Among Us*. Do EVERYTHING in your power to make that happen!"

I started seeing passionate tweets from complete strangers commenting on the possible collaboration, urging it to happen.

I turned to the dancer I was photographing. "Who is Alex Wong?"

She looked at me like I had just said, *Who's this Obama guy I keep hearing about?*

"Alex is incredible. He was going to win *So You Think You Can Dance* until he tore his Achilles tendon before the final round. It was devastating. He's a huge star."

I really need to watch more television.

Once I started researching Alex, I got very excited. He's a tremendously athletic and beautiful dancer, with stunning lines and jumps up to the sky. His background with American Ballet Theatre and Miami City Ballet gives him an artistry many commercial dancers lack.

I also learned that he'd torn his other Achilles and was in recovery. So what could he actually do? Guess I'd find out.

For some reason, the image of a streetlight at night kept popping into my head whenever I thought about shooting Alex. I couldn't shake it. We planned to meet one evening around Christmas in the West Village. I walked around looking for the right streetlight when I stumbled upon Minetta Lane. It had been raining, which added a nice reflection on the street and a misty quality to the atmosphere. Alex started warming up. "I'm at about 50 percent recovery. I can jump, but I'll take it easy."

I need to shoot him again and see how 100 percent looks.

I asked Alex to grab a garbage bag and throw it into the pile at the height of his jump. I figured I'd call the photo, "Garbage Night."

CRASH!!! The bag was filled with bottles. Maybe I should have called it "Recycling Night" instead. We tried a few more throws.

CRASH!!! CRASH!!! CRASH!!!

"What the hell are you doin' down there?!" an angry voice bellowed from a window.

"We're taking a photograph, sir. We're almost finished," I replied, trying to sound casual.

"Do you have a permit?"

"Of course," I lied.

"I hope so, because I'm callin' the police!"

This put a little cramp in my creative process. I liked the shots we had taken, but there was something missing. I didn't want to get arrested trying to figure it out, but I didn't want to leave either. Neither did Alex.

Then it hit me like a ton of bricks.

"Can you take off your shirt?"

Three more jumps. *CRASH!!! CRASH!!! CRASH!!!*

I could just feel the guy in the window fuming (with good reason: It was after 10:00 p.m.). We looked at the shot together and agreed that it couldn't get any better. We loved it—the pose, the colors, the streetlight, the reflections . . . the *body*! We escaped before the police could add more blue light to the scene.

Alone Together (pp. 192–193) Southern hospitality was in full swing for this photograph. The Madison Oaks Inn offered me full access to their expansive grounds simply because I asked, and they even made us sweet tea for our prop. The pose is much more difficult than it looks, even for Atlanta Ballet principals. Local photographer Will Day made a video that reveals a very unceremonious ending to the photo shoot. It can be seen at dancersamongus.com.

Morning Routine (p. 197) I flew to Aspen through the worst turbulence I've ever experienced. There, I spent a long day exploring nature with incredibly talented dancers from the Aspen Santa Fe Ballet. I came to Aspen for the beautiful Colorado landscape, yet in the end the shots selected for the book were all interior locations. That was the beauty of this process: I never knew what would happen when I boarded a plane, and sometimes things didn't turn out as I had anticipated. I have to give credit to Paul for his creativity: I shot lots of men for this book, and he's the only one who brought along pointe shoes.

Sweet Reward (p. 197) This is Melody with her son, Isaac.

When I arrived at their house, I imagined I would take a photo of Melody tucking him in for the night. That is, until I saw Isaac casually scale this doorway like Spider-Man. We tried several takes of the photo, and every time I asked for more ice cream on Isaac's cone. It was about an hour past his bedtime, so the shot should probably be titled "Sleepless Night"! Isaac was able to steal the spotlight from a Houston Ballet star—perhaps it's a fortuitous beginning to a dance career of his own.

Friends (p. 199) I wrote an open blog to a Tony-winning Broadway legend—best known for her role as Lilith on the hit television shows *Cheers* and *Frasier*—imploring her to pose for me. It was titled, "Bebe Neuwirth, I Want YOU for *Dancers Among Us*!" It was a long shot, but you never know until you ask, right? Stranger things have happened. After a few days with no response, I let go of my fantasy.

Six weeks later, an email shook my world.

"I just saw your blog request. I looked at the slide show of your book's shots, and I'm completely charmed, moved, delighted, and willing!"

Signed simply: "Bebe."

At this point, my life became totally surreal. Later that same day, I met Bebe at Prodigy Coffee, her husband's awesome coffee shop in New York's West Village. They were raving to me about ME. I was dumbstruck. After two hours of kicking around ideas, we settled on a plan I never would have anticipated. The location would be Equine Advocates, an amazing horse sanctuary Bebe works with in Chatham, New York.

I was leaving for a West Coast trip, so I scheduled the shoot for the day I returned. I flew in late Friday night and arrived home at 2:00 a.m. By 5:00 a.m., it had begun to snow, and by 7:00 a.m., it was a snowstorm. At 9:00 a.m., I was on the road to Chatham. As a testament to Bebe's commitment, she didn't cancel, despite the doom-and-gloom forecast.

After a treacherous four-hour drive (it usually takes two hours), we both arrived around the same time. The 140-acre facility was breathtaking. So was the generosity of Susan and Karen Wagner, who opened their home to us—much appreciated given the twenty-degree temperature. We shot in several locations around the property, including the horse stalls, but it was this moment that captured the beauty of the horse, the dancer, and the sanctuary best.

Iconic (p. 201) Before this shoot, I spent a long day in sweltering heat, but the payoff was fantastic: I created four images that would eventually land in this book. I was on a roll, and Jennifer was the perfect dancer for my final chapter. We had worked together several times, including in Times Square during a blizzard, and I knew she was a risk taker. If she could jump in

clogs during a raging snowstorm, I figured she could definitely jump in heels over a subway grate to replicate Marilyn's iconic image. She jumped eighteen times, but we didn't even need that many—this was the fifth shot we took.

Substitute Teacher (pp. 202–203) The students at Holy Rosary School waited two hours for me to arrive. When I finally walked into the room, they were respectfully quiet. I saw a paper airplane on the ground, and it gave me an idea. I told them to grab something soft and throw it at the teacher—it was time to live out every student's fantasy. They all stayed still, not sure what to do.

"I'm serious," I said.

"I'm serious," a boy's voice mocked me under his breath.

"Who said that?"

Everyone looked at the same kid. He smiled sheepishly.

"Perfect. That's the kind of attitude I'm looking for," I told him. "Come sit in Cyrus's desk and be a real pain in the butt. Everyone follow his lead."

It didn't take them long to warm up. They improvised masterfully, right down to sleeping on the desk and whispering in one another's ears. The teacher was a great sport, and Claire consistently nailed her pose, as you can see on the contact sheets.

Thank you to Claire's mom, Leanne, for arranging the shoot. I had an absolute blast.

All Hail (p. 204) This image was taken on my very first day of shooting. I was walking around with my original dancers from the Paul Taylor Dance Company, trying to figure out what I was doing (I was so green that I didn't even know the difference between modern dance and ballet). I had originally wanted the dancers to wear all black street clothes—an idea I quickly abandoned. Michael and I had been all over the West Village without firing a shot until this idea came to me. Michael conceived of the pose within seconds, adding the lovely detail of putting his hand in his pocket. I definitely learned from the best! We took only seven photos while the cabs were stuck at the stoplight: I missed the shot badly six times, but fortunately I released the shutter at the right moment for this image. When I reviewed the photograph, I got chills because I had never seen anything like it.

Cram Session (pp. 206–207) This is the final photograph I shot with a Paul Taylor dancer. The clothing had become brighter, the locations more crowded, and the stories a little more complex. The project had definitely evolved over the summer. I assumed we would have only a minute for this shot before security arrived, but that never happened. This pose is called planking, and a couple of years later, images of people planking started popping up all over the Internet. *Saturday Night Live* even did a skit about it. Do I have any legal grounds here?

Joy (p. 209) One of the last photographs I took for *Dancers Among Us* is, to me, the most inspiring. Evan lost his leg to bone cancer after five surgeries, and he spent sixteen months in chemotherapy once the cancer spread to his lungs. He had been a tap dancer since he was five, and he took it up again immediately after finishing chemo. Videos of him tapping went viral, and his aunt contacted me about photographing him. I met him outside Memorial Sloan-Kettering Cancer Center after one of his many checkups. He immediately impressed me as a dynamic, thoughtful, down-to-earth young man. He attempted twenty-two jumps, and I still have no idea how he landed safely every time. But he did. And I know he will.

The Artist (pp. 210–211) Samantha is my social media coordinator, working with Design Brooklyn, as well as a dancer and freelance photographer. She felt strongly that I should be featured dancing in the book, and she offered to take the photo. Given all the crazy things I have asked dancers to do over the years, it was only fitting that when it came my turn to jump, the heavens opened up. I'm no dancer, so I channeled my college baseball days and pretended I was turning a double play. I jumped twenty-one times, and that was more than enough to gain a deeper understanding of exactly how difficult the poses in this book are. They all make it look so effortless, and yet it is so, so difficult.

about the technique

I like to move quickly. I never use strobes or other manufactured light sources, because they take time to set up. I shoot everything using available light. As a result, I need a camera that is especially good in low-light conditions. Most of the images in this book were shot with the Nikon D3s. I tried to keep my ISO as low as possible, but in some of the darker situations I shot up to 6400.

I travel light. I bring one large bag filled with two camera bodies and three Nikon zoom lenses: the 14–24mm f/2.8, the 28–70mm f/2.8, and the 70–200mm f/2.8. For low light I also have the Nikon 28mm f/1.4, the 50mm f/1.4, and the 85mm f/1.4. I used them all for this book.

Photographing dancers can be difficult because they move so quickly; the moment lasts only a millisecond. When freezing a jump in midair, I try to set the shutter speed at a minimum of 1/320. I usually shoot a single frame for each jump, rather than holding the shutter down and relying on continuous frames. It is easier for me to anticipate the decisive moment than to luck into it.

Because I rely so heavily on circumstance, I don't usually have many ideas for the shoot before I meet a dancer. I ask them to bring several bright clothing options, and we explore the environment together; what's amazing is how often we discover the perfect scenario. But I tend to overshoot, often to the frustration of the exhausted dancers. Once I am certain I have the shot, I try it again from a different perspective.

My editing partner, Jeremy Saladyga, and I have done minimal postproduction work on these photographs. I use Adobe Bridge to review the images and Photoshop to color correct and, on a couple of occasions, to remove a distracting element from the background. But the dancers' poses were never altered: What I saw is what you get.

acknowledgments

I must begin by thanking serendipity. Without a lot of good fortune and some blind luck, this book might never have happened.

In March 2009 I received an email from Jeffrey Smith, a dancer with the renowned Paul Taylor Dance Company (PTDC): "I need photographs for personal use, and I'd like to hire you to take them. Can you come to a show so you have a better sense of who I am and what I do?"

The PTDC performance was my first exposure to modern dance, and I was blown away. When I photographed Jeffrey a few weeks later, I was hooked. I didn't know the human body was capable of such beautiful extremes. As I explained in the Introduction, I already had the germ of an idea about photographing joy in everyday life. Now I knew I wanted dancers to help me tell that story.

Incredibly, Jeffrey convinced many of the PTDC dancers to volunteer their time and pose for me. I had limited—okay, no—dance photography experience, and I was suddenly collaborating with some of the best dancers in the world. Initially I was torn about what they should wear, so I suggested leotards or street clothing. They revolted en masse at the idea of leotards, so the "among us" concept was born, with the dancers sporting the everyday garb of their surroundings.

I spent the spring and summer of 2009 exploring New York City with PTDC. I relied on chance to guide me as I developed the style that would become *Dancers Among Us*. I discovered immediately that using trampolines or Photoshop manipulation was unnecessary. The dancers were willing to push themselves beyond their limits, sometimes at great danger to themselves. They were very invested, often returning several times with new ideas. Their commitment and creativity were invaluable, and I am indebted to them.

After Labor Day I sent thirty images to PTDC executive director John Tomlinson, with no strings attached; the company was free to use the photographs however it wanted. John was very enthusiastic, but the images didn't work with PTDC's marketing strategy at the time. It wouldn't be using them.

Since I had created the images for PTDC, I had no idea what to do next. John's excitement inspired me to continue shooting with new dancers, but the photos remained largely unnoticed on my website through the fall and winter. Then, in the spring of 2010, something remarkable happened: Prompted by technical editor Dan Havlik, *Photo District News* chose Annmaria Mazzini's cover image for their prestigious "Photo of the Day" blog.

That's all it took; *Dancers Among Us* went viral. My photos were showing up in newspapers, magazines, and blogs around the world, eventually drawing over 700,000 visitors to my website. I was flooded with congratulatory emails and requests for interviews, plus phenomenal dancers were contacting me, asking to be photographed.

Then, after a flattering interview by Chuck Scarborough on NBC in New York, the New York *Daily News* asked to run one of my photos in its arts section. I swung for the fences and offered a counterproposal: "Why don't you do a behind-the-scenes feature instead? Send a reporter and photographer—we'll have lots of fun and probably get kicked out of a few places as well. It will make a great story!"

They took me up on the offer and ran a terrific four-page spread in the weekend section. It was my great fortune that literary agent extraordinaire Barney Karpfinger happened to read the story. He contacted me about pitching a book; after months of preparation, we started making the rounds in the winter of 2010.

The response to the photos was overwhelmingly positive, but the response to the book? Not so much. Everyone worried that it was too specific to New York City. Barney's certainty never wavered, but mine did.

Enter Netta Rabin, senior designer, editor at Workman Publishing. She saw dancersamongus.com and thought it would make a great calendar. She enlisted the help of creative director Raquel Jaramillo. Together they bombarded editor in chief Susan Bolotin with my photographs; we agreed to discuss a calendar in June 2011. The prospect of a book deal hadn't been mentioned.

I brought it up anyway.

The team at Workman was intrigued, but they had the familiar reservations about using New York City exclusively as a backdrop. I had been shooting *Dancers Among Us* for two years and had never considered moving outside the Big Apple. That was about to change.

"As a matter of fact, I have plans to shoot across America this summer," I said.

I didn't mention that my plans were about five seconds old.

"Oh, that's interesting," they said, their curiosity piqued. "Where are you going?"

"Oh, you know, San Francisco, Chicago, Philadelphia . . . uh, Colorado." My voice trailed off. "Is there even dance in Colorado?" I wondered.

"Email us some photos from the road. Let's see if the concept works outside New York."

I booked my first plane ticket the next day.

I spent the next seven months traveling the country whenever my schedule allowed. I visited some cities for a week, others for less than a day. I used social media to find dancers and enlisted local volunteers to help navigate different regions. I worked twelve to fifteen hours every day, until I eventually collapsed in a heap of exhaustion outside Newark Airport.

I would do it all over again in a heartbeat.

❖

In addition to everyone I've already mentioned, there are a few million more people who deserve recognition for their participation in *Dancers Among Us*.

Through various social media platforms, many people around the world spread the word about the project, taking it from online obscurity to a bookstore near you. I'll never know most of them, but I'm indebted to all of them.

The initial members of the Paul Taylor Dance Company who volunteered their immense talents for someone with no dance photography experience deserve a very special shout-out. Here are the original Dancers Among Us: Michael Apuzzo, Eran Bugge, Michelle Fleet, Francisco Graciano, Laura Halzack, Parisa Khobdeh, Robert Kleinendorst, Annmaria Mazzini (who appears on the cover), Michael Trusnovec, Jamie Rae Walker, and, of course, Jeffrey Smith.

As I moved beyond New York, I was fortunate to find spectacular dancers willing to donate their time and energy. Many traveled for hours to participate. I've thanked each of them individually, and now I'd like to thank them collectively. I could not have found more inspiring collaborators.

I am particularly grateful to several additional dance companies (and one television show) whose dancers participated in large numbers: Alvin Ailey American Dance Theatre, Aspen–Santa Fe Ballet, Atlanta Ballet, Ballet Hispanico, Houston Ballet, NobleMotion Dance, Pacific Northwest Ballet, Parsons Dance, Sarasota Ballet, *So You Think You Can Dance*, and TAKE Dance. (Nashville Ballet, I'm sorry I left you all dressed up with nowhere to go. I was at the end of my rope and my body just refused to get on the airplane. If we do a sequel, you'll be my first stop!)

Enthusiasm for *Dancers Among Us* extended far beyond the dance community, and for that I am grateful. Throughout the country, people offered their homes and businesses as locations, with no advance notice or payment. Locals volunteered to help just to observe the process. There are many people who dedicated a tremendous amount of time and energy, and I owe them a huge thank you: Kevin Ban, Mary Barrett, Patrick Cliett, Will Day, Mariette Edwards, Ian Finlinson, Dudley Flores, Thomas V. Hartmann, Jim Hennessey, Ellen Ianelli, Stephen Lee, Kara Lozanovski, Anna Marie Panlilio, Claire Stallman, Ryan Swearingen, Lindsay Thomas, Ivy Vahanian, Nancy Wozny, Steve Wylie, and Kathryn Yohe.

In New York City, countless people helped me out by recommending dancers, securing locations, suggesting scenarios, critiquing the photos, collaborating during the shoots, and photographing the process. A few among the many are Joe Barna, Pamela Bob, Caleb Custer, Travis Francis, Jennifer Jones, Jeremy Saladyga, Sydney Skybetter, Lakey Wolff, and the late Geoff Legg.

Thanks to Will Arnold, Samantha Siegel, and the rest of the creative team at Design Brooklyn, who brilliantly managed all my social media needs. And my assistant, Ben Esner, was invaluable in every conceivable way.

This entire process—from my first meeting with my agent, Barney Karpfinger, to designing the book with the superior Workman team—has been pure joy. I feel lucky to have found talented individuals whose passion and perfectionism match my own.

From an early age, my father instilled in me the importance of finding work that filled me with passion. He has been a generous supporter of my photography career since the beginning, and his enthusiasm was essential to my success.

My mother passed away a week before my first meeting with Workman, and I regret that she didn't get to see everything unfold. She was my biggest fan, often to a fault. Her exuberance extended to almost everything I did. I can only imagine the field day she would have had with this book; anything short of a Nobel Prize would have been an insult to her.

Thank you to my children, Hudson and Salish, for inspiring this book, and for taking such good care of Mommy every time

I left home. I don't think I fully realized the sacrifices my family made for me until I had this exchange with Hudson:

"Look at that man, Daddy," he said, referring to a construction worker swinging a pickax. "He's really strong."

"He's definitely working hard," I replied.

"You're lucky that you don't have to work hard. You just take pictures."

"Well, there's more to it than that," I reminded him. "I also have to edit . . . "

"And have meetings . . . ," he continued.

"And answer email . . . ," I said.

"And leave your family," he concluded.

Fortunately, I don't have to leave my family very often anymore. I'm sure they will think twice before inspiring a new project.

I want the final sentences I write in this book to be for my wife, Lauren: Your unqualified love and unyielding support for everything I do have given me the freedom and confidence to follow my dreams, to live a passionate life, and to be alive. Thank you. I love you.

Rohan Thompson

Jordan and Lauren (pregnant with Salish), November 2009